TOO FAST FOR LOVE
HEAVY METAL PORTRAITS

BY DAVID YELLEN

INTRODUCTION BY CHUCK KLOSTERMAN

powerHouse Books

NEW YORK, NY

THIS BOOK IS DEDICATED TO
THE FANS OF HEAVY METAL
WHO SHOWED ME THE TRUE MEANING
OF KEEPING IT REAL.

—DAVID YELLEN

INTRODUCTION

BY CHUCK KLOSTERMAN

The first time I ever saw a groupie, she wasn't a groupie; she was either a model, an actress, or an extremely expensive stripper. This is because the groupie I saw was on "Friday Night Videos." I'm not sure what band she was pretending to support (Britney Fox, maybe, or possibly Krokus), but—even as a sixth grader—I was fairly certain that this groupie wasn't authentic. I inherently knew that people like that could not exist.

Five years later, I went to see Ratt, Great White, and Warrant at the West Fargo Fairgrounds. The following summer, I saw Kiss, Faster Pussycat, and Slaughter at the same venue. It was at these two concerts where I learned two things: I was right, and I was wrong. I was right about the fact that the groupies in the videos I saw on television were not real; I was wrong about my assumption that these people did not exist. They did exist. They did not look like Tawny Kitaen, and they weren't doing splits on the hoods of Jaguars in the parking lot; they did not look like Bobbi Brown, and they did not have slices of cherry pie falling into their laps. *But they wanted to be those women*. They wanted it so much. They wanted to be Tawny Kitaen and Bobbi Brown far more than I wanted to be David Lee Roth or Paul Stanley. And it was at these shows that I realized something obvious about rock music that had (somehow) never occurred to me: groupies are normal people. And that's what these photographs prove.

Over the past decade, there's been a lot of revisionist history about heavy metal and its culture; you suddenly find dozens of hypocritical rock writers who insist that they had always adored Led Zeppelin and that they secretly had a soft spot for Mötley Crüe and Guns N' Roses. It has become trendy to lionize the debased excesses of cock rock that once were despised; after Cameron Crowe cast Kate Hudson in *Almost Famous*, people actually started to believe that the doe-eyed chicks who hung out backstage at Nassau Coliseum were nomadic love angels, spawned by Jimmy Page and Stevie Nicks in some kind of rock 'n' roll Narnia. That was not the case. Maybe it was for forty-five minutes on Sunset Strip in the summer of '88, but that's never how it was in Omaha (or in Jacksonville, or in Milwaukee, or any other American city where real people exist).

The people in David Yellen's portraits are attending concerts by bands who passed their prime more than ten years ago. Superficially, the same could be said about these groupies (had these same shots been taken in 1991, these photos would probably have become a calendar instead of a book). But what we see in these images is so much more interesting than any kind of erotica—what we see are humans trying to reconcile what they love with who they are.

One of Yellen's photographs shows a woman at a Poison concert trying to dress like a "sexy nurse." It doesn't work. Even if I was in the hospital with kidney failure and this woman walked into my room *dressed exactly as she did for this rock show*, I would not find it arousing. As a consequence, some naysayers might find her pathetic. They might feel sorry for this woman. I do not. I find her amazing, and I almost envy her. This woman is not dressing up like a nurse to be cool, or because she thinks she looks awesome, or because some element of society is telling her that this is what she must do in order to gain approval. She is doing it because she wants to experience Poison the way she dreams about Bret Michaels in her head. She wants to embrace the fantasy that makes her happy, and I'll bet it worked. I bet she loved that concert more than I've ever loved anything. I bet she cried during "Every Rose Has Its Thorn."

I realize fantasies don't work for everybody, and they certainly don't work for me. But these photos of other people's fantasies are also photos of our reality, and that never stops being interesting.

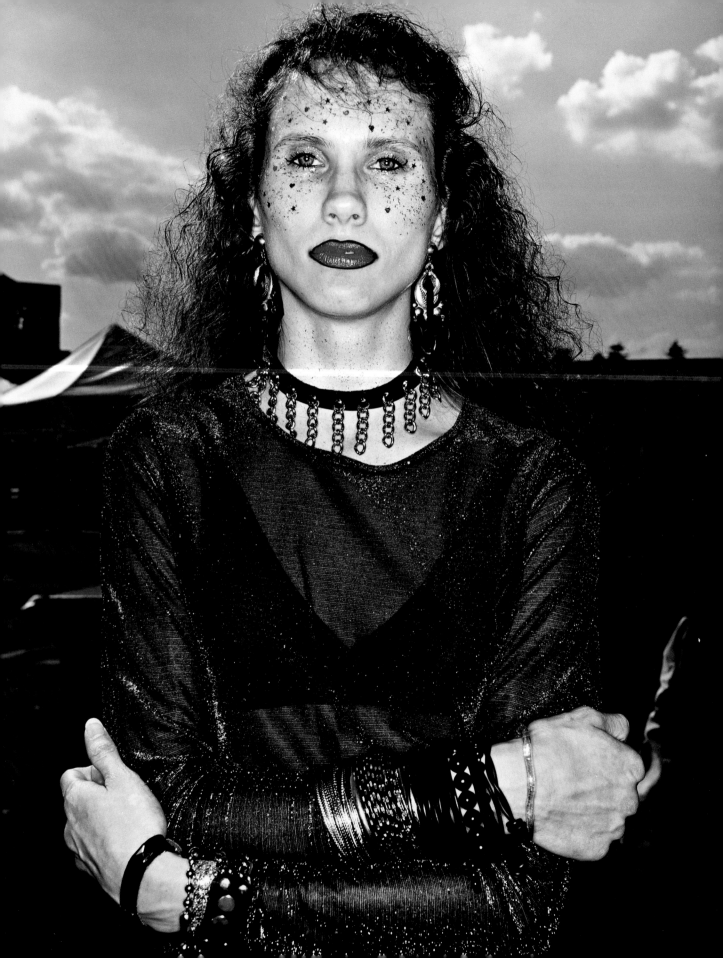

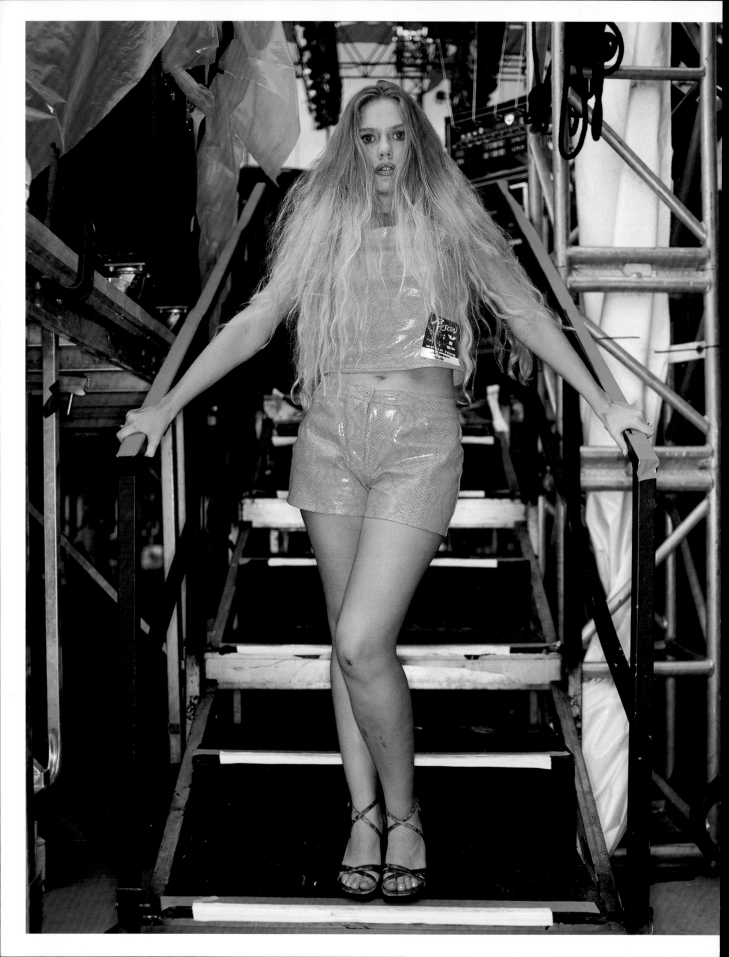

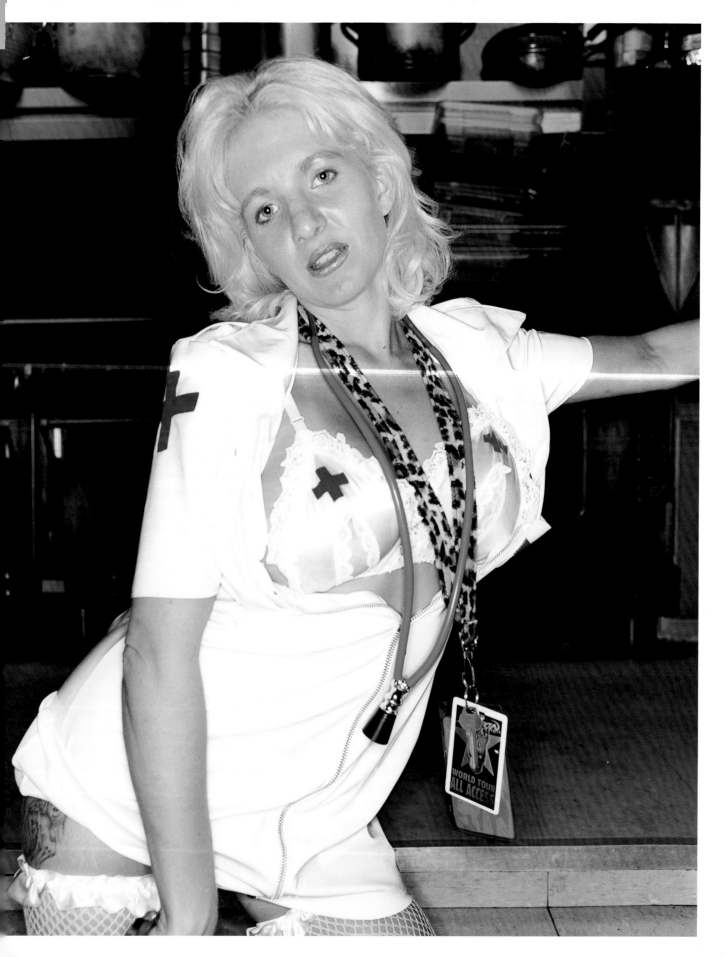

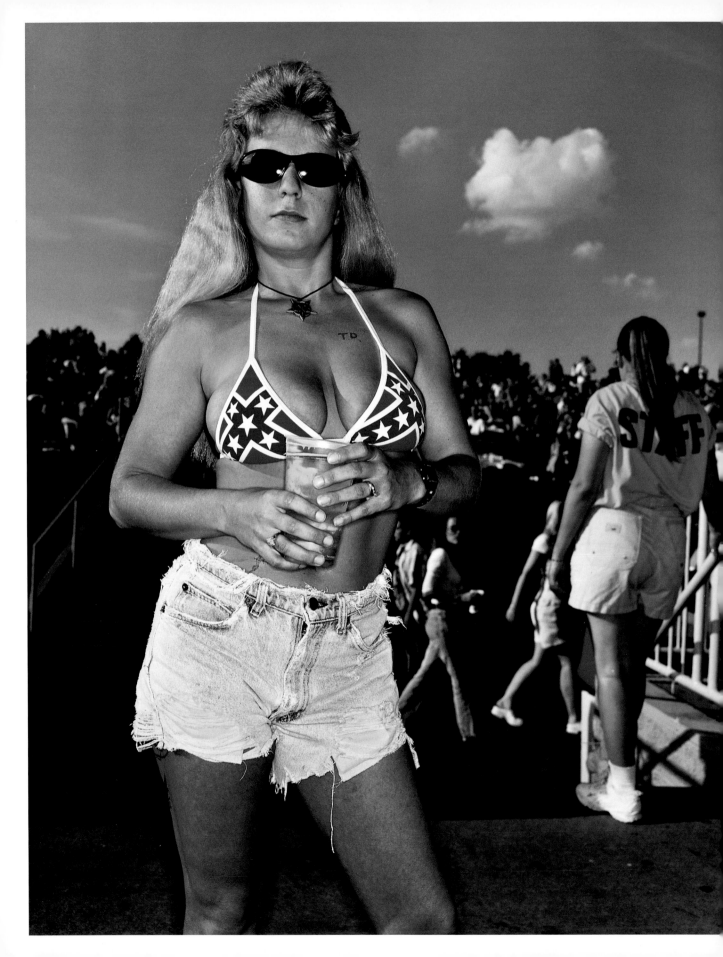

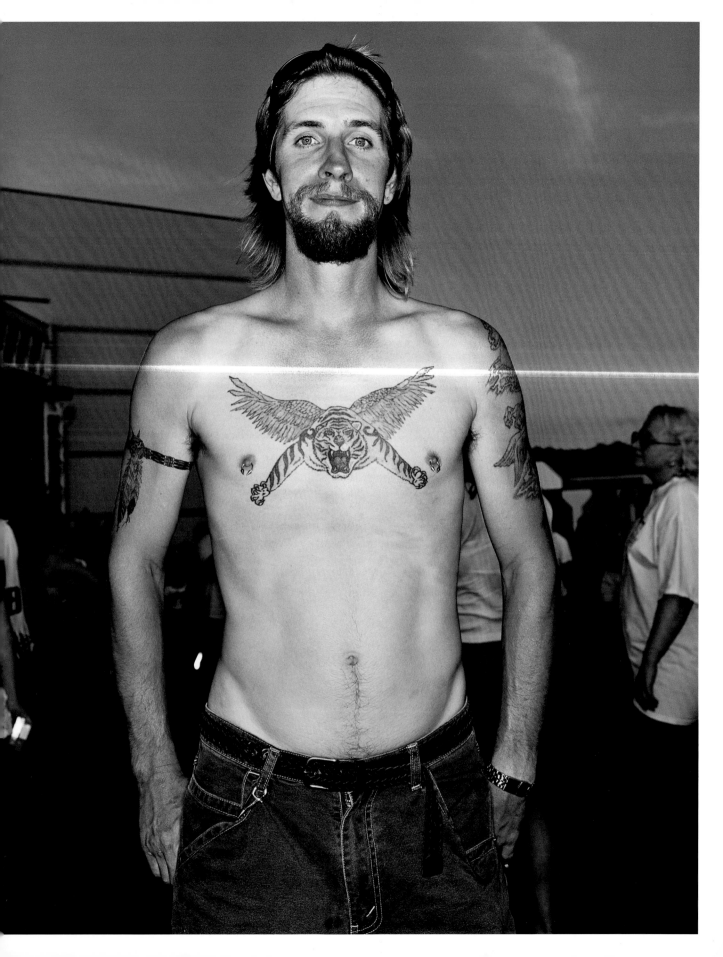

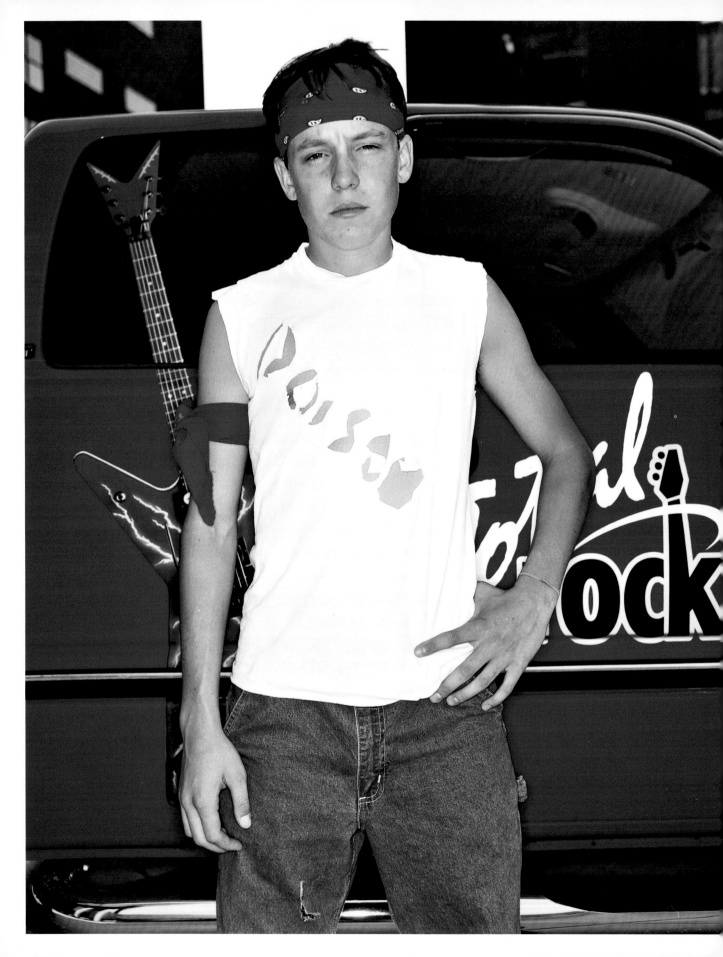

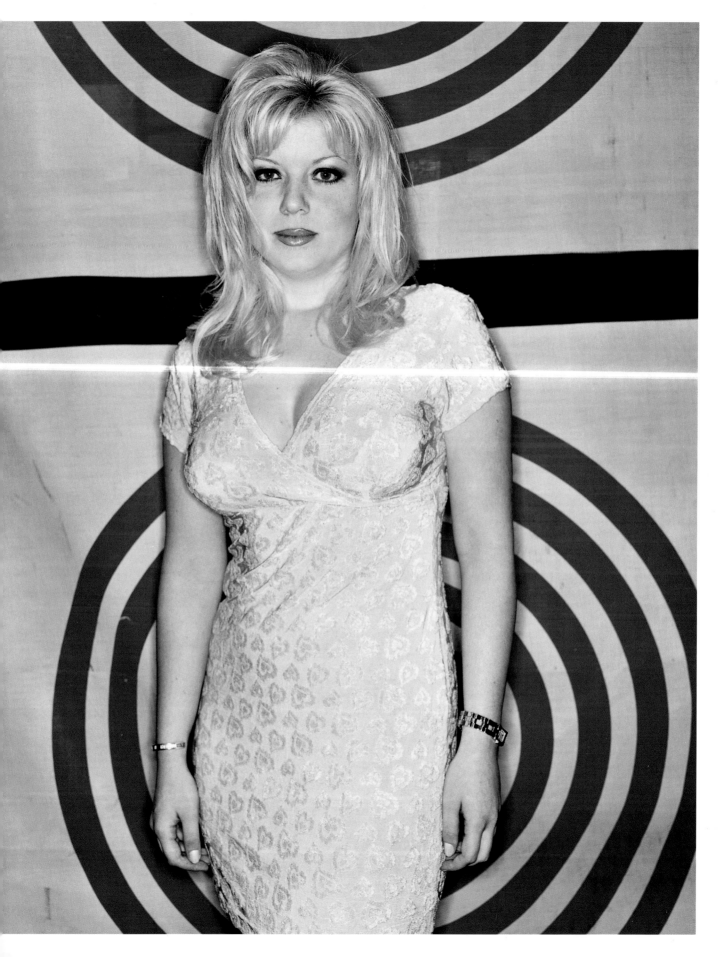

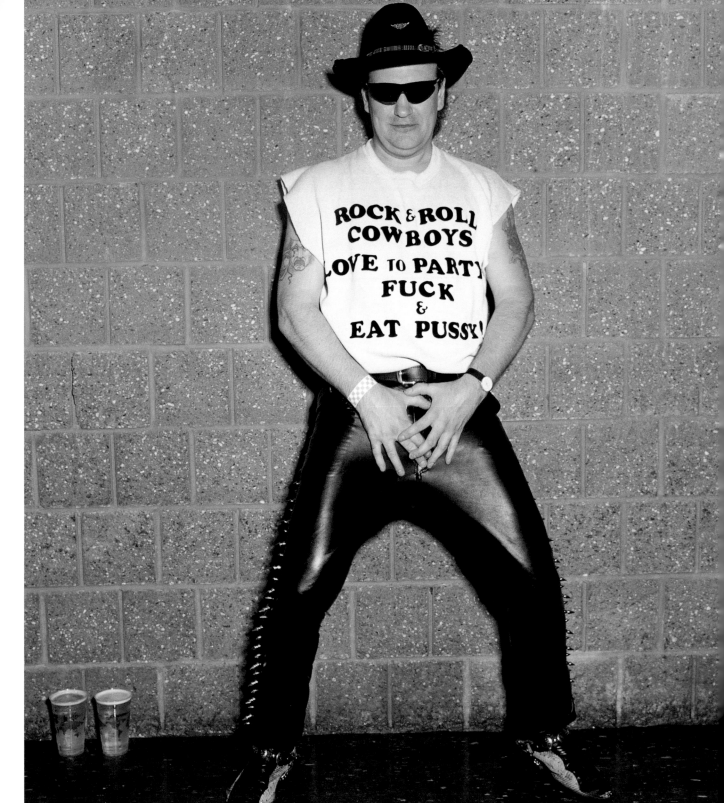

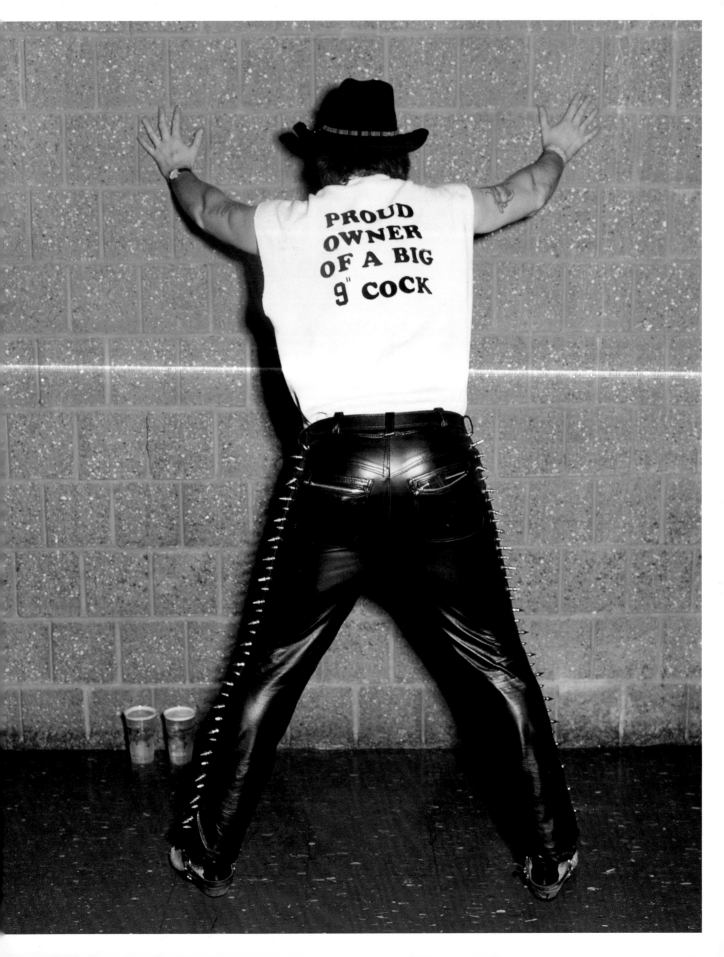

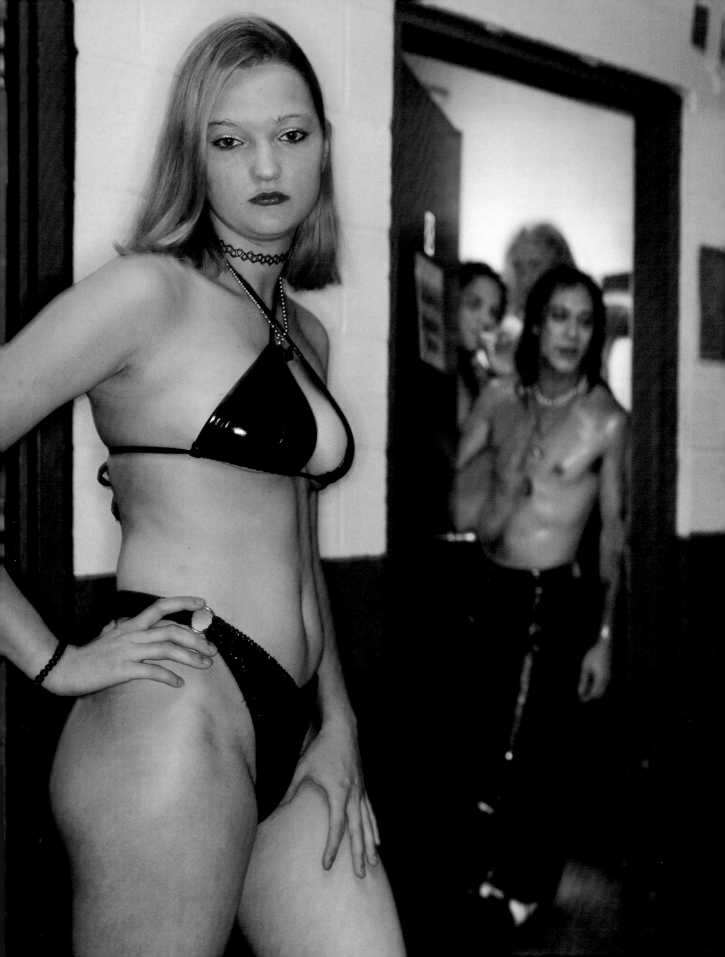

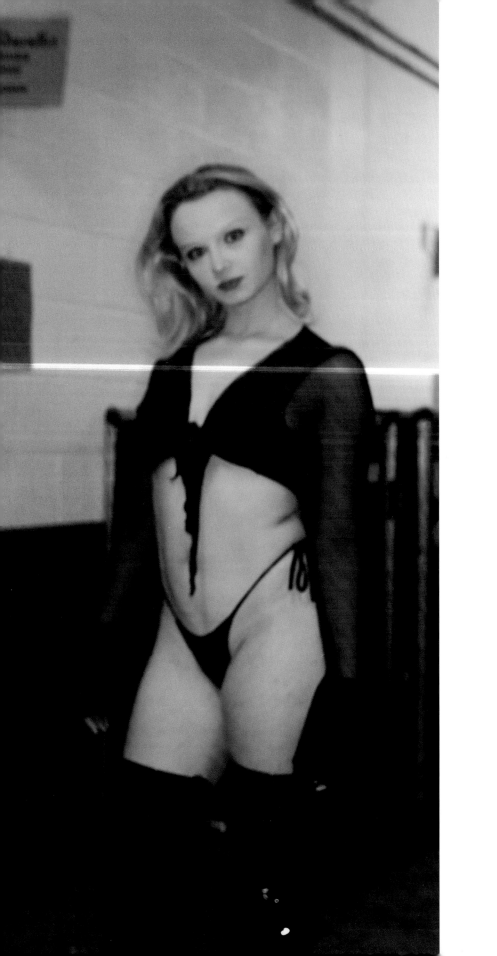

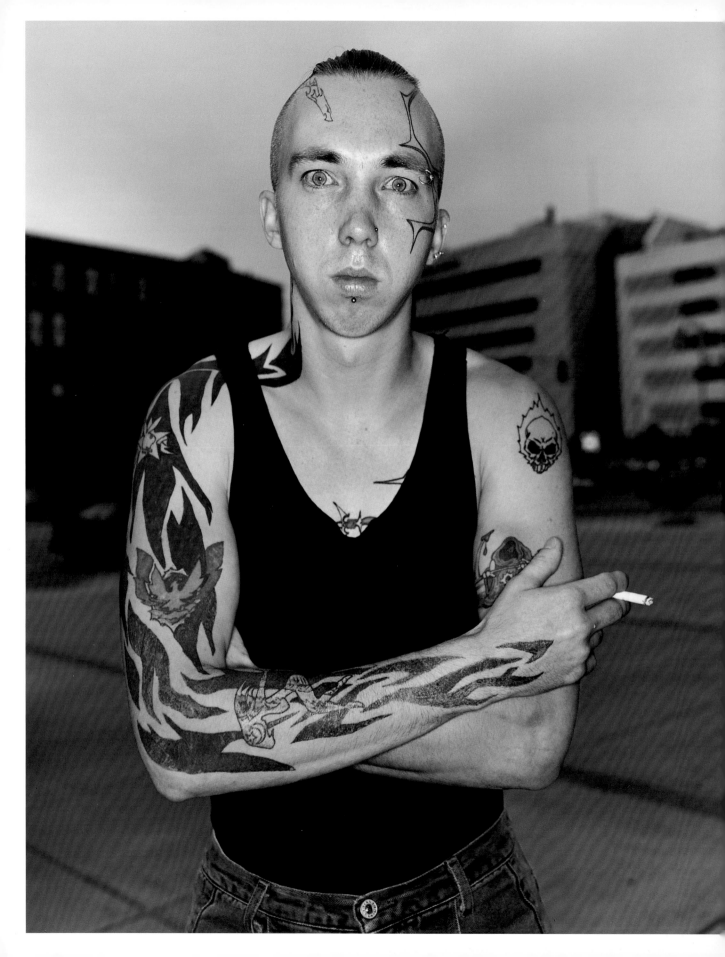

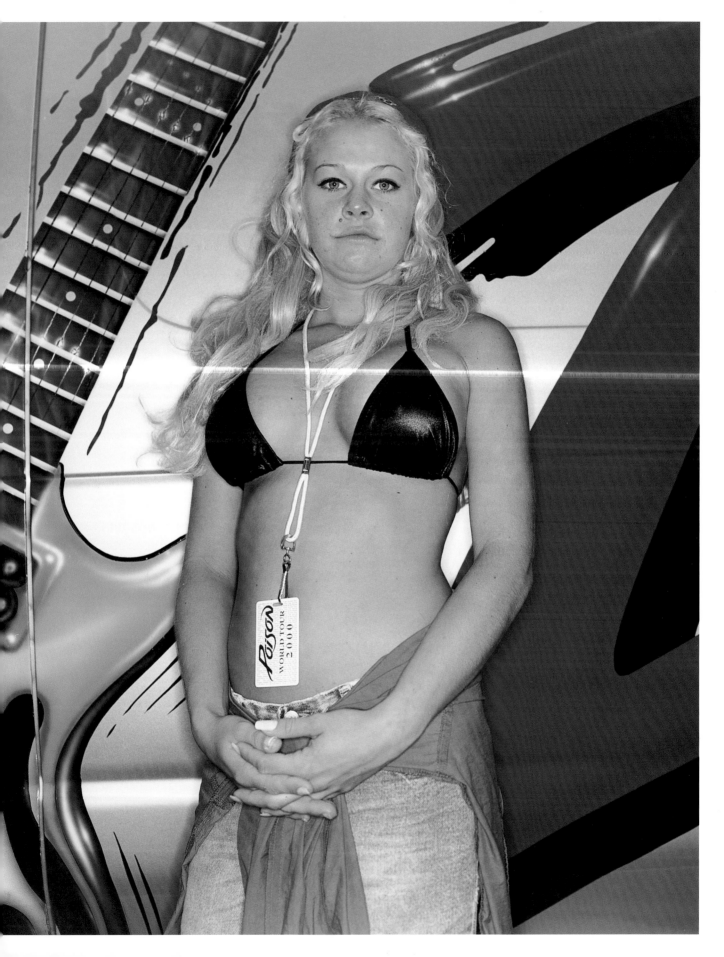

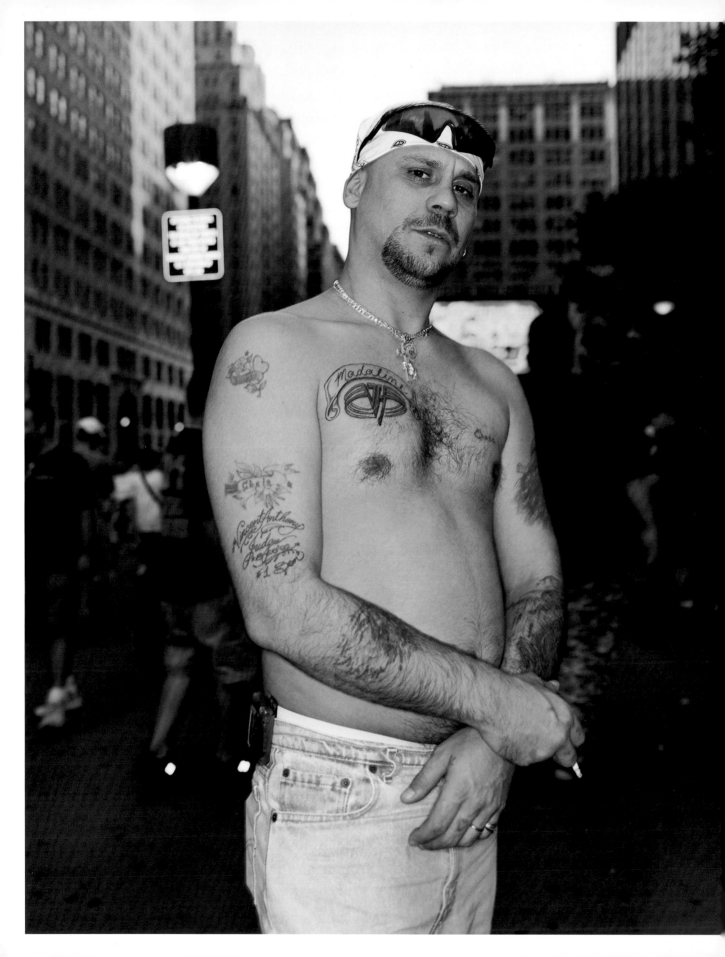

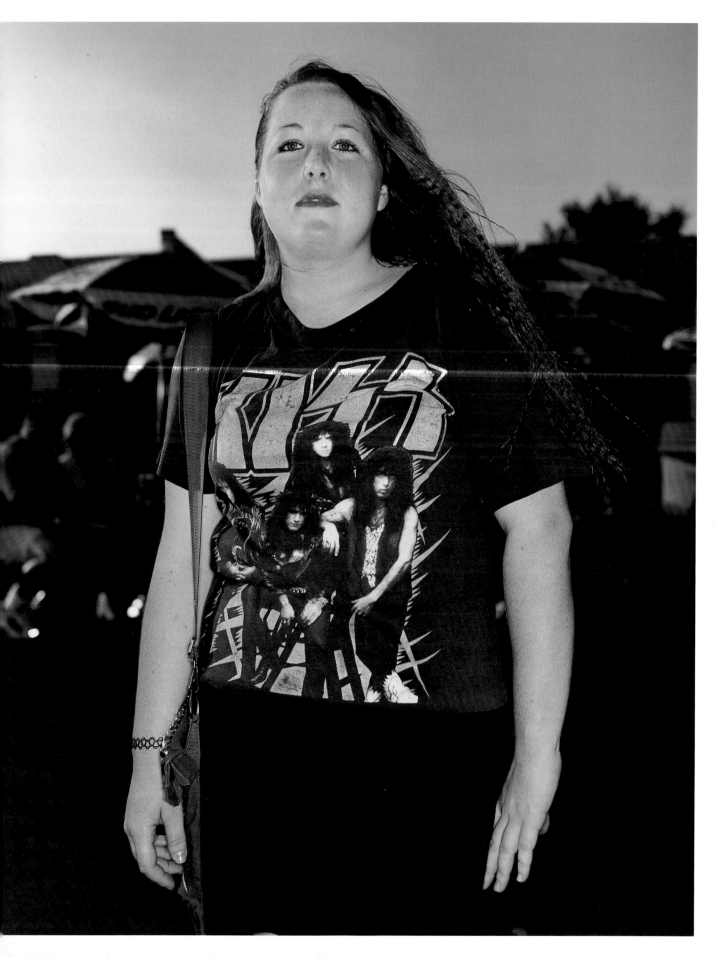

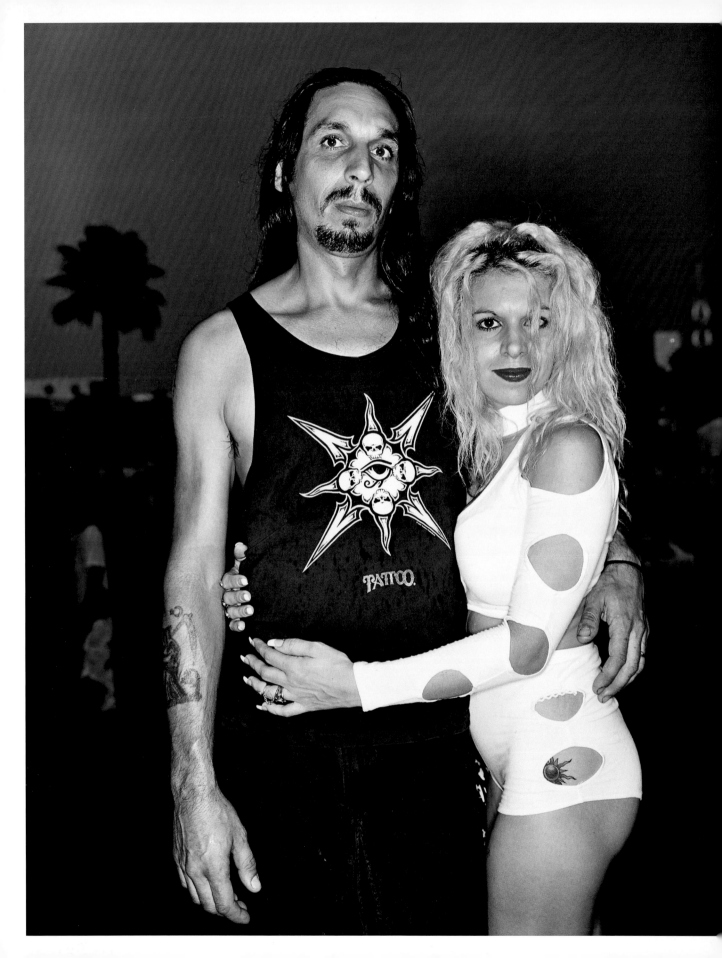

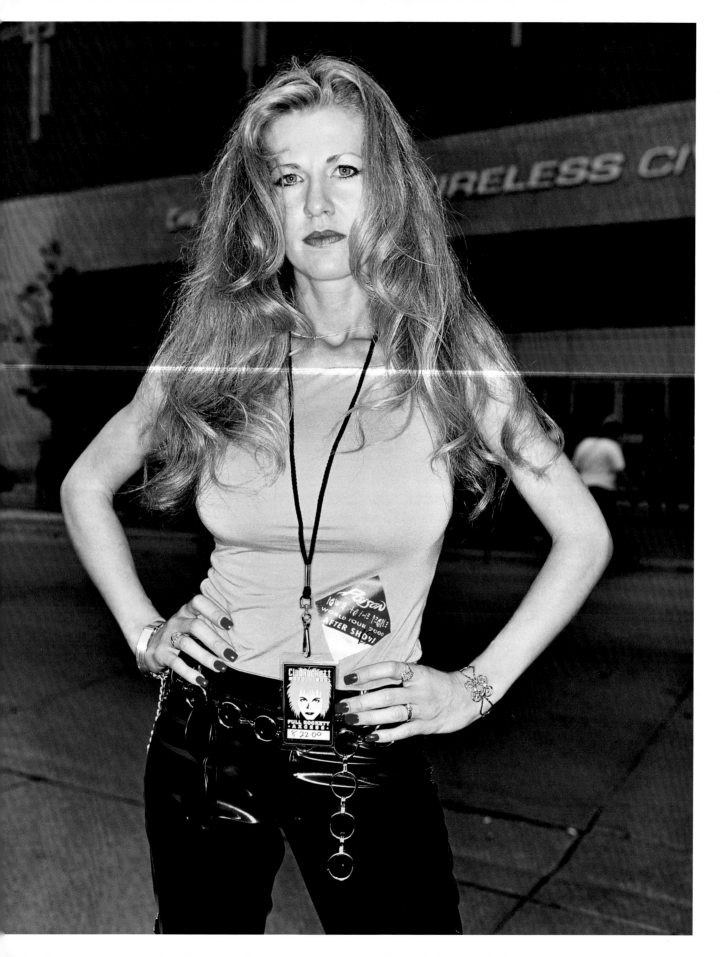

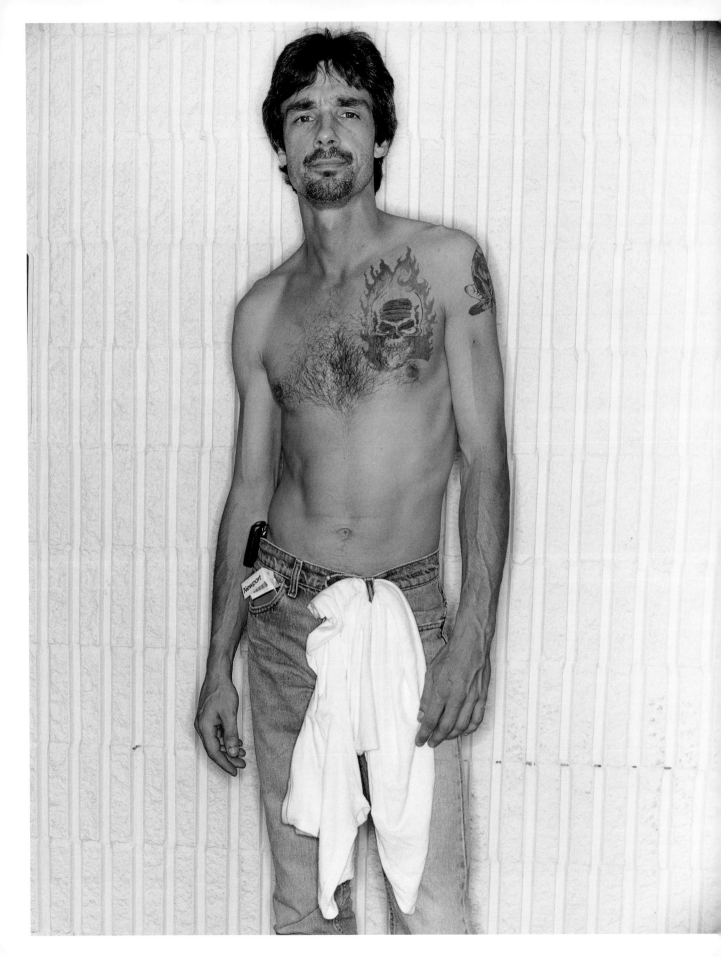

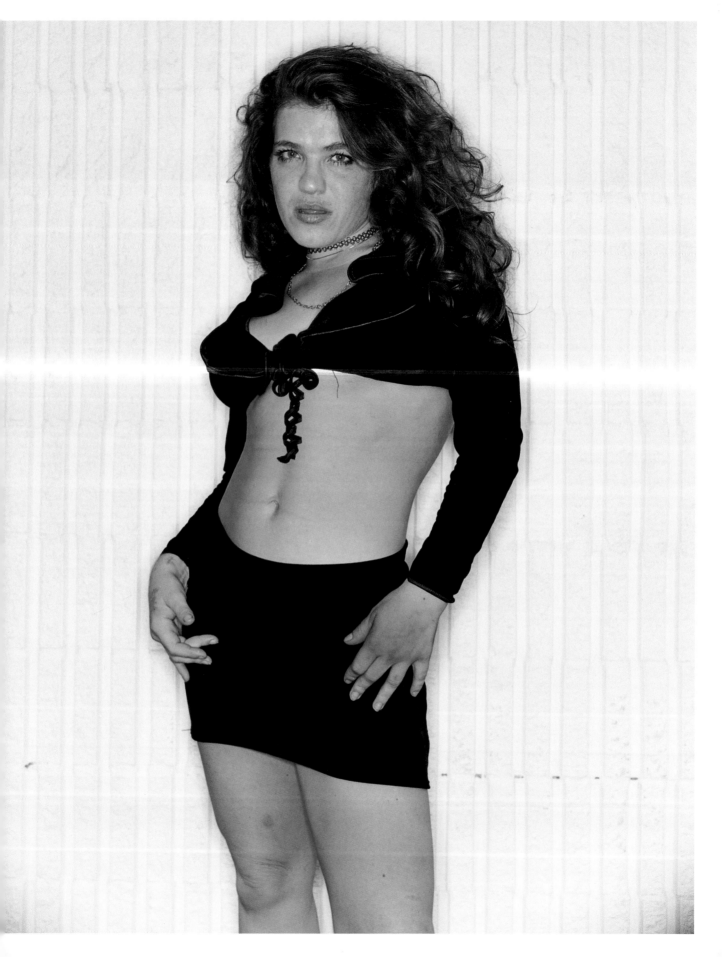

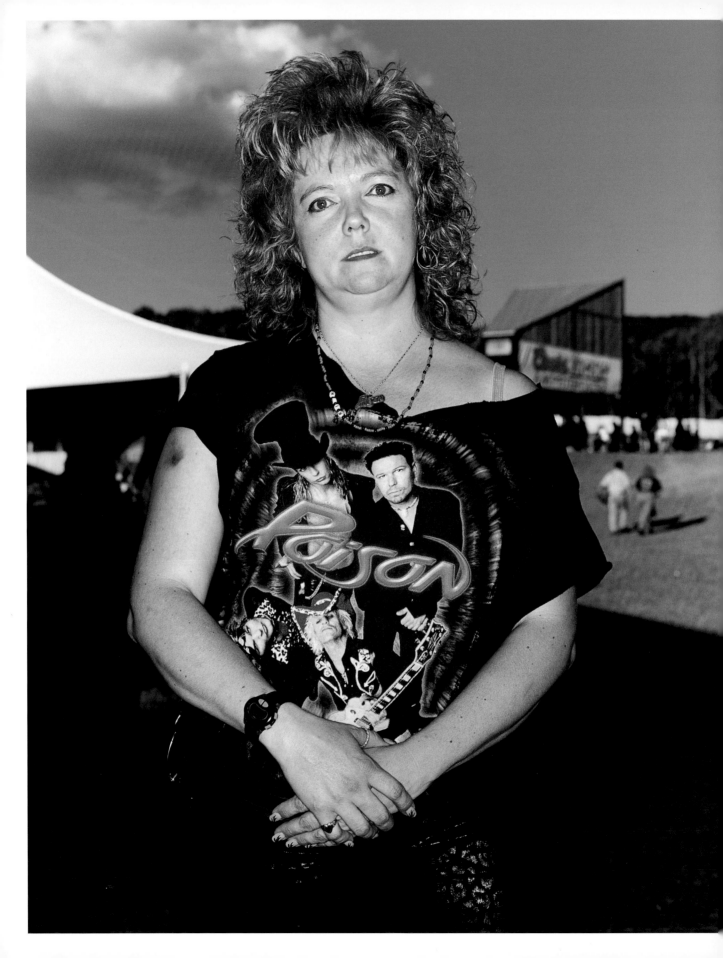

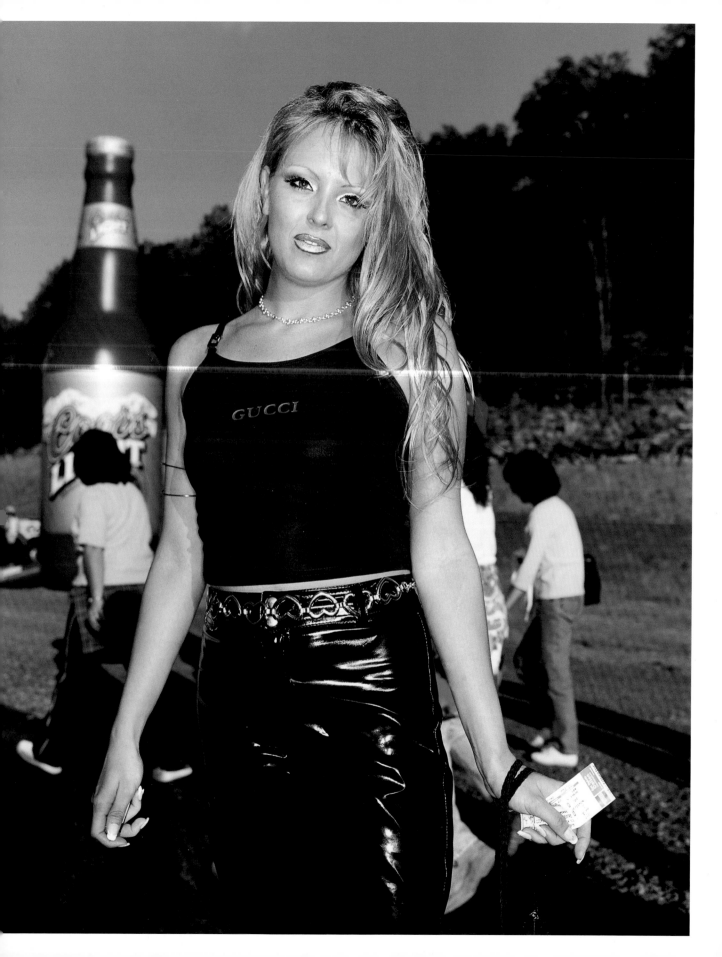

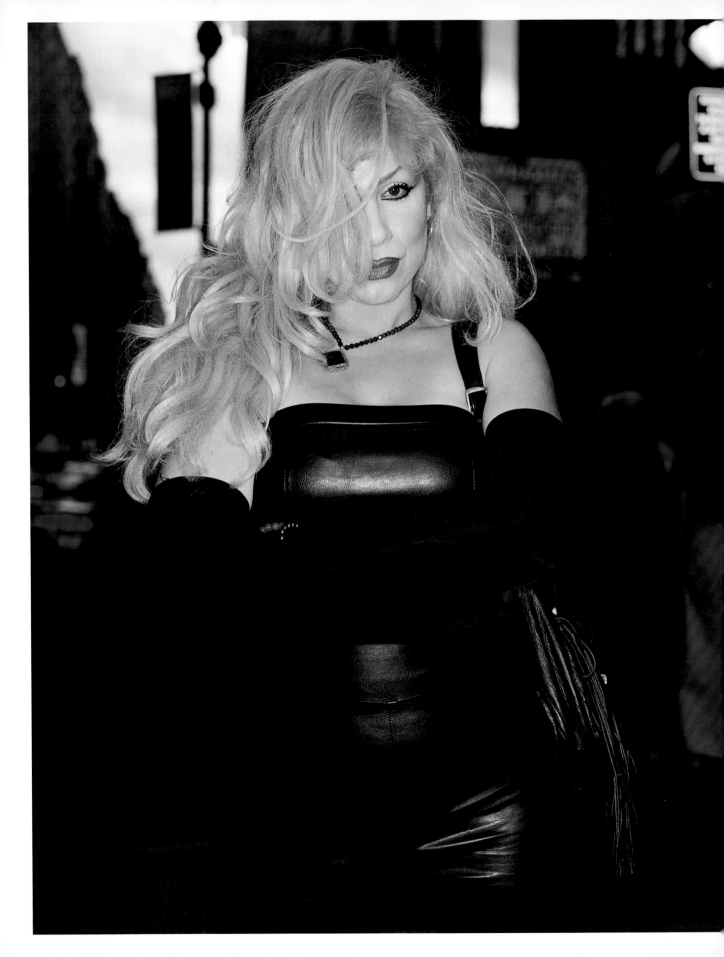

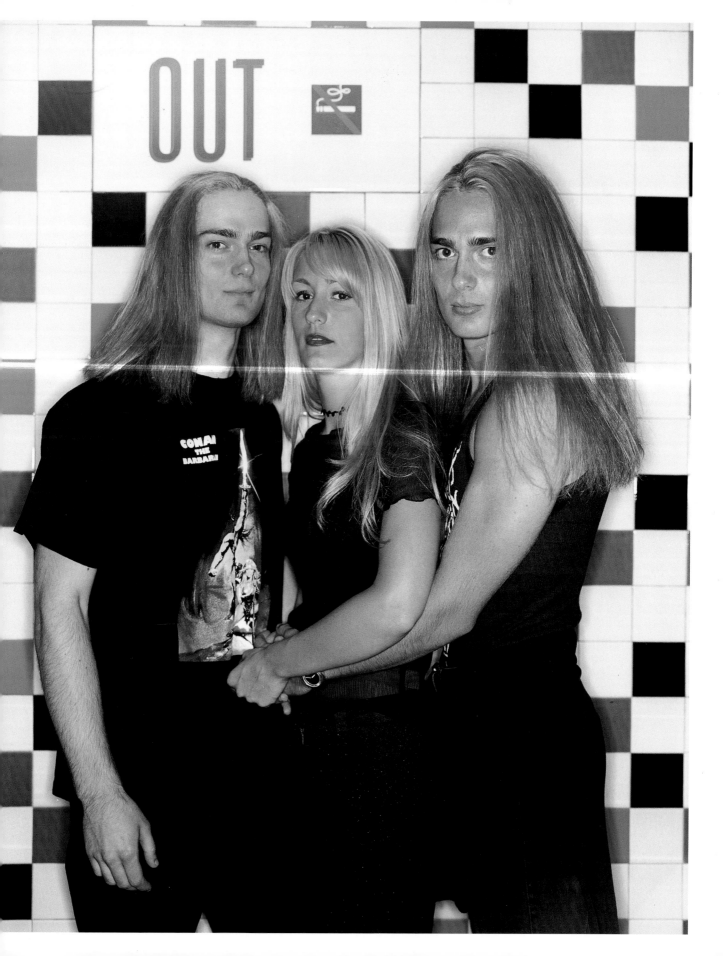

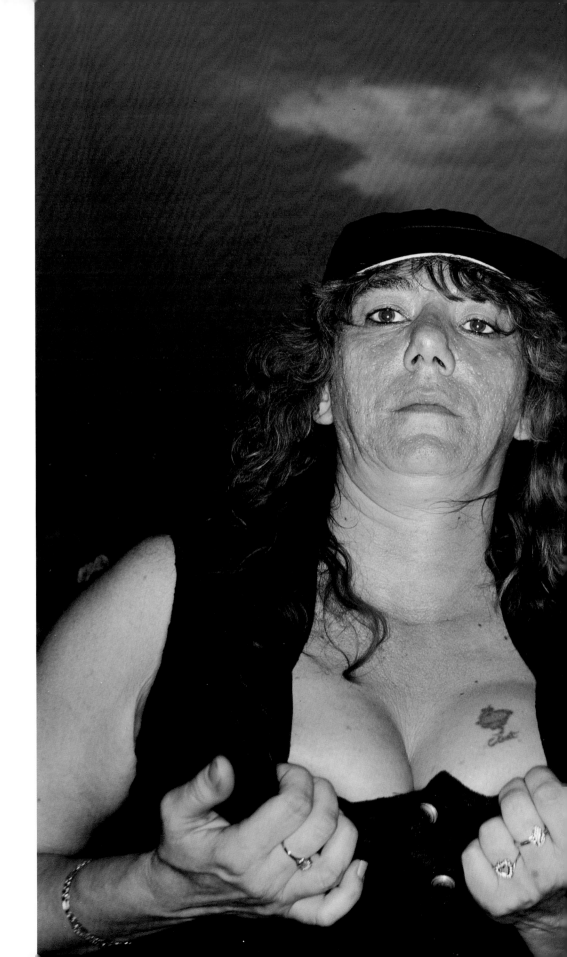

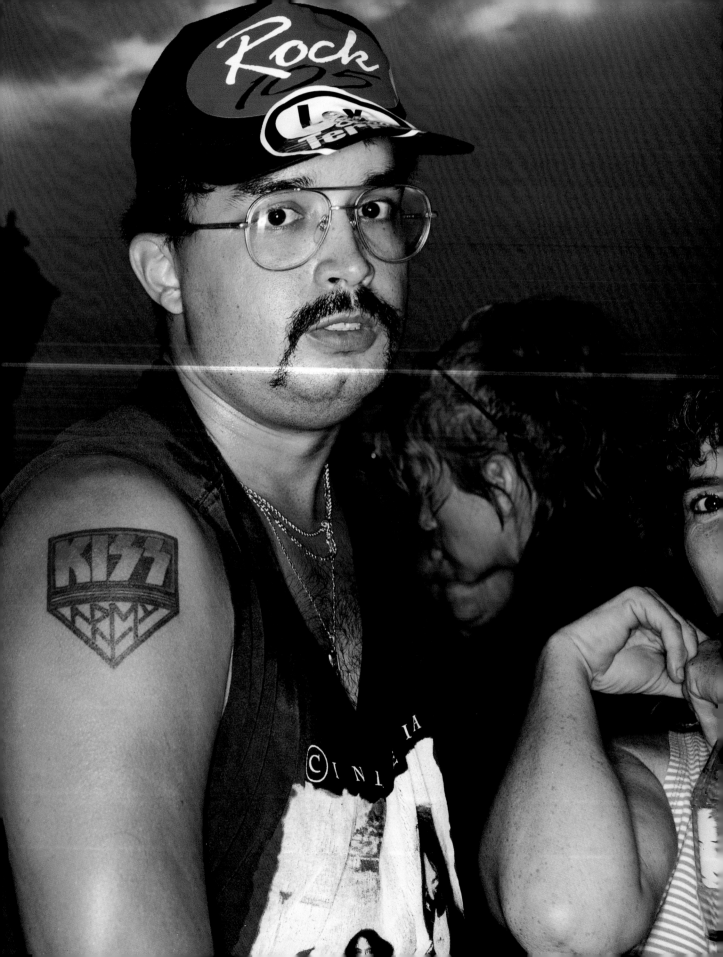

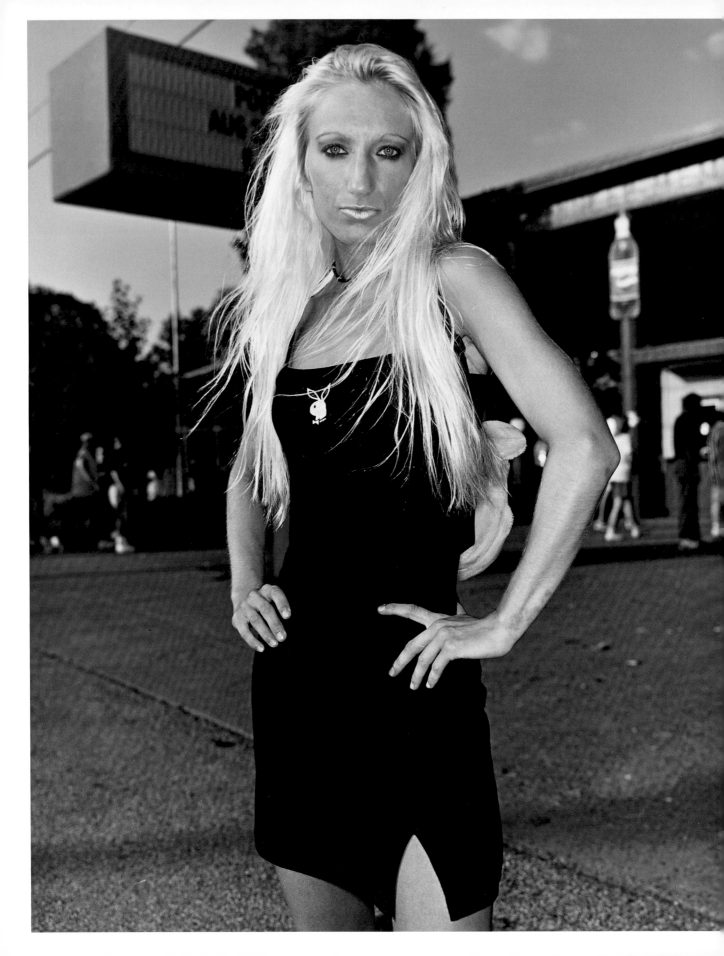

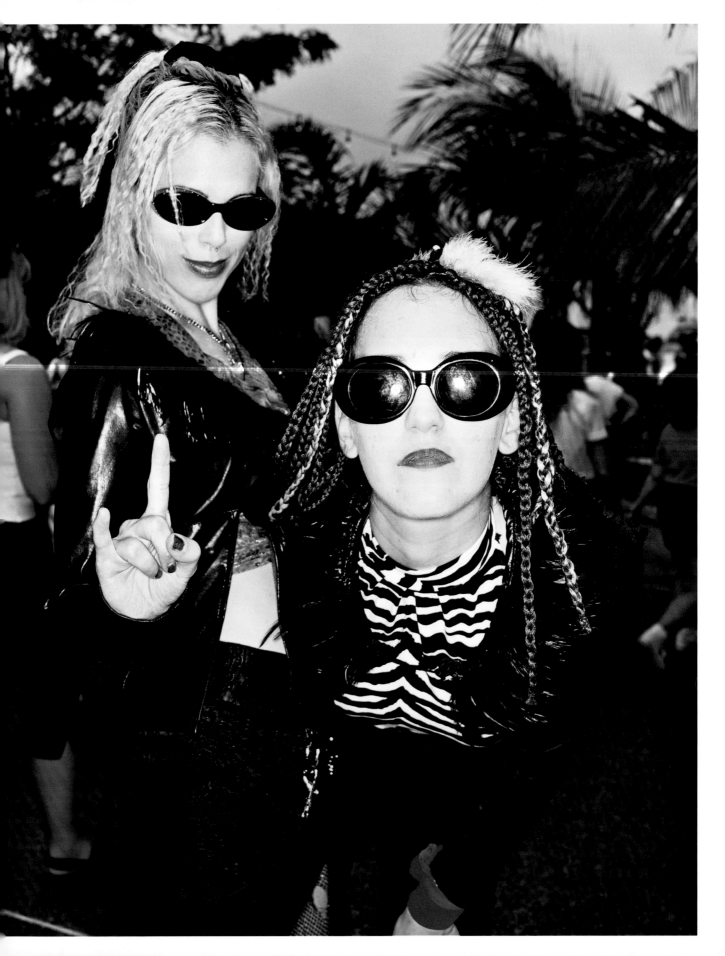

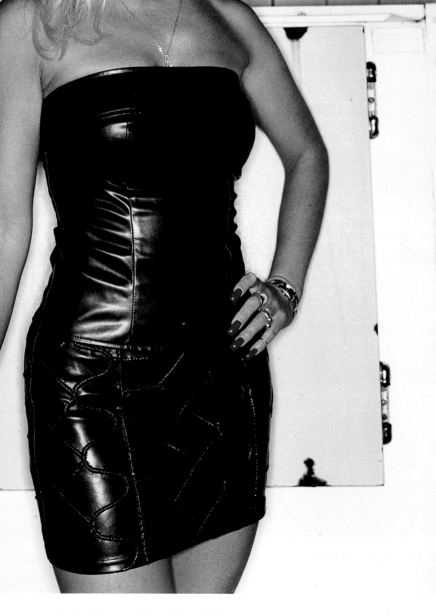

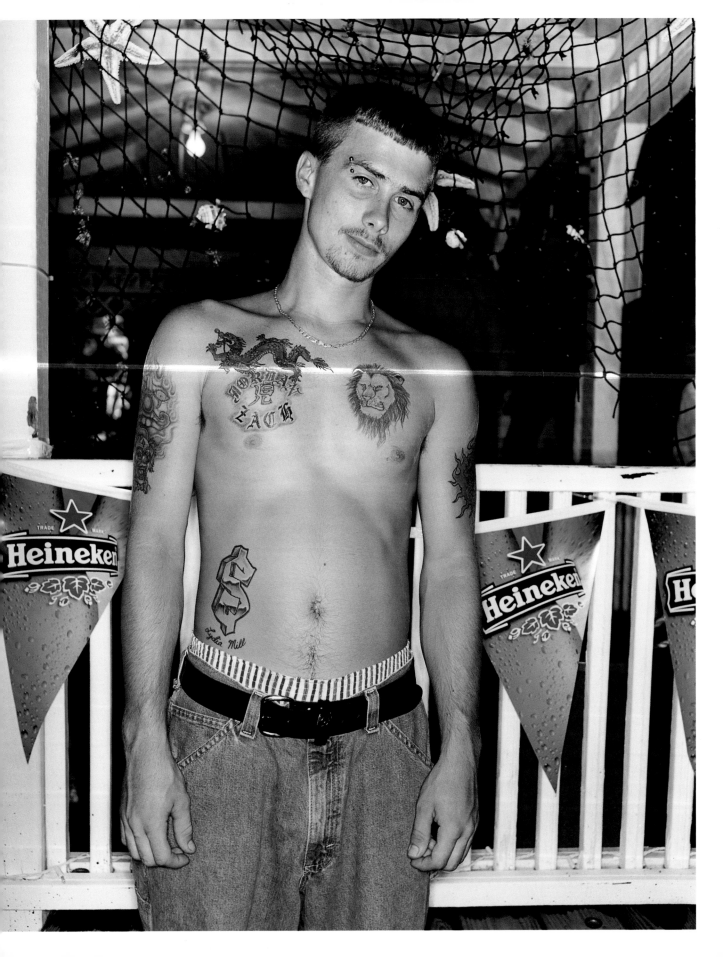

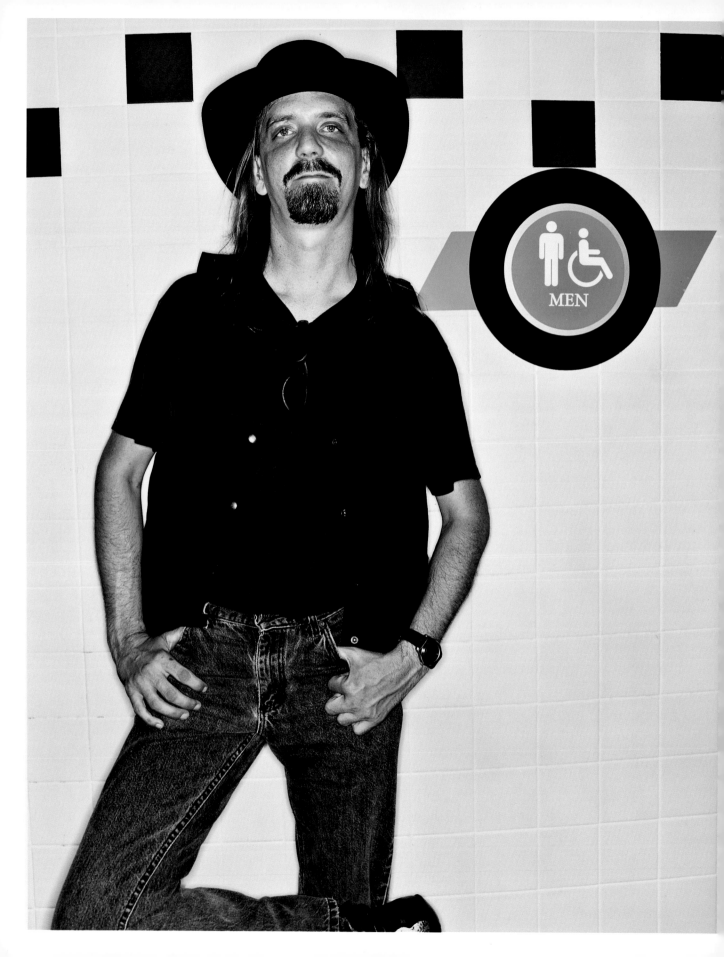

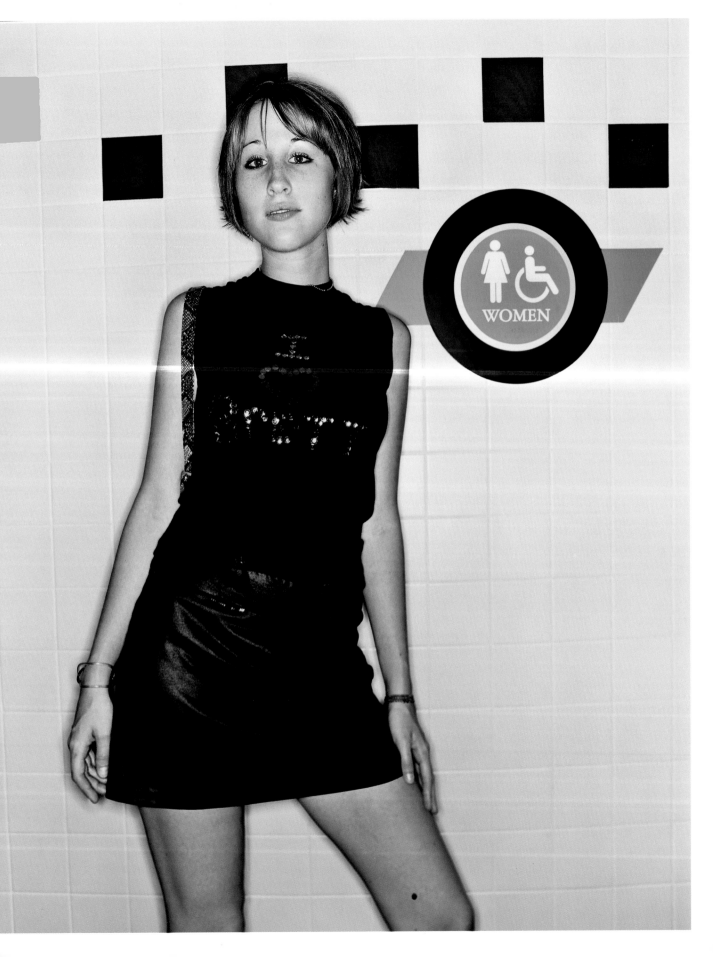

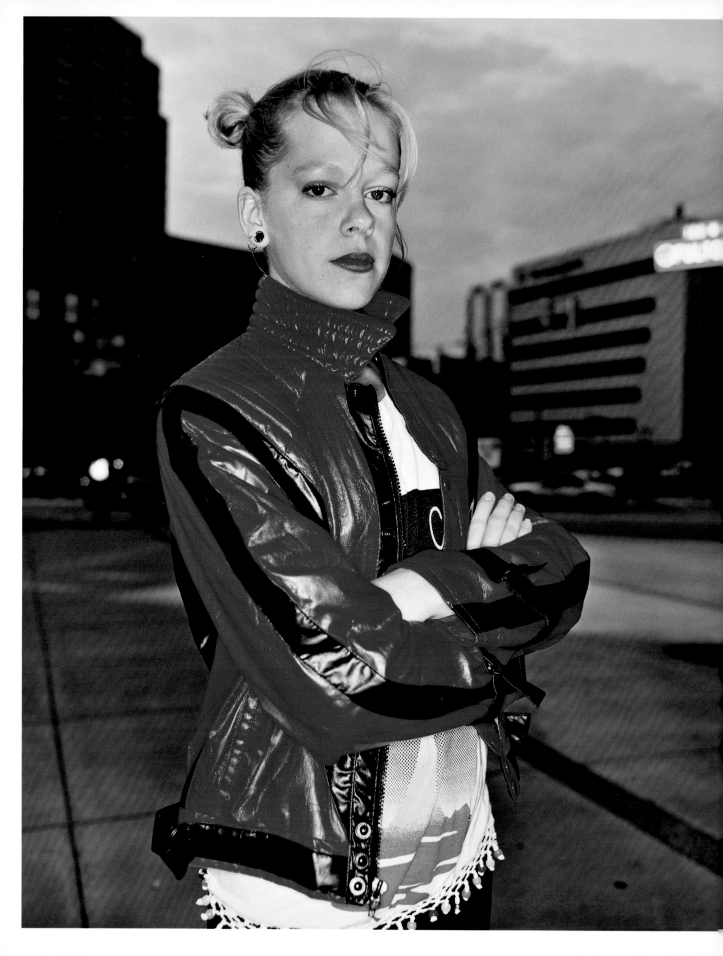

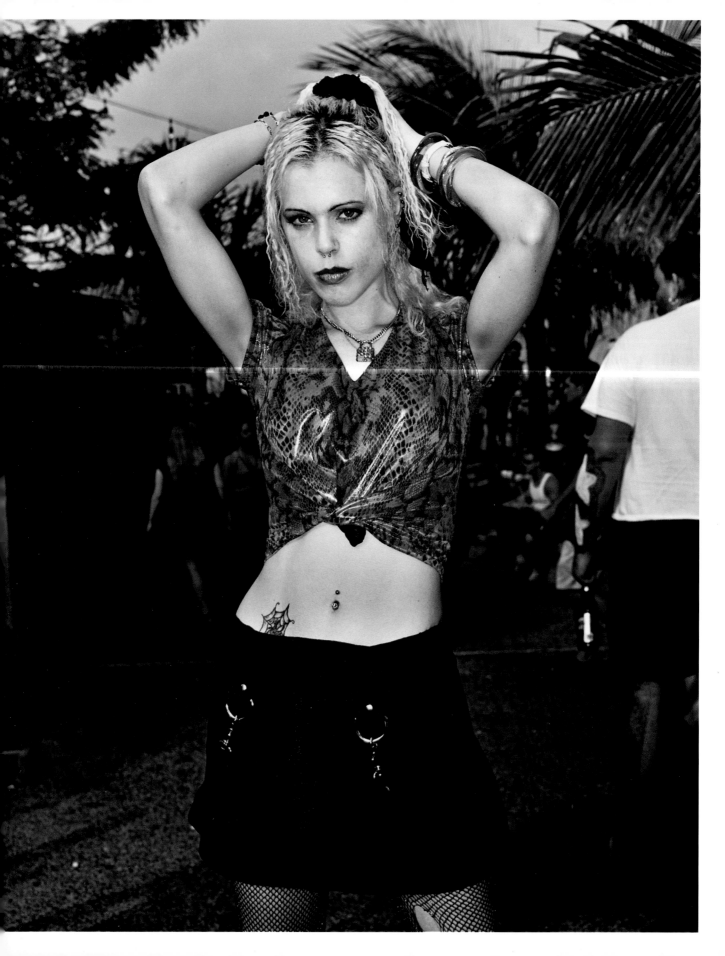

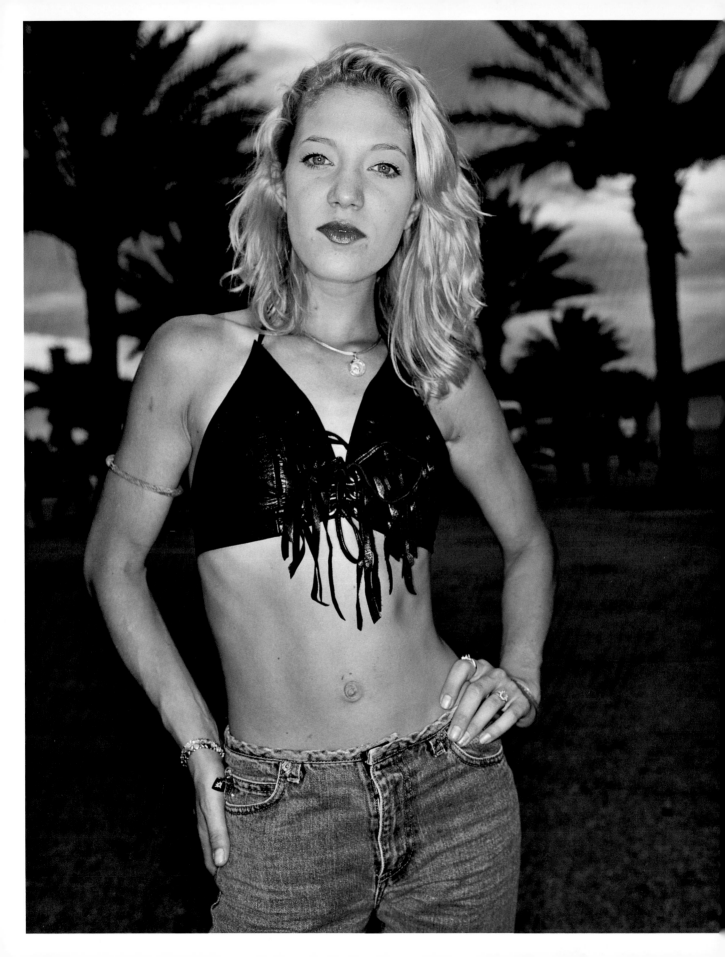

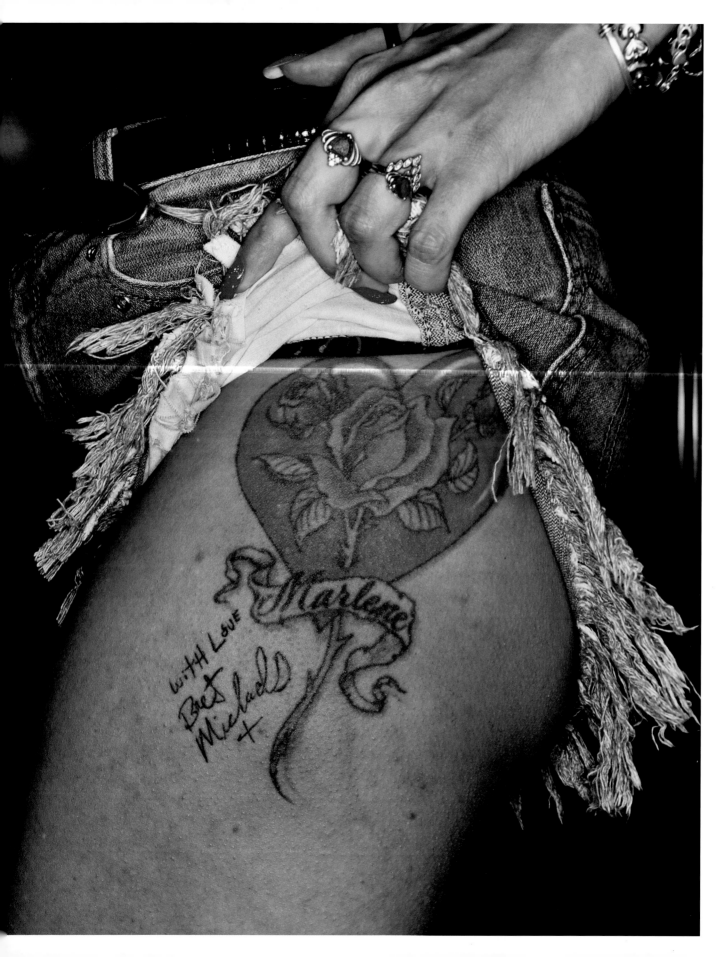

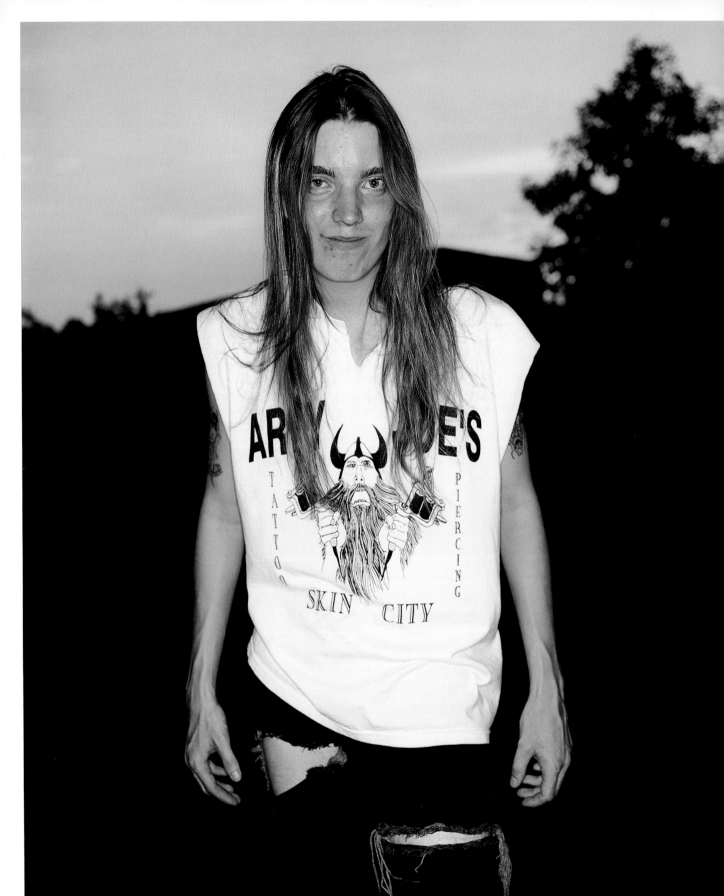

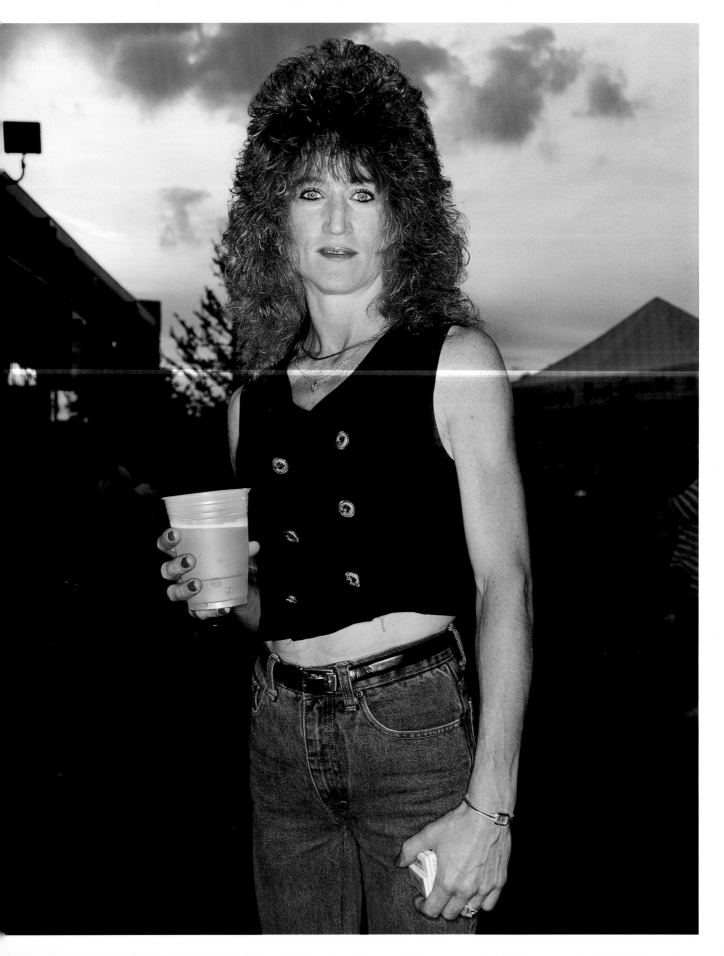

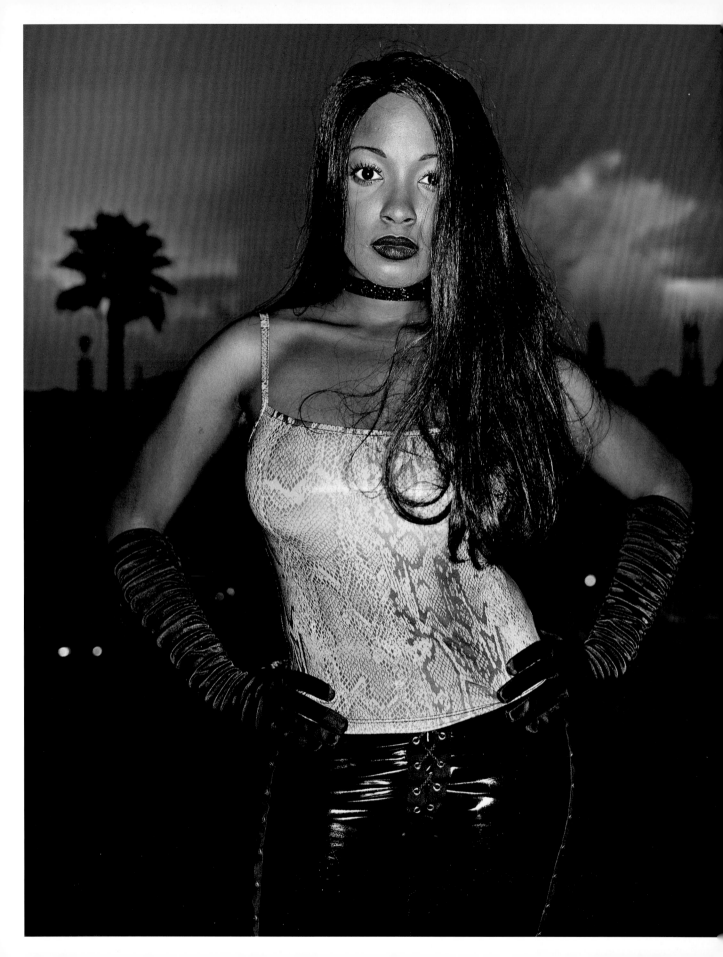

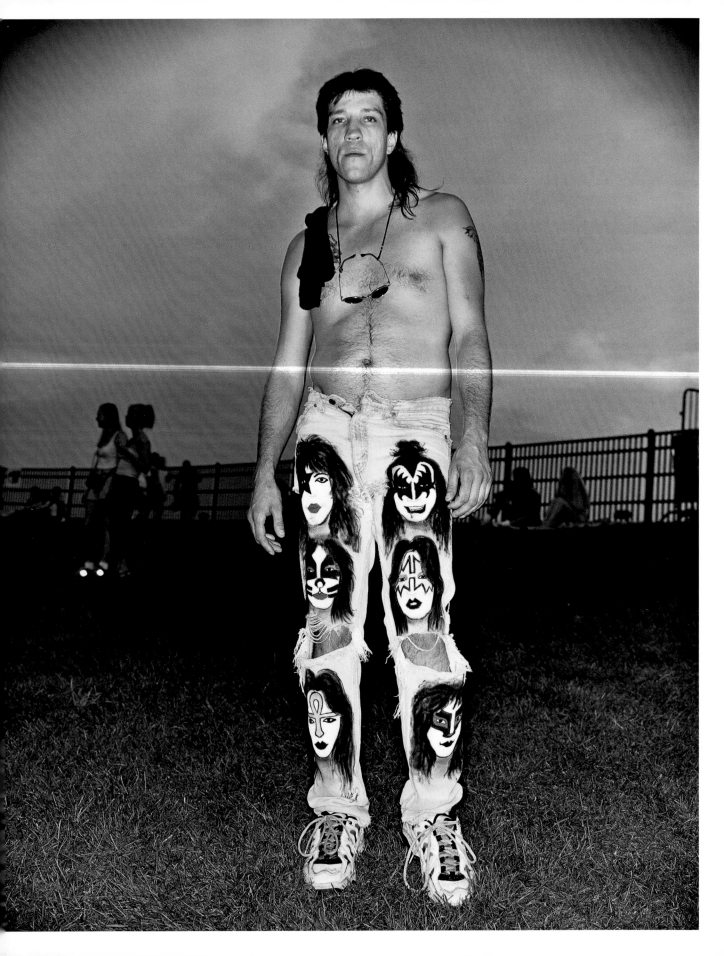

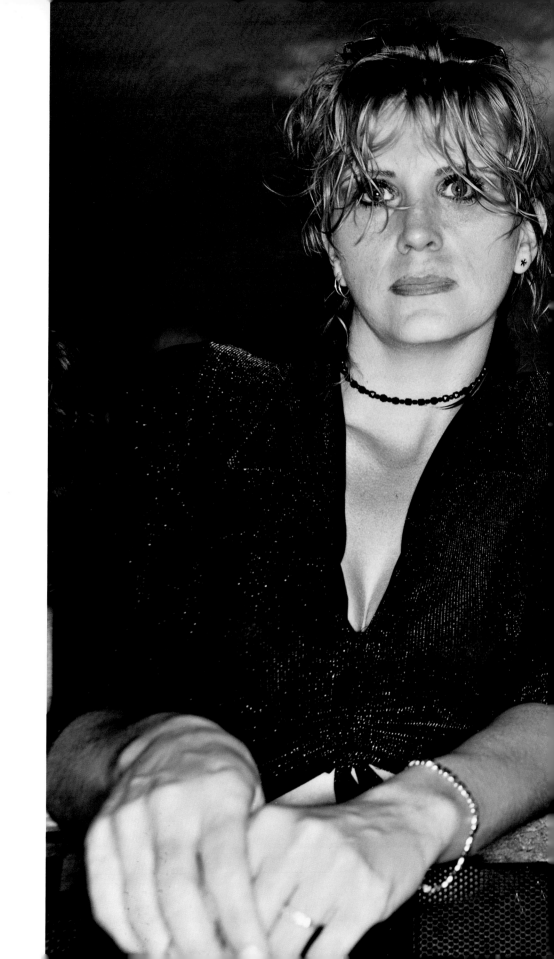

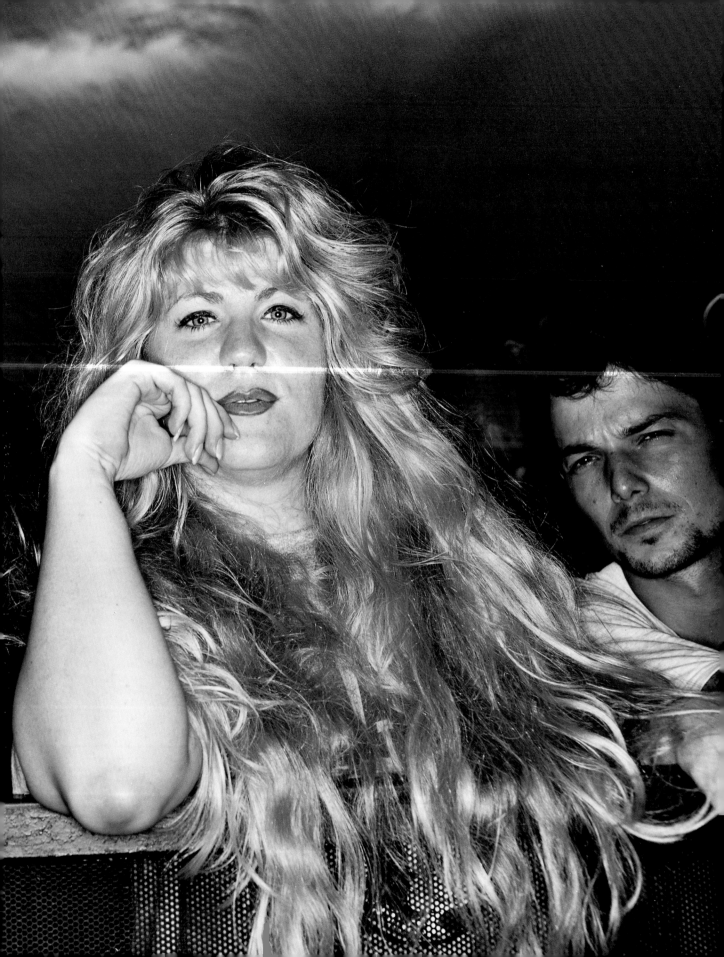

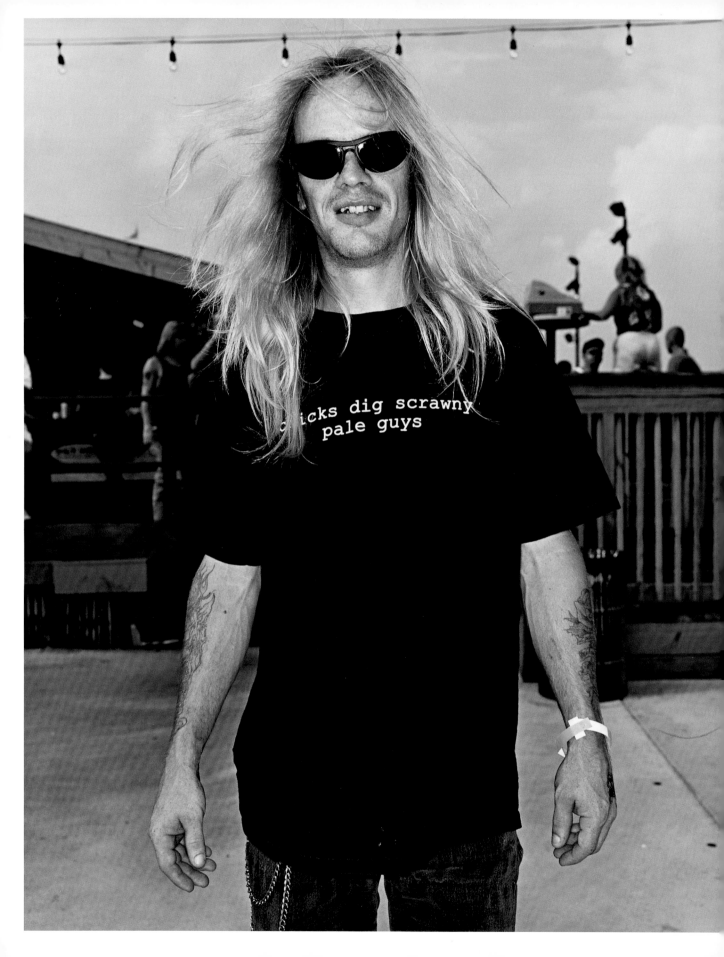

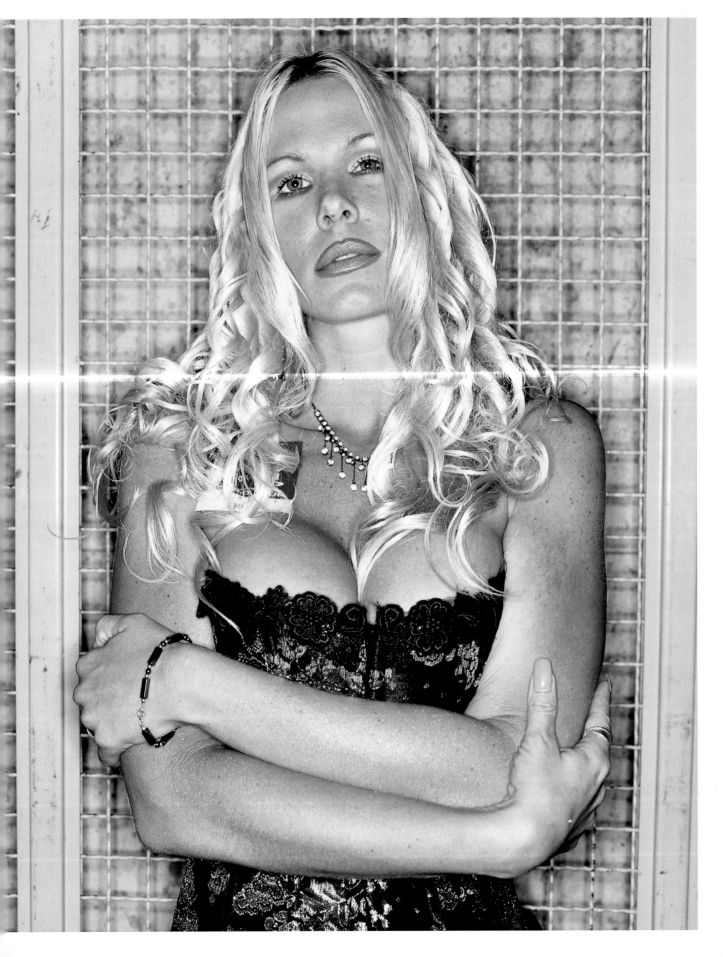

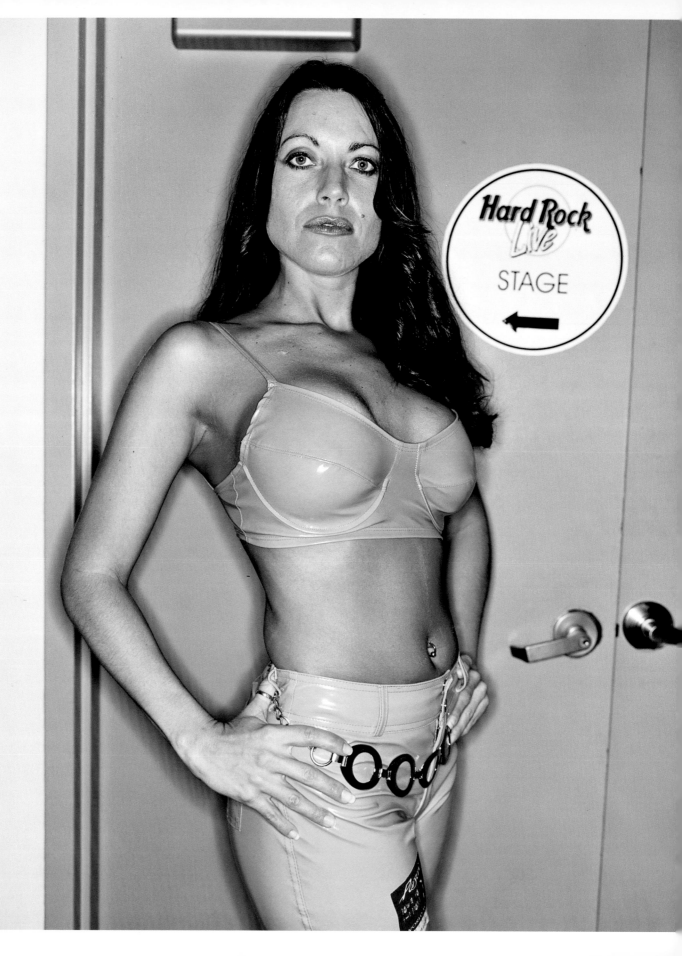

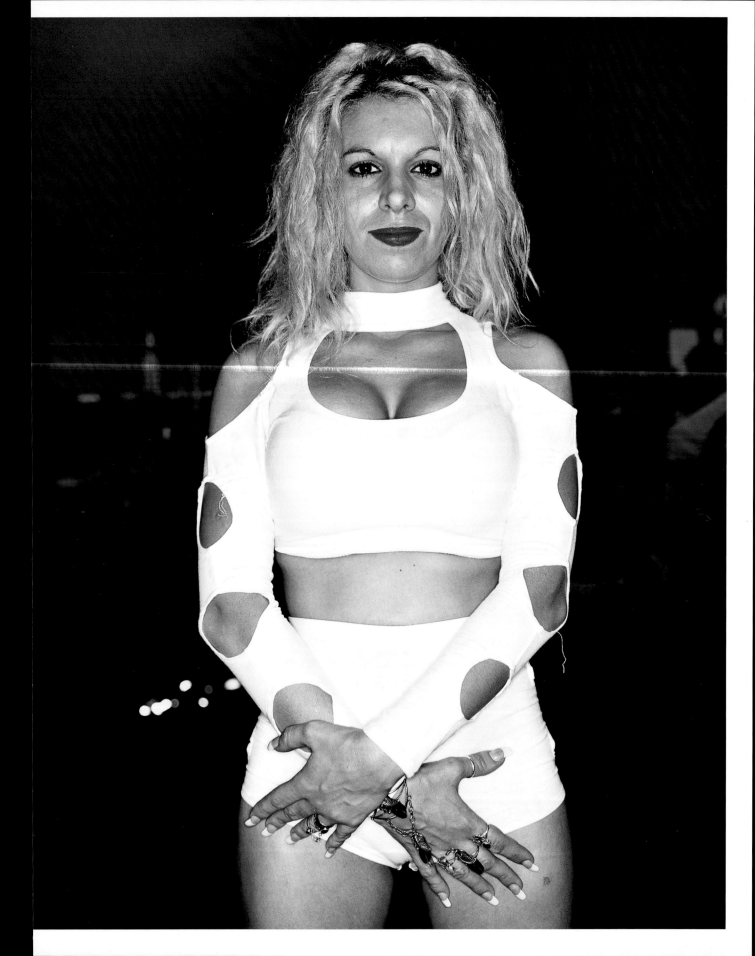

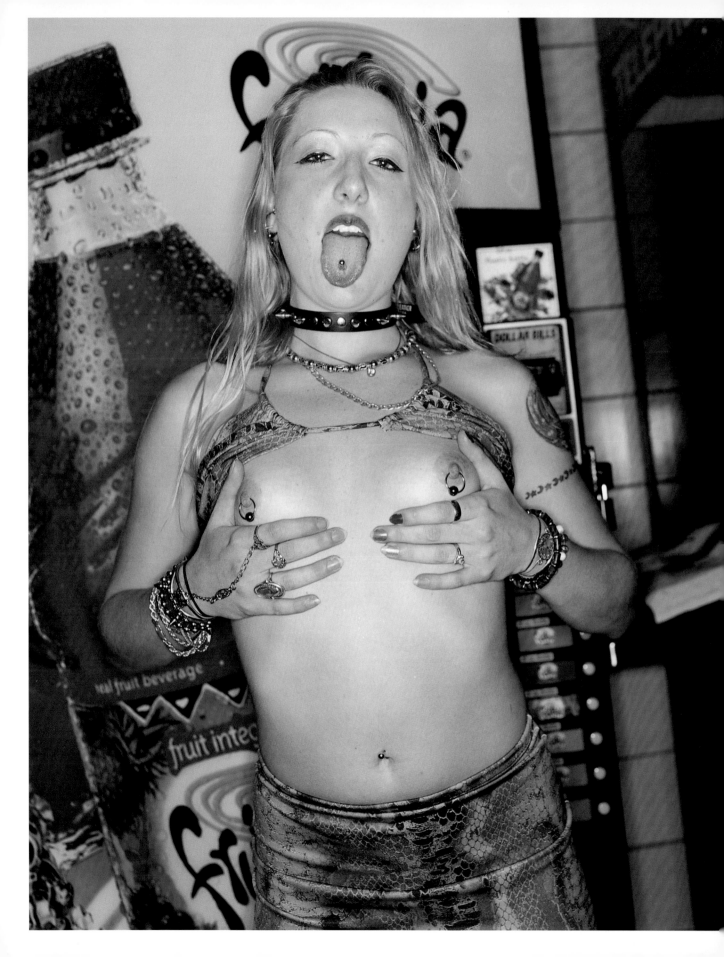

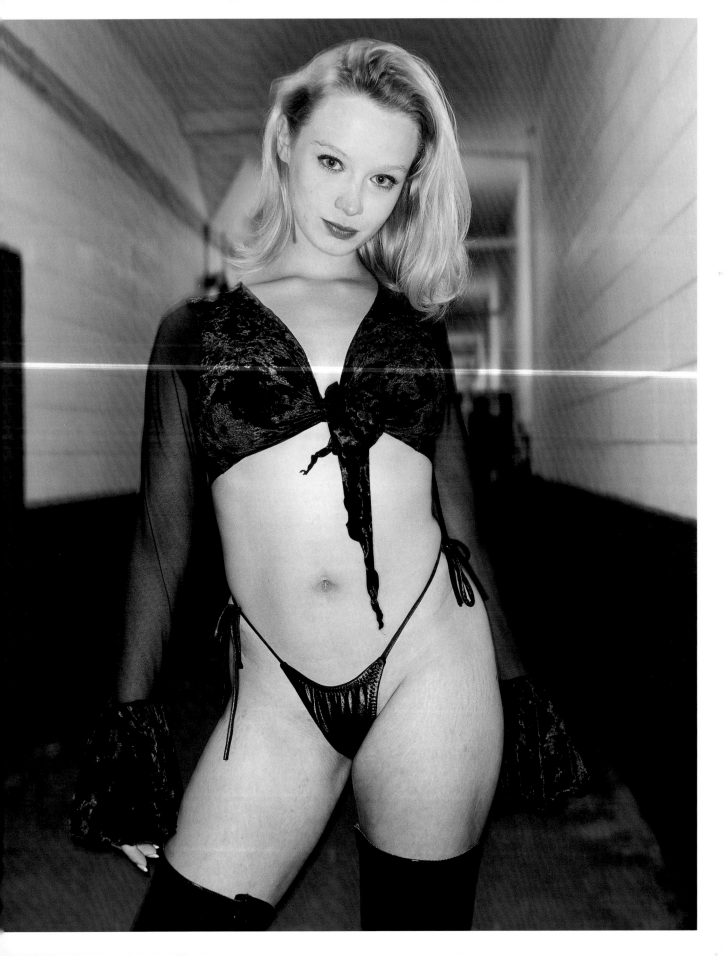

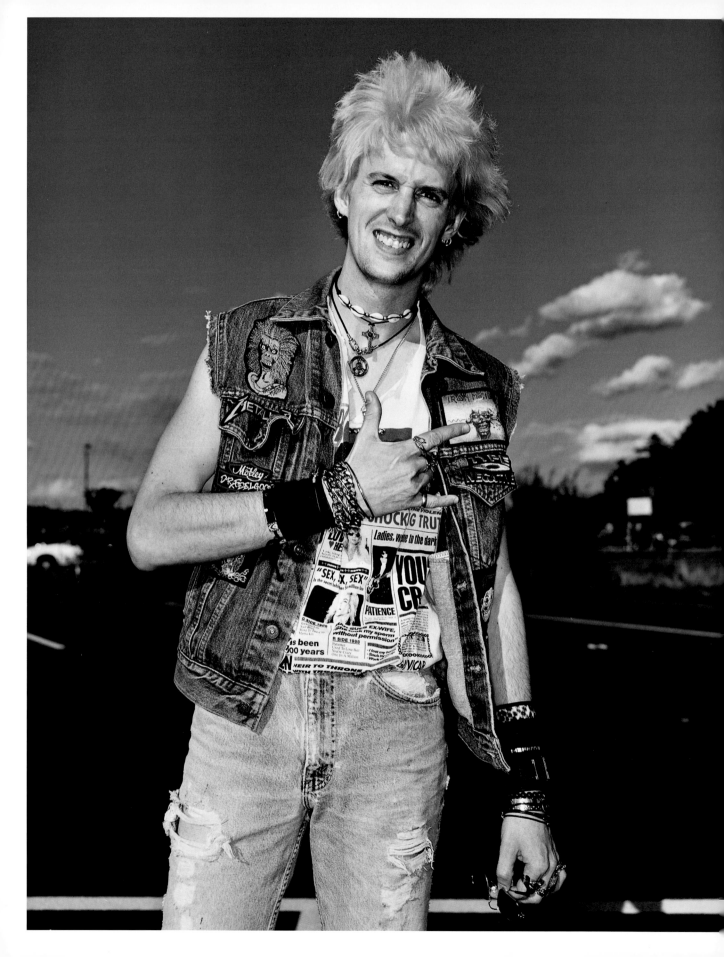

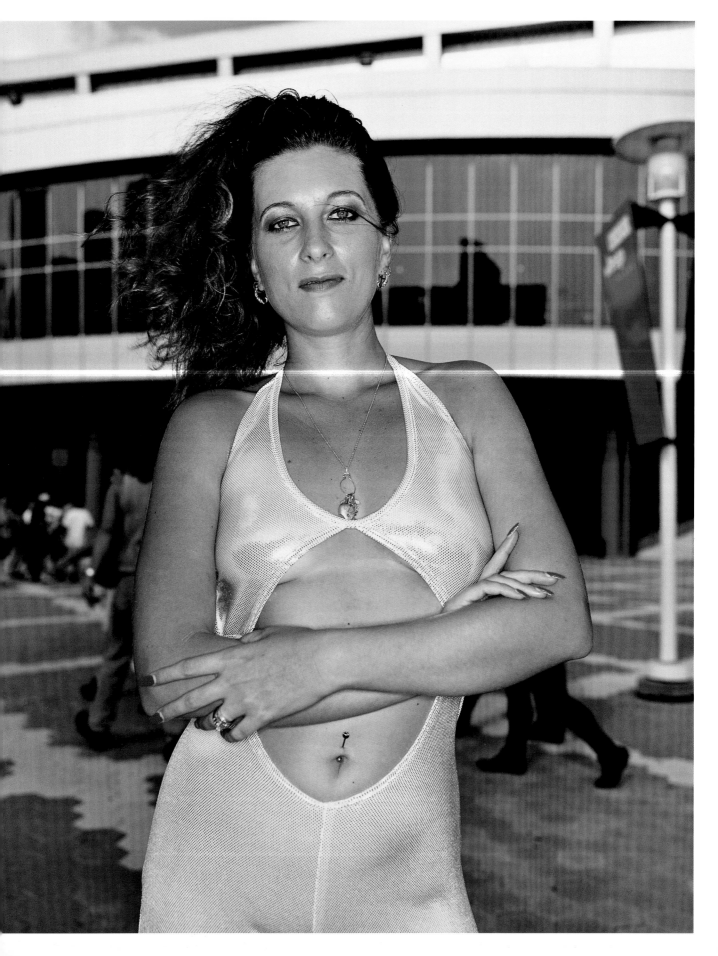

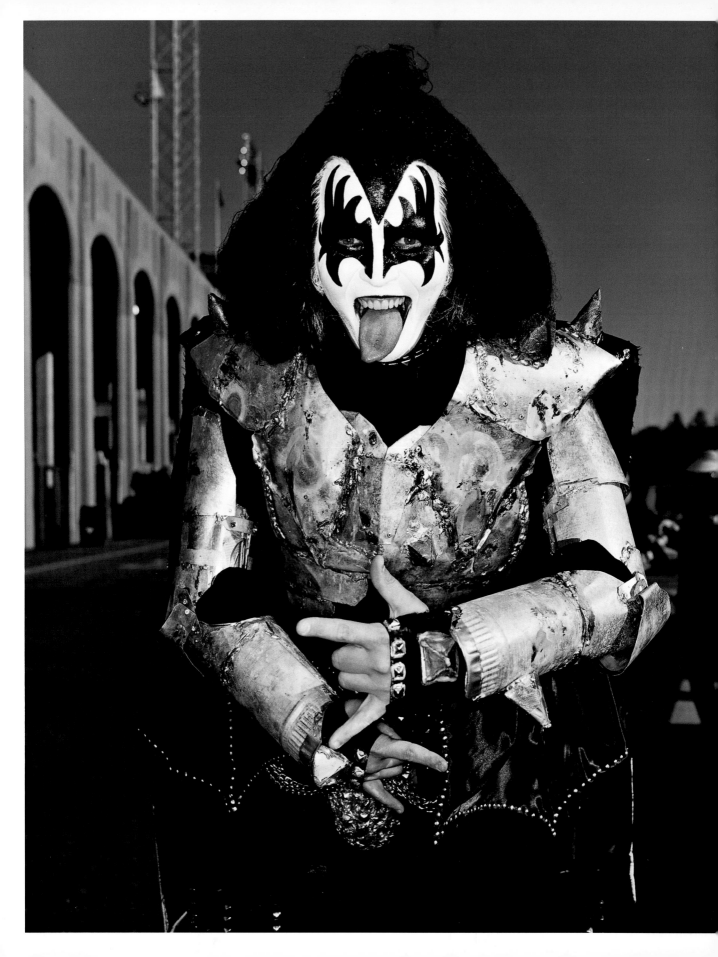

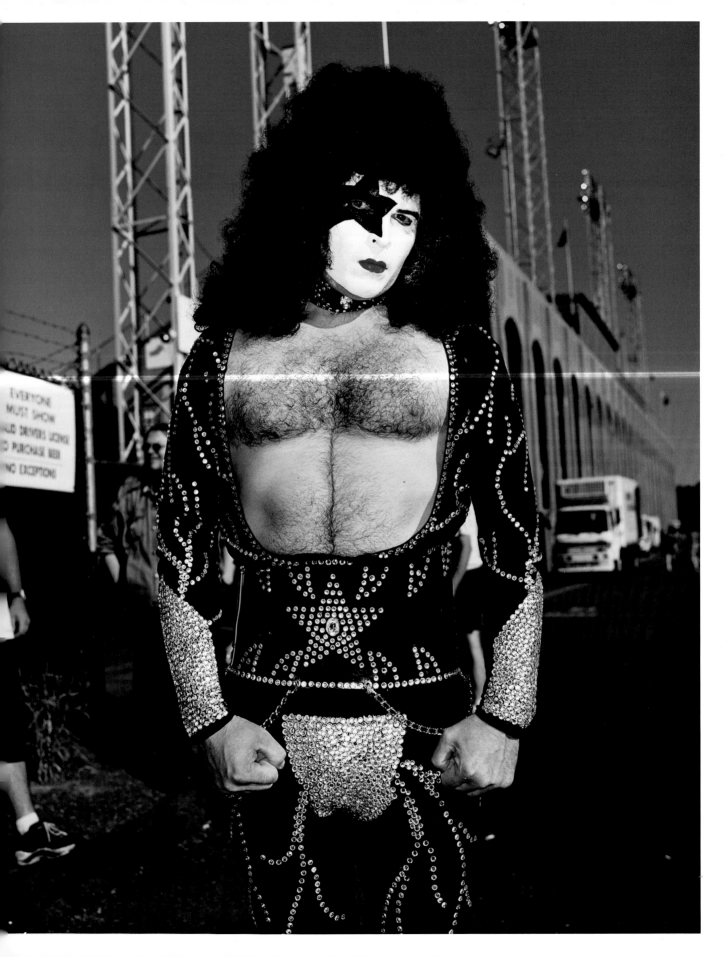

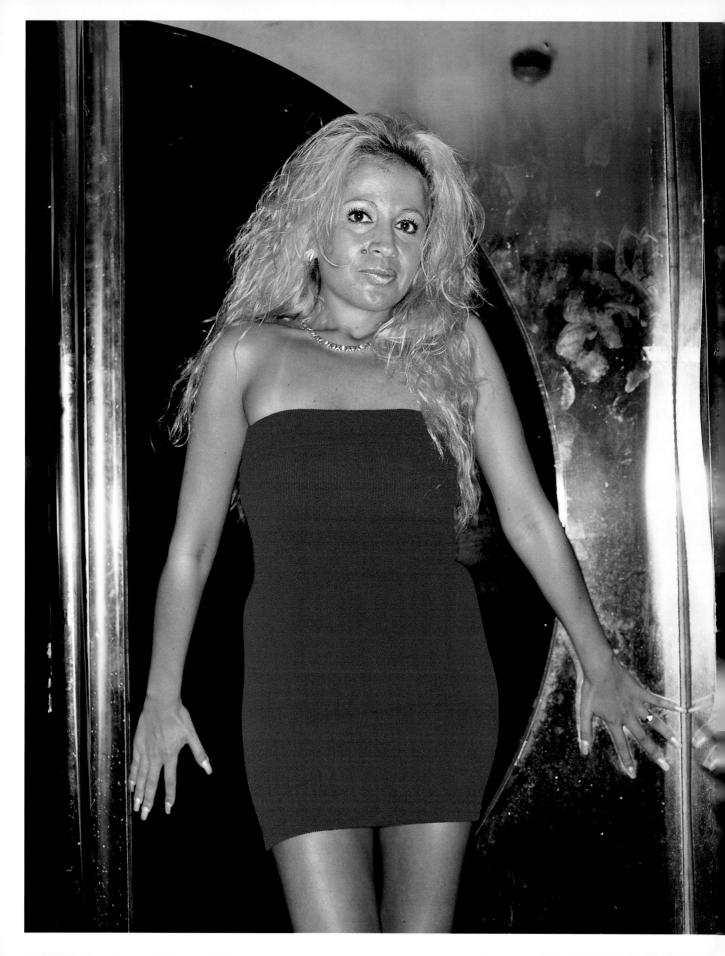

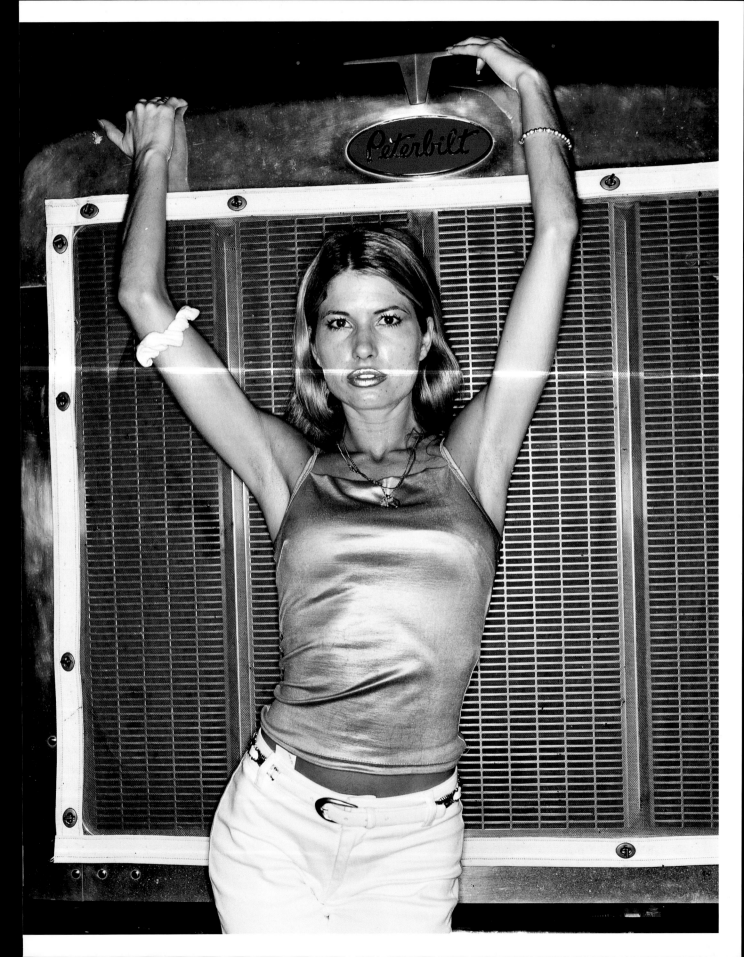

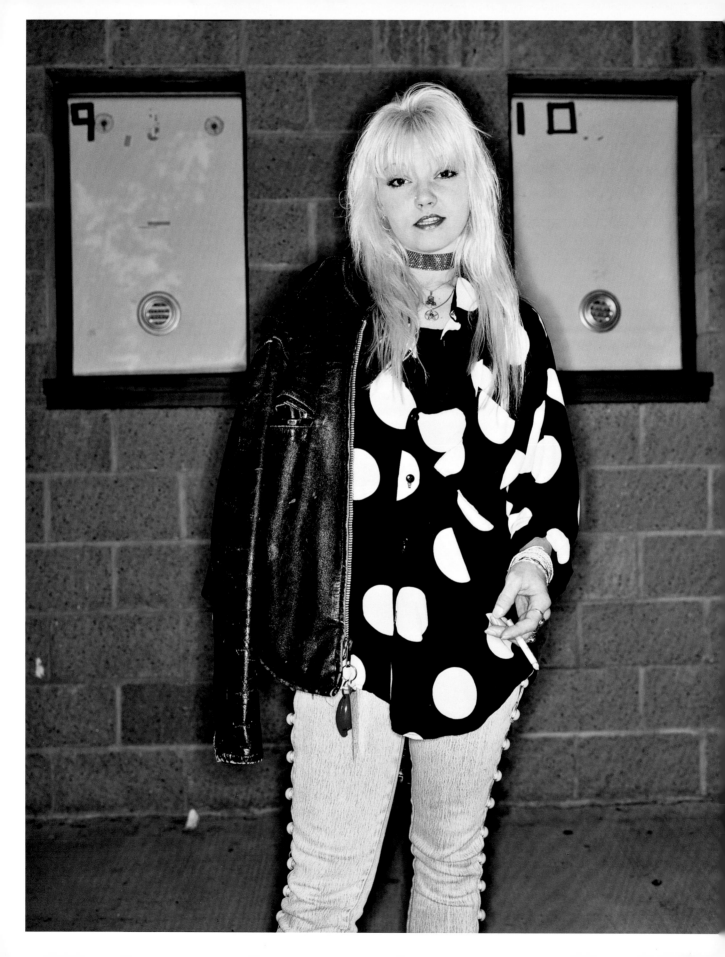

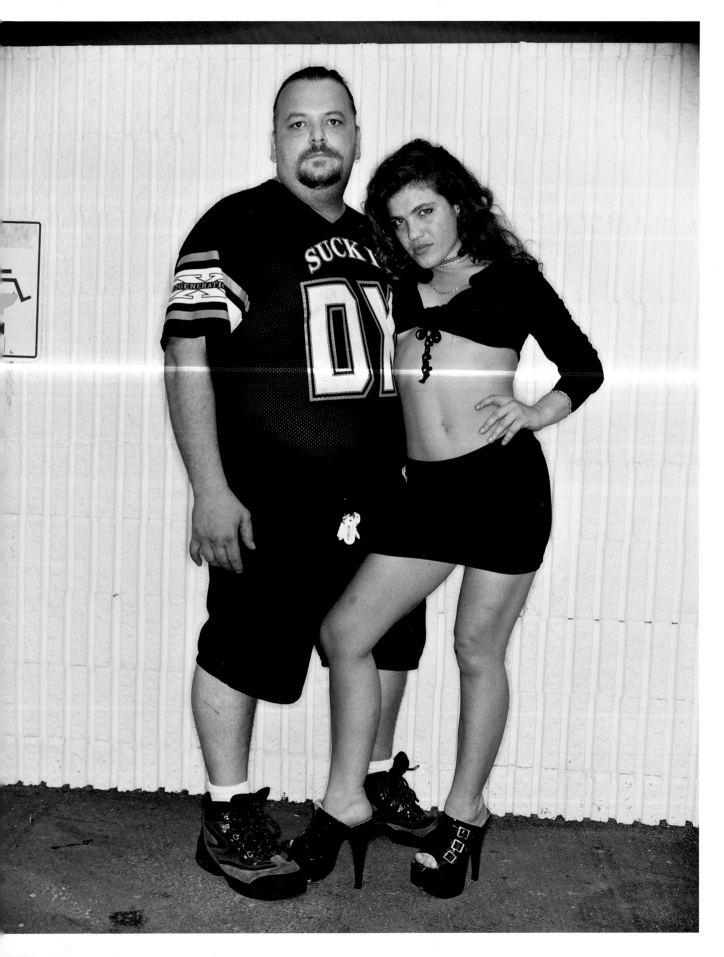

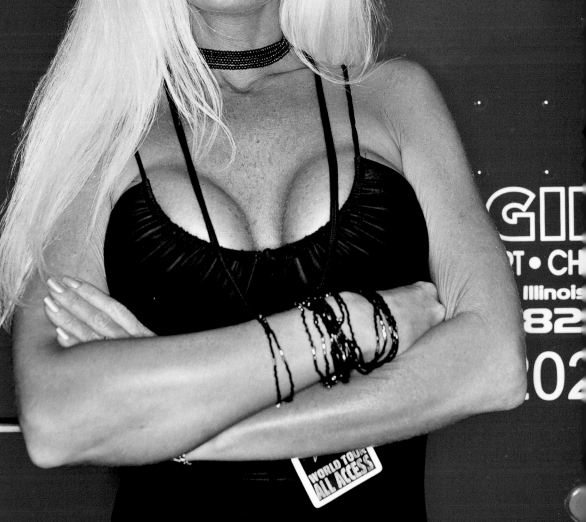

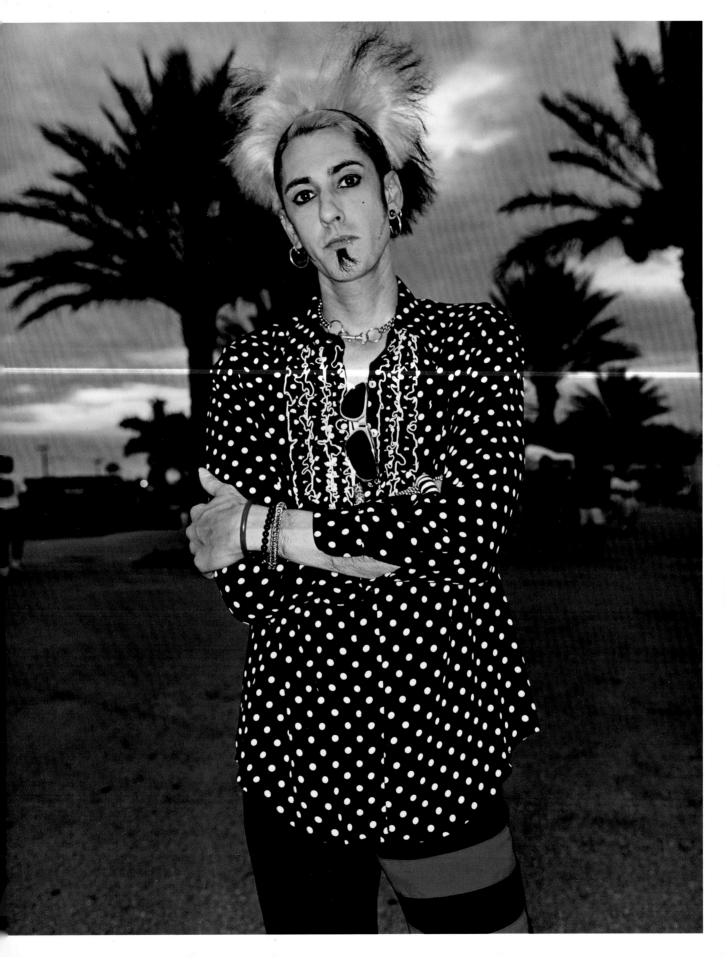

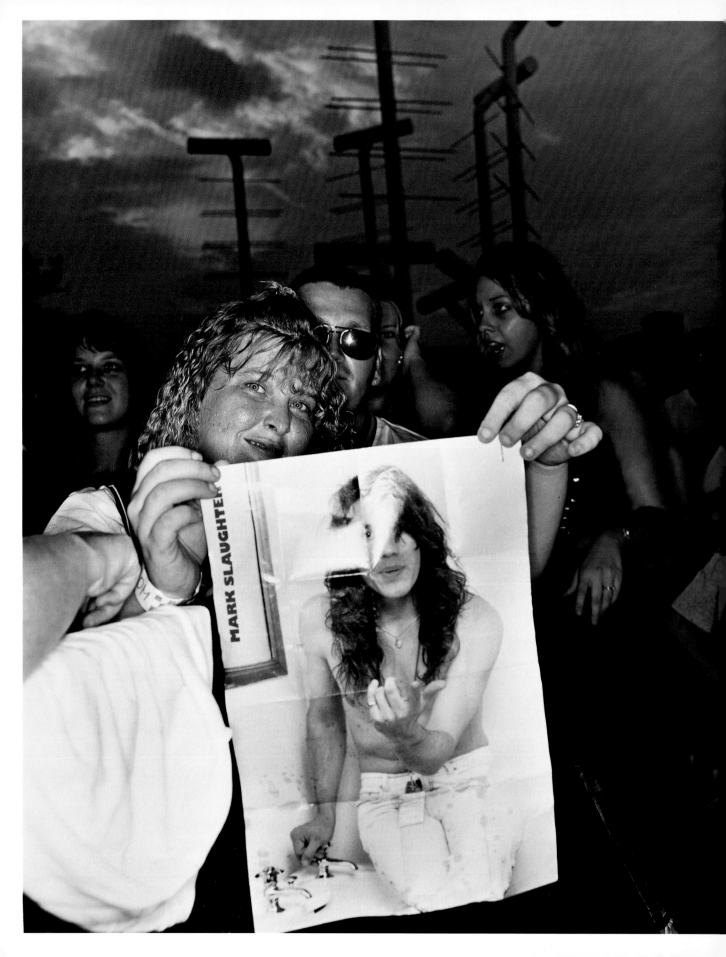

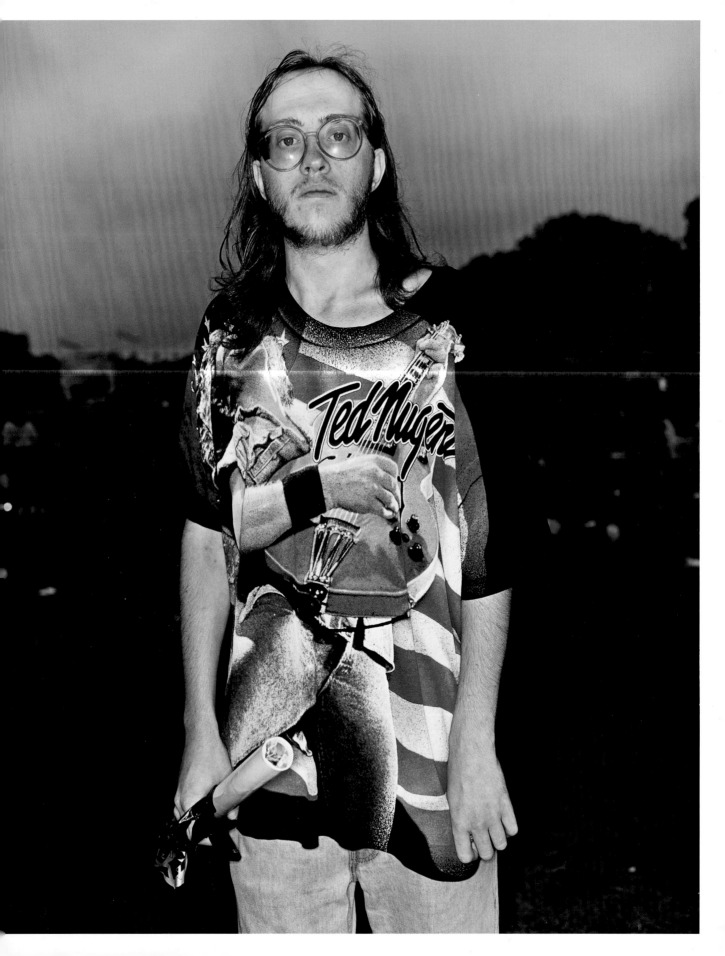

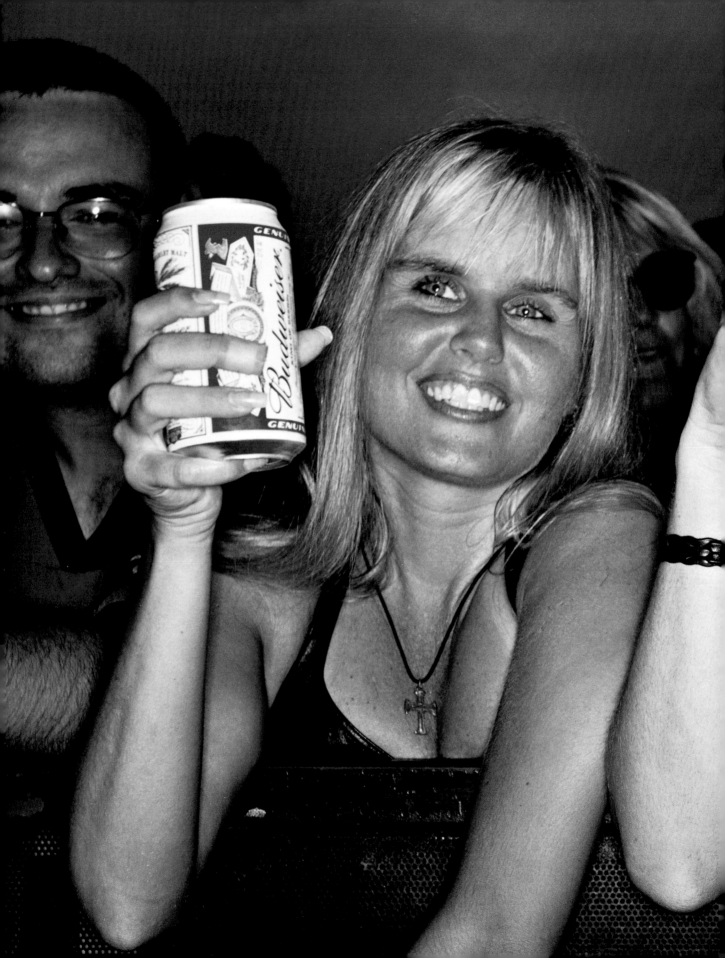

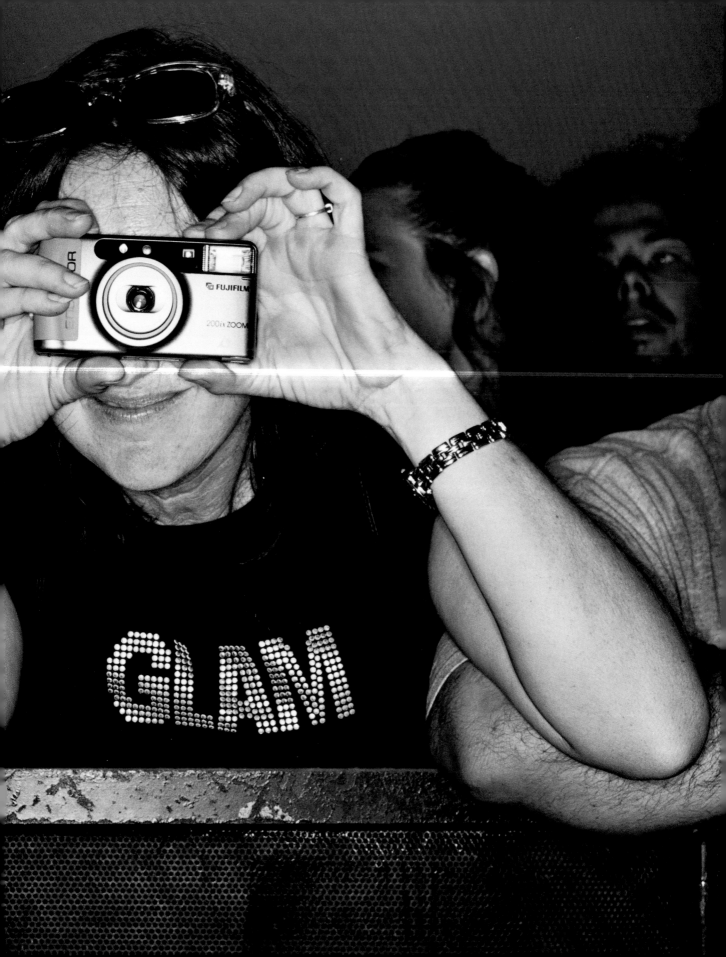

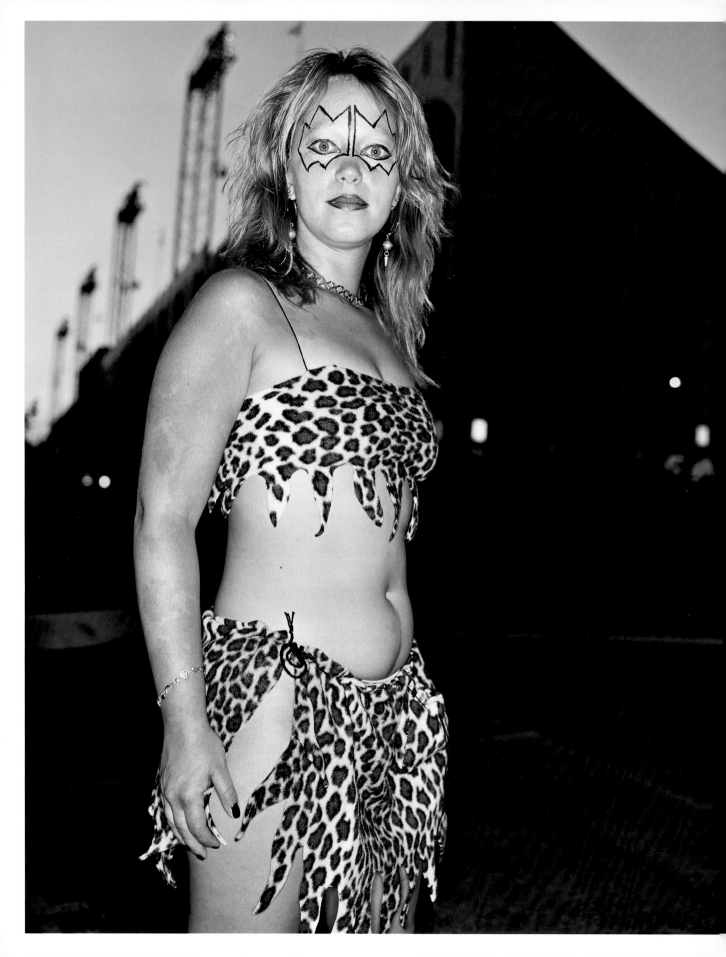

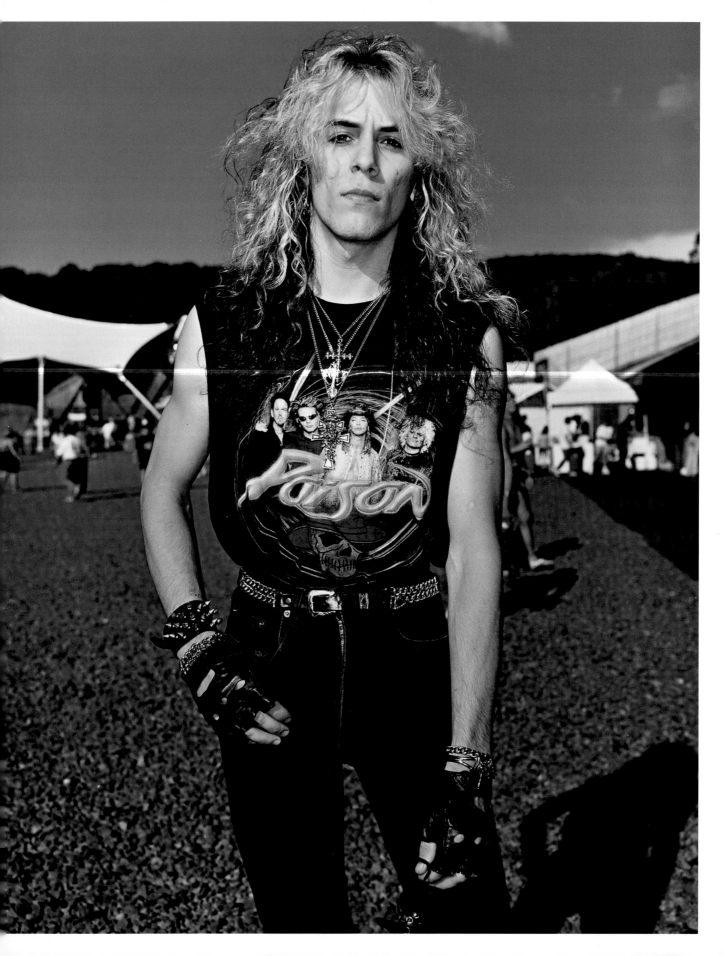

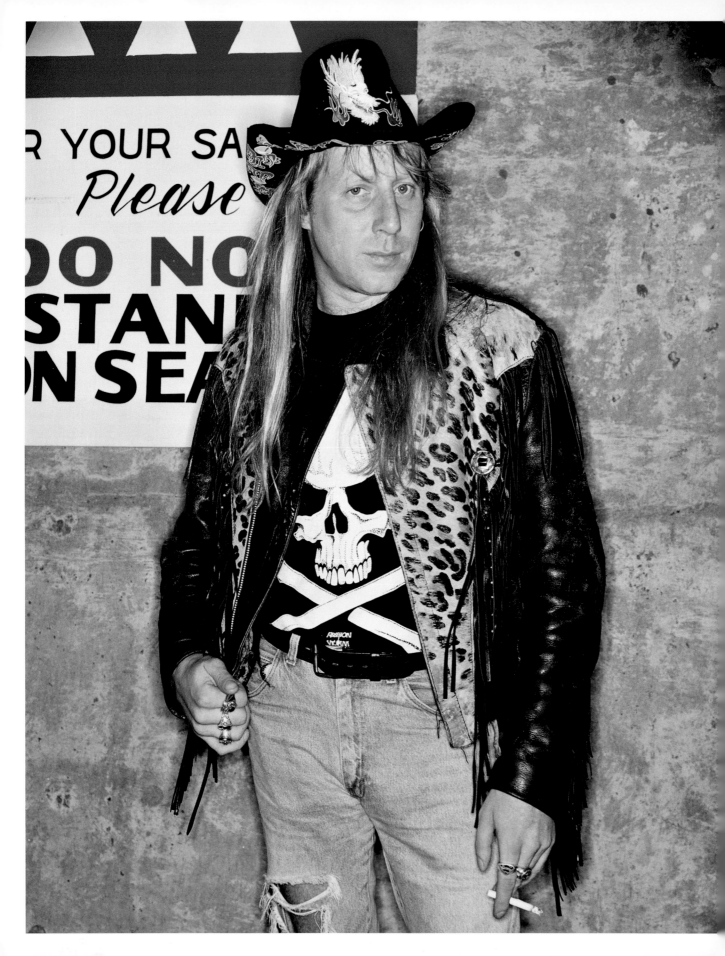

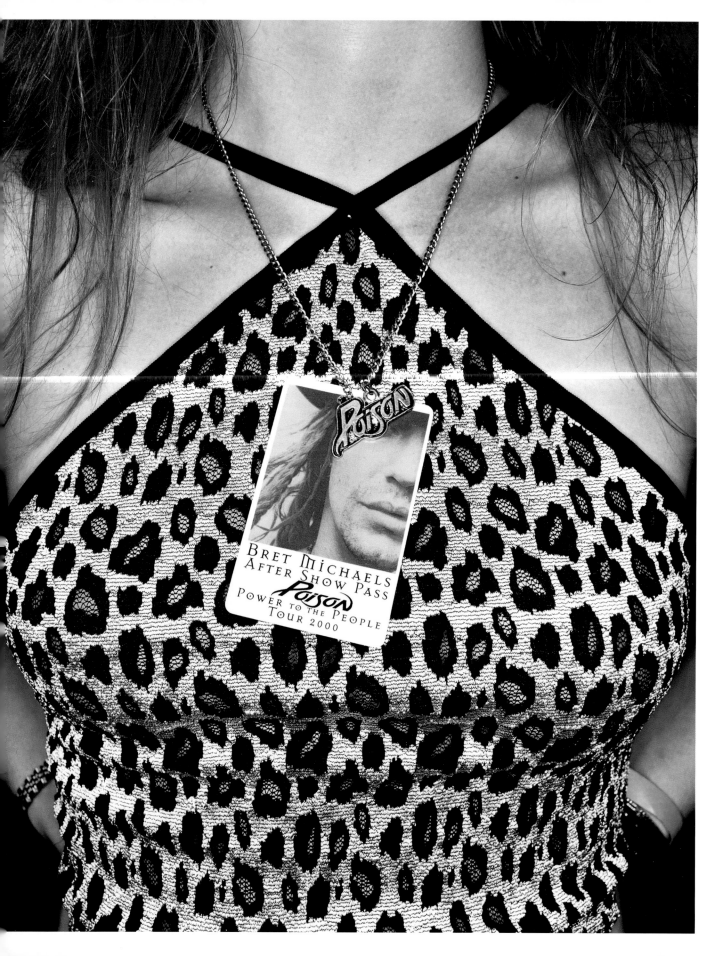

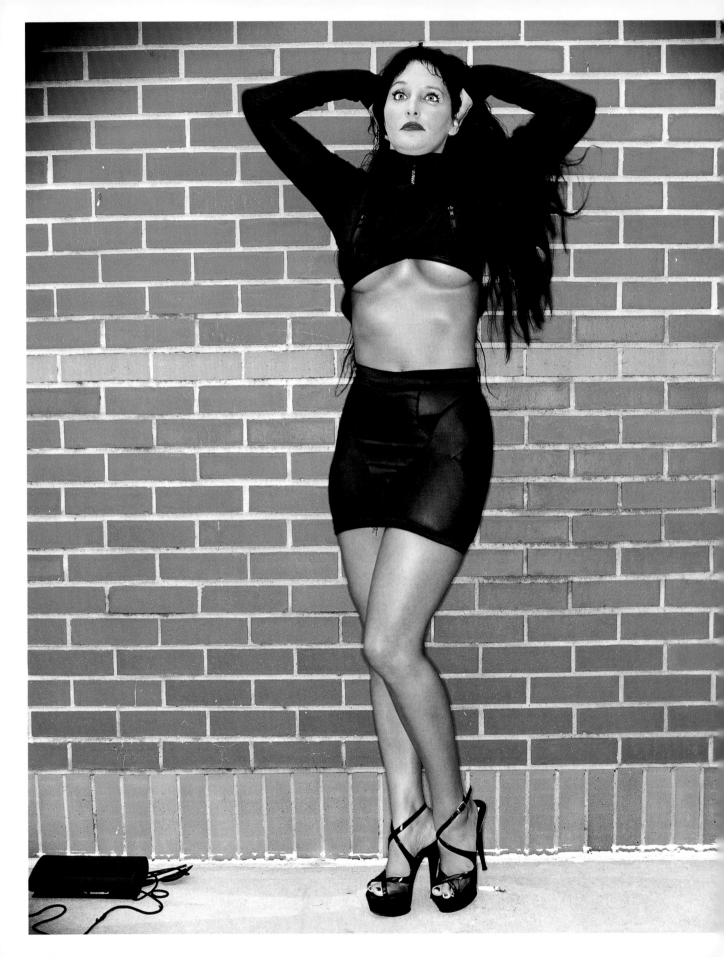

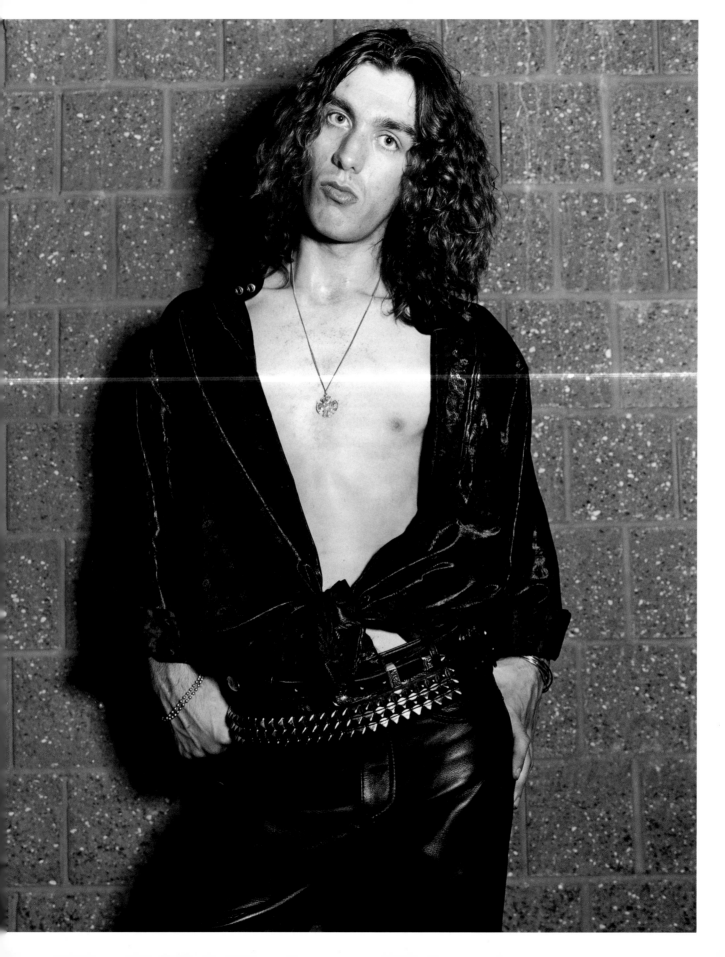

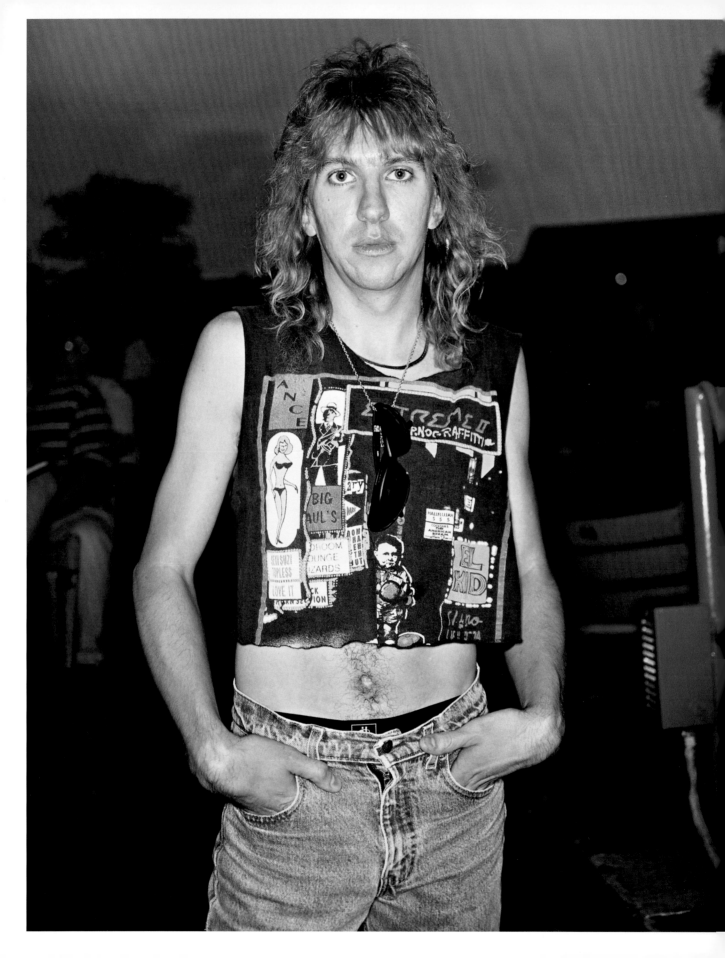

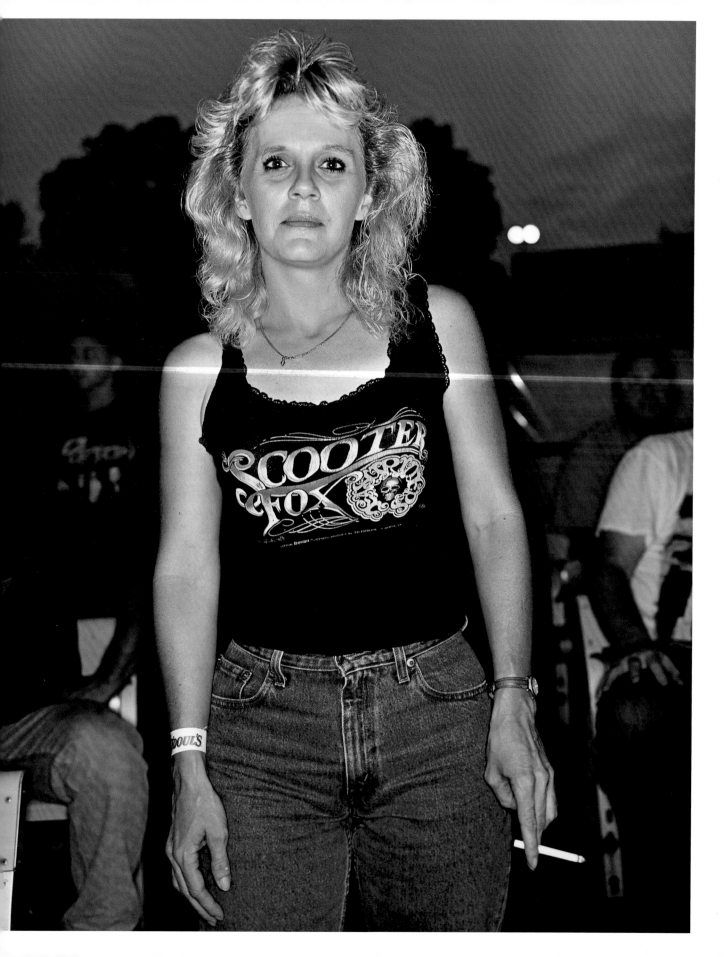

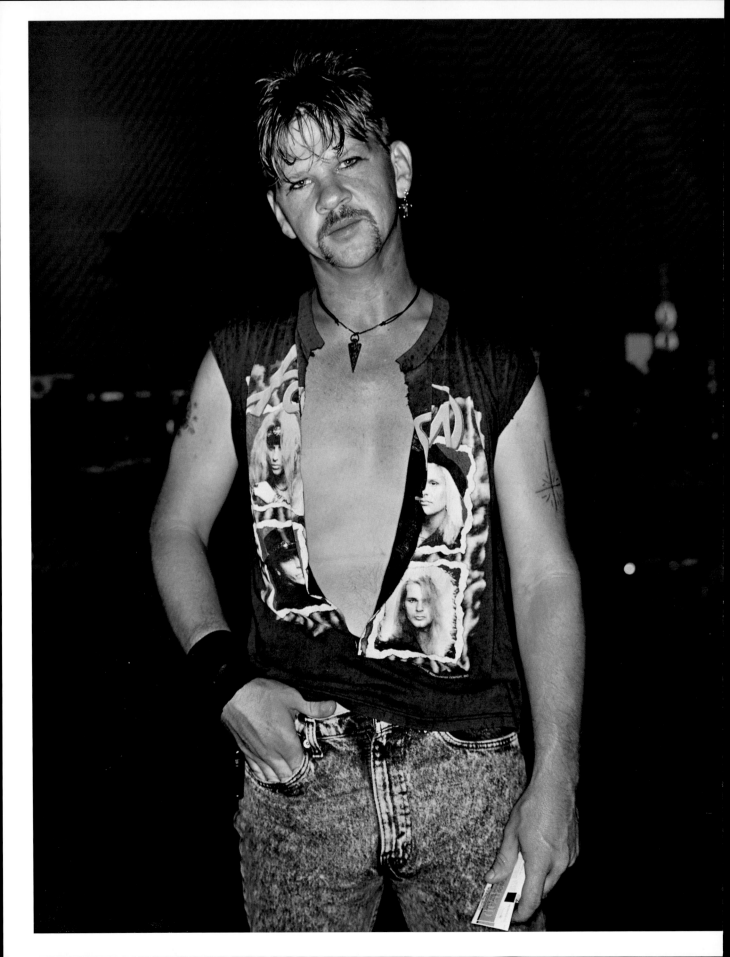

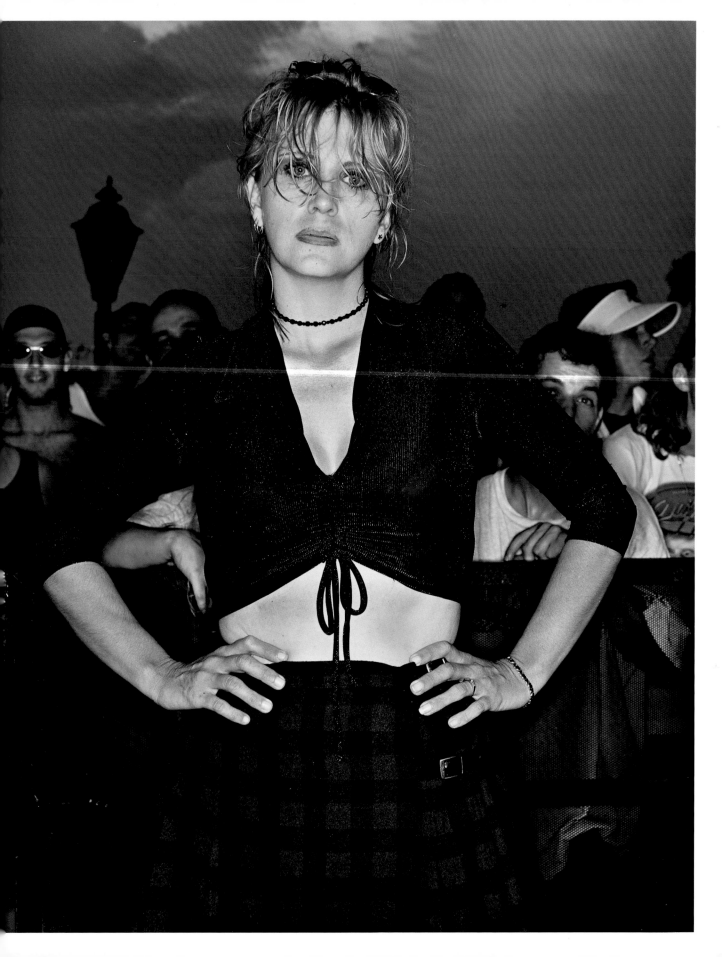

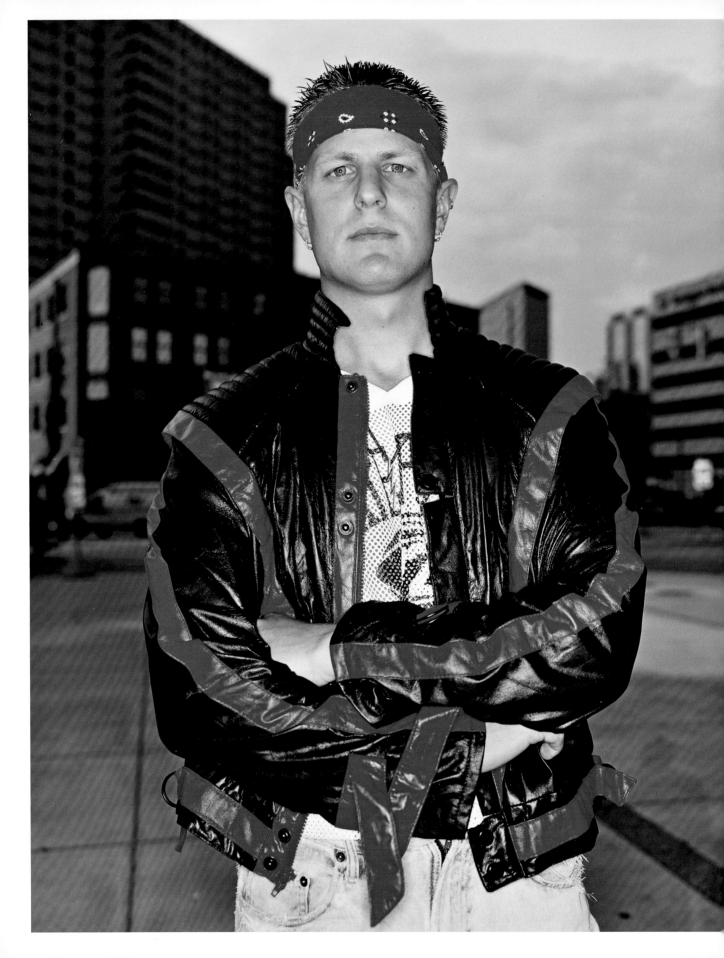

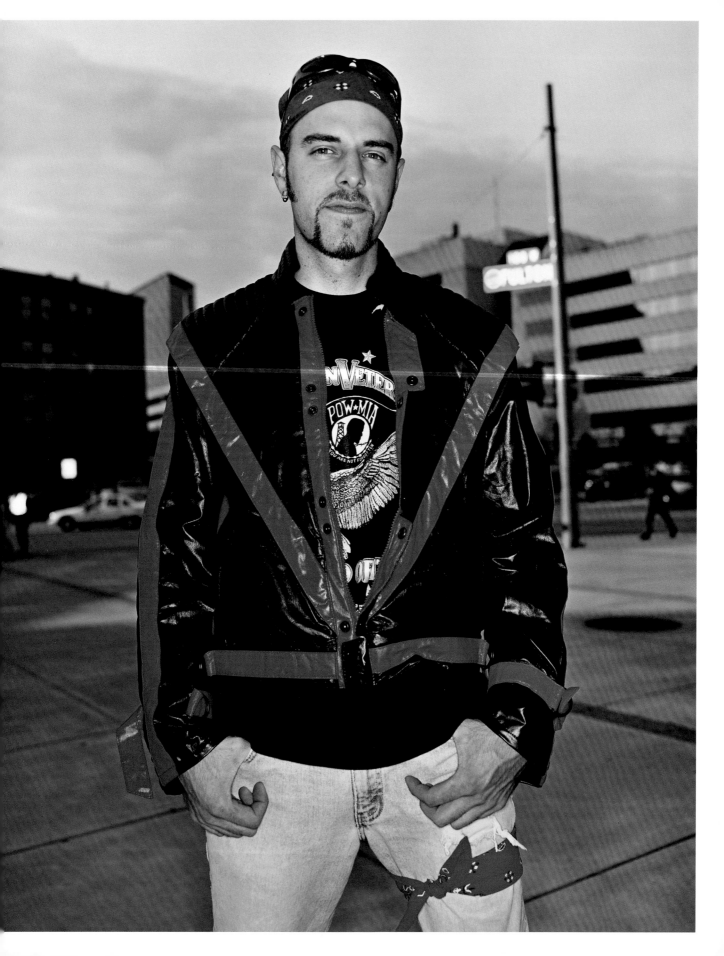

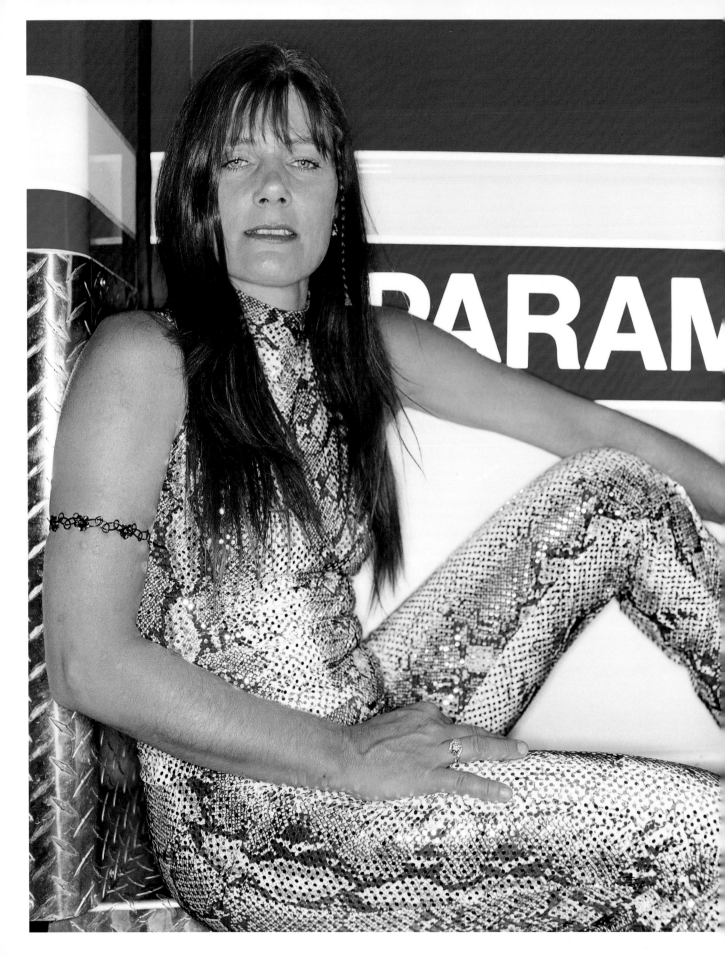

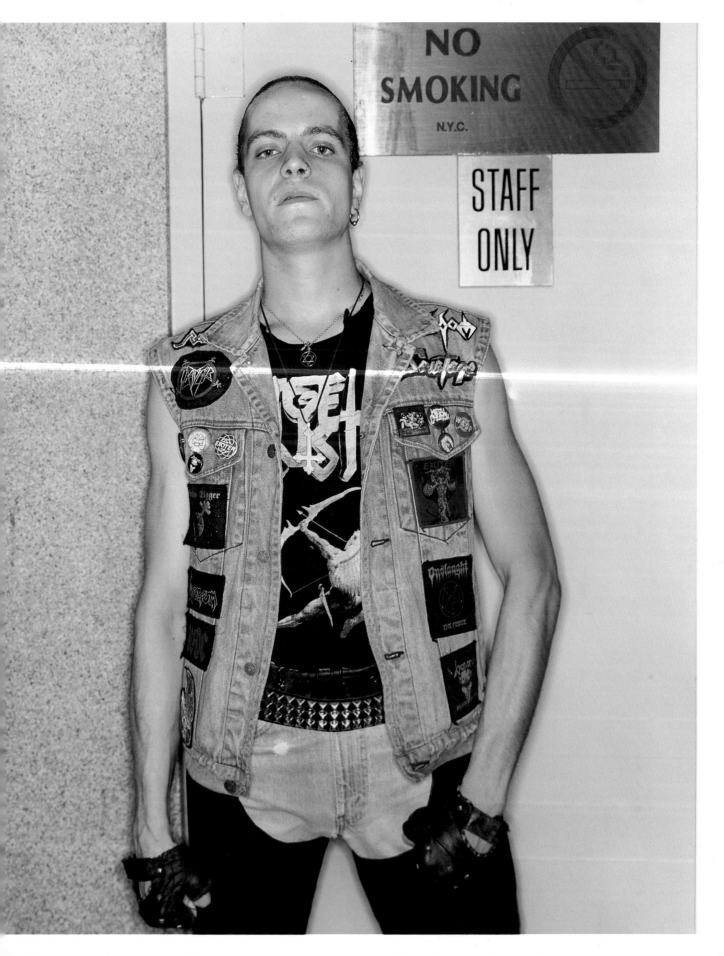

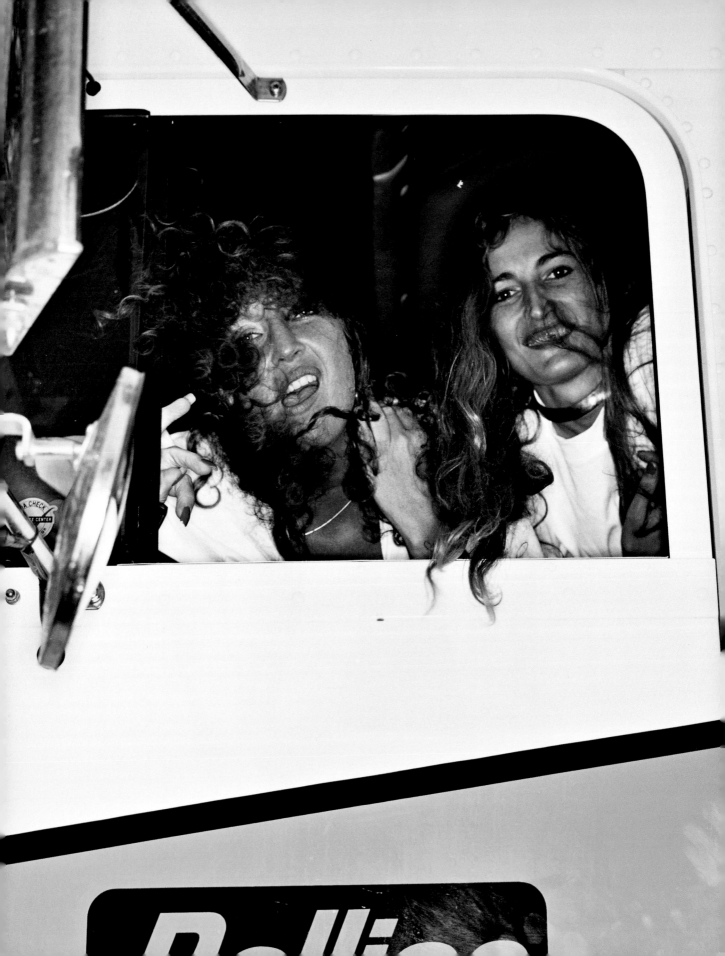

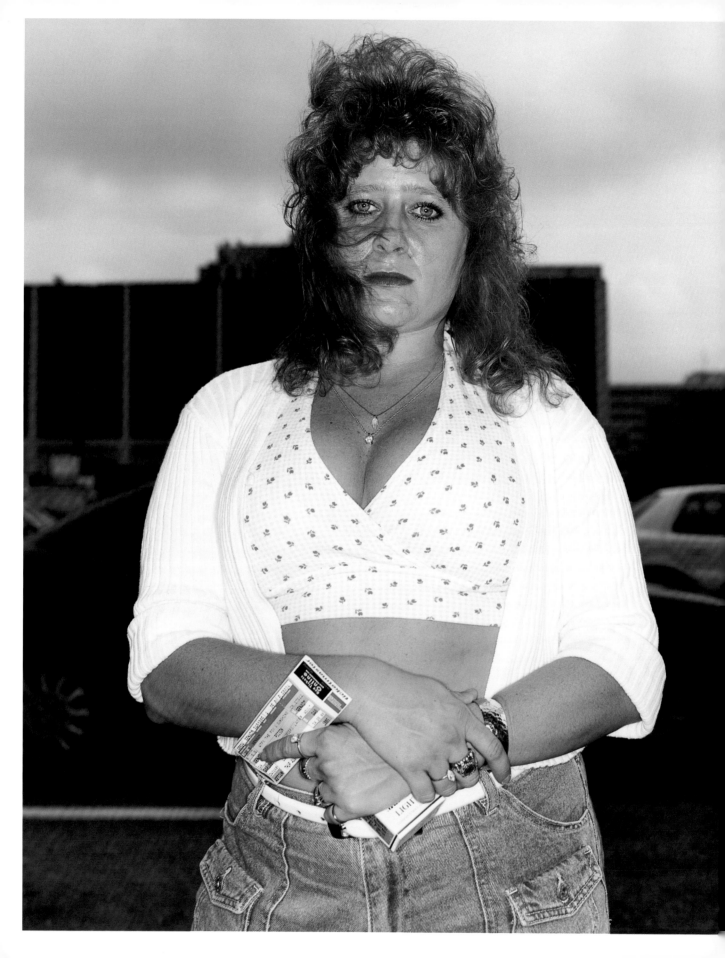

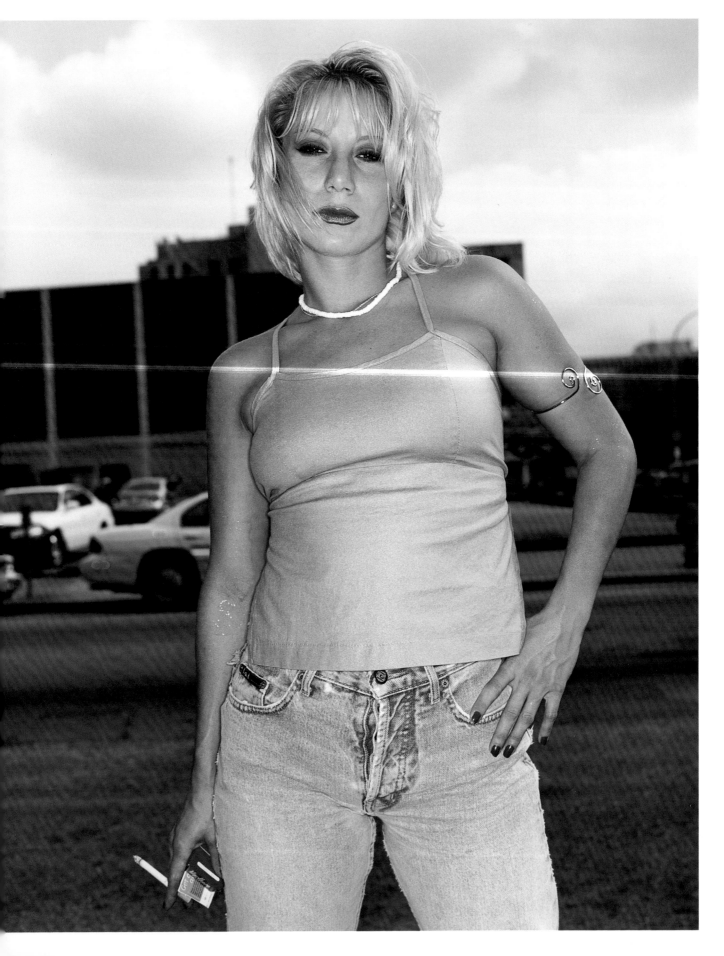

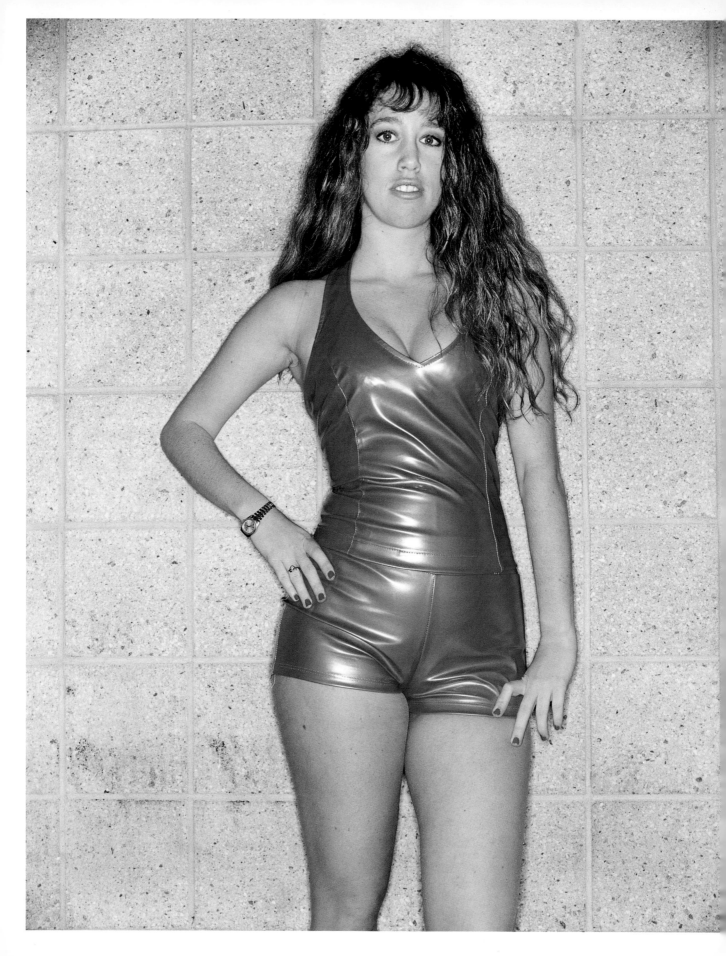

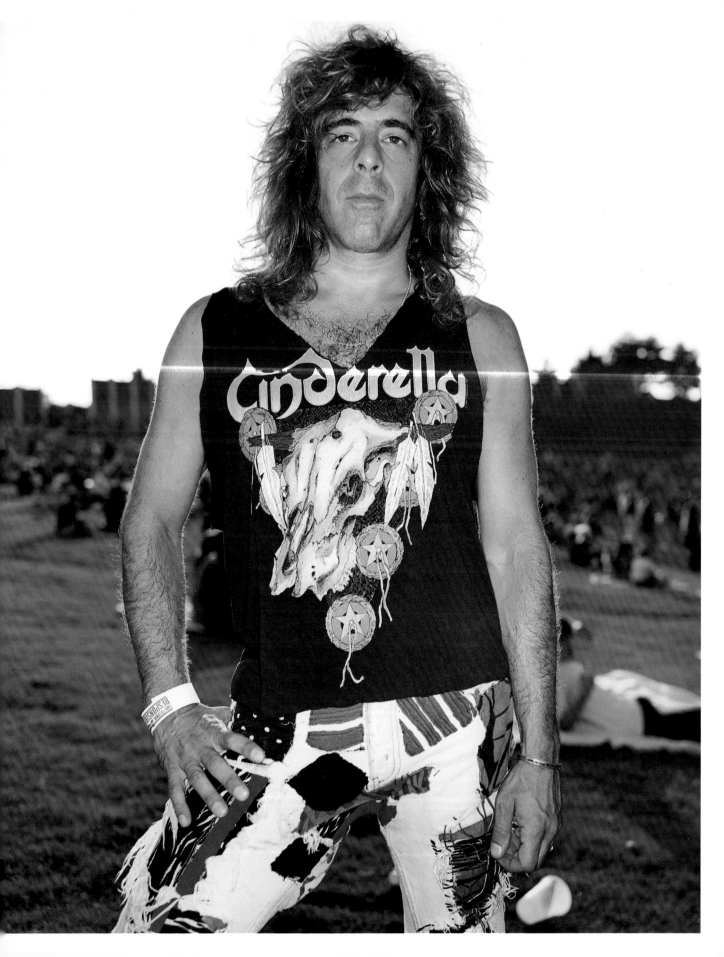

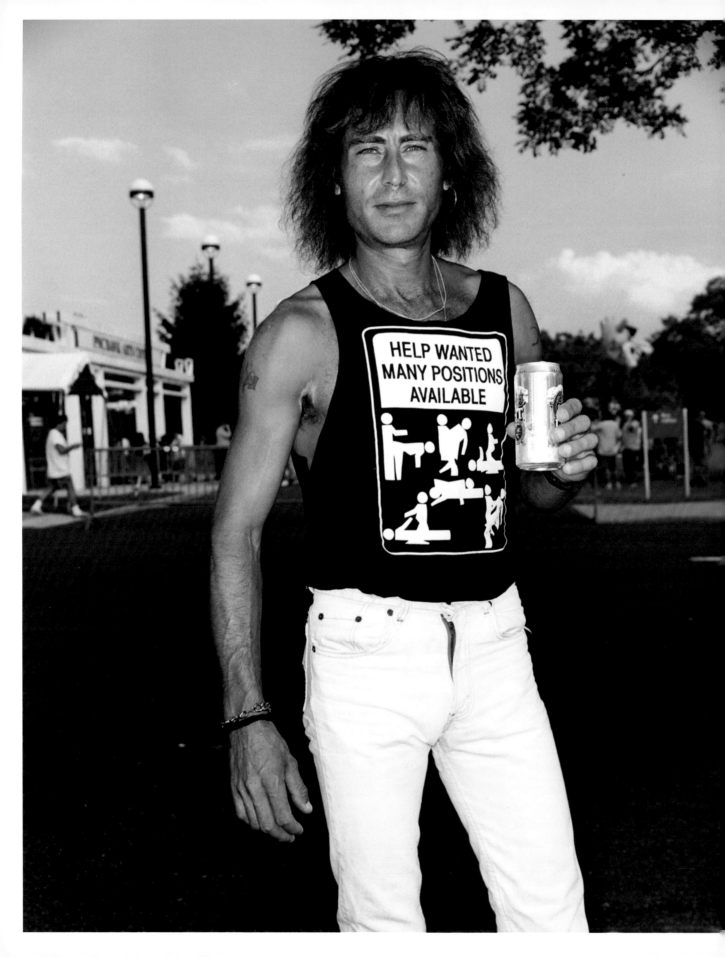

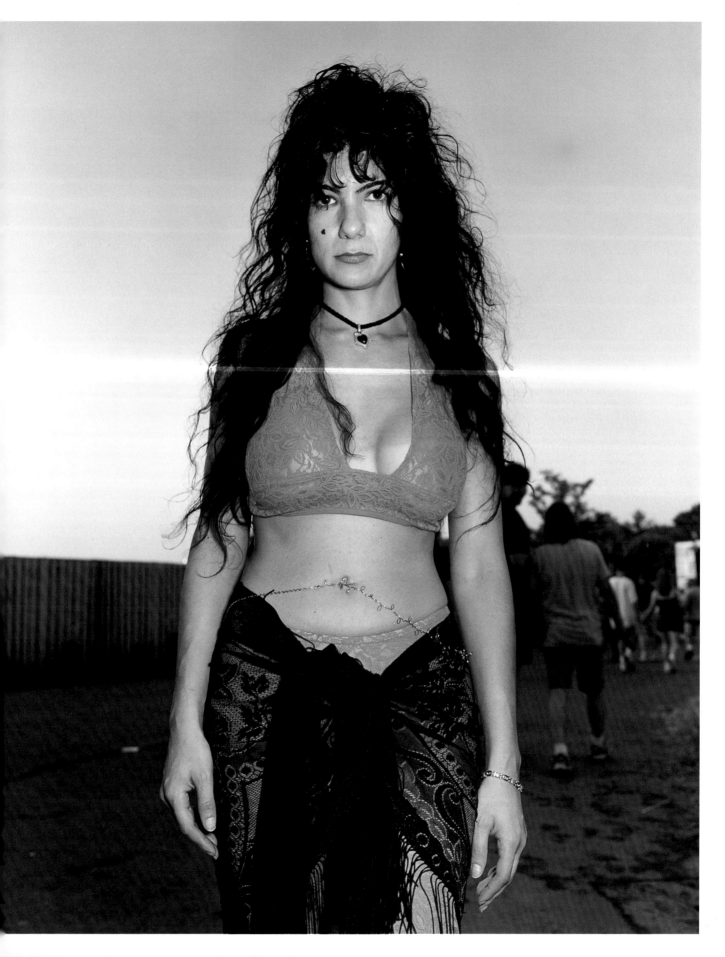

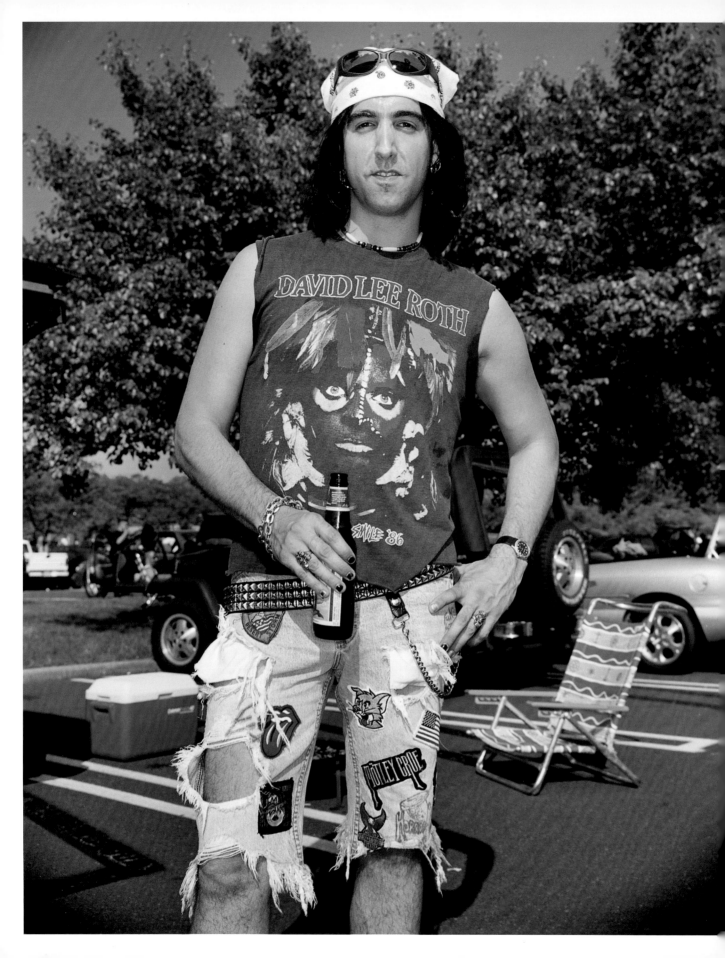

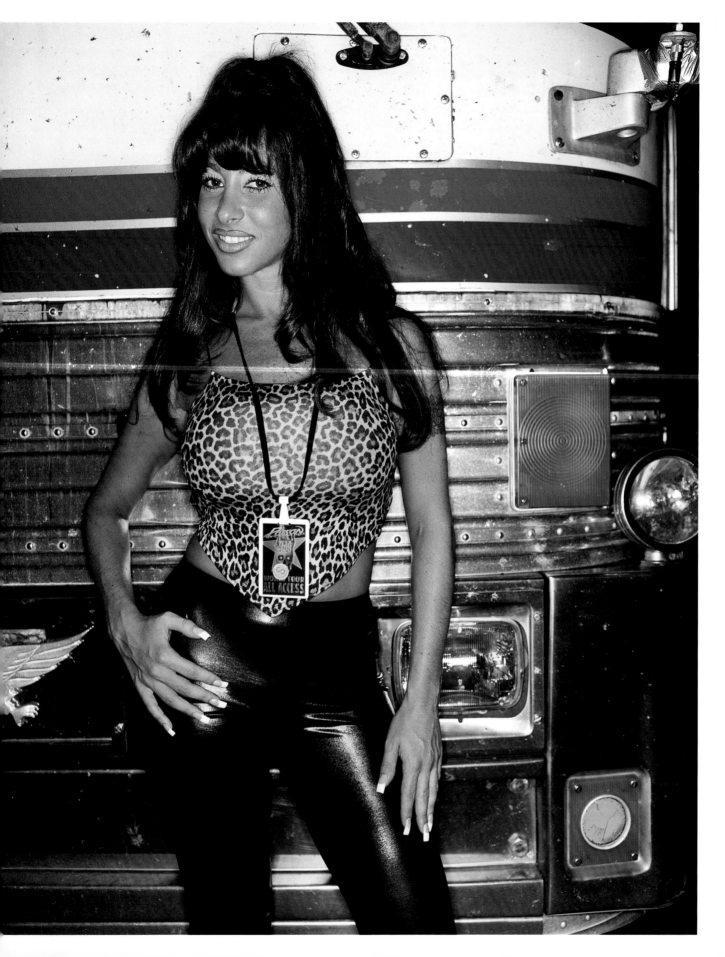

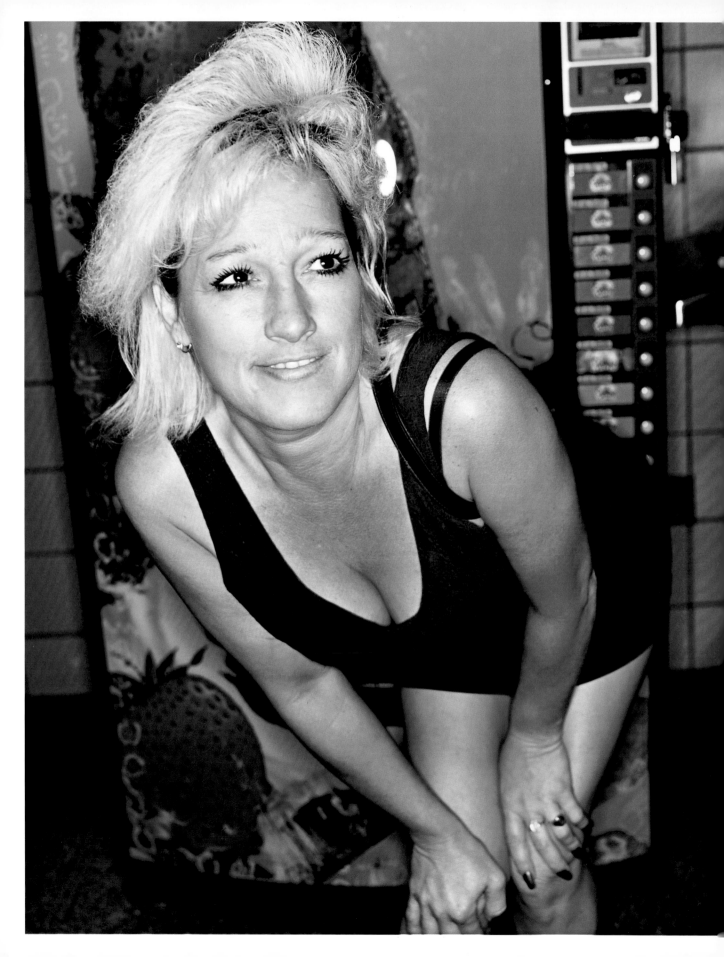

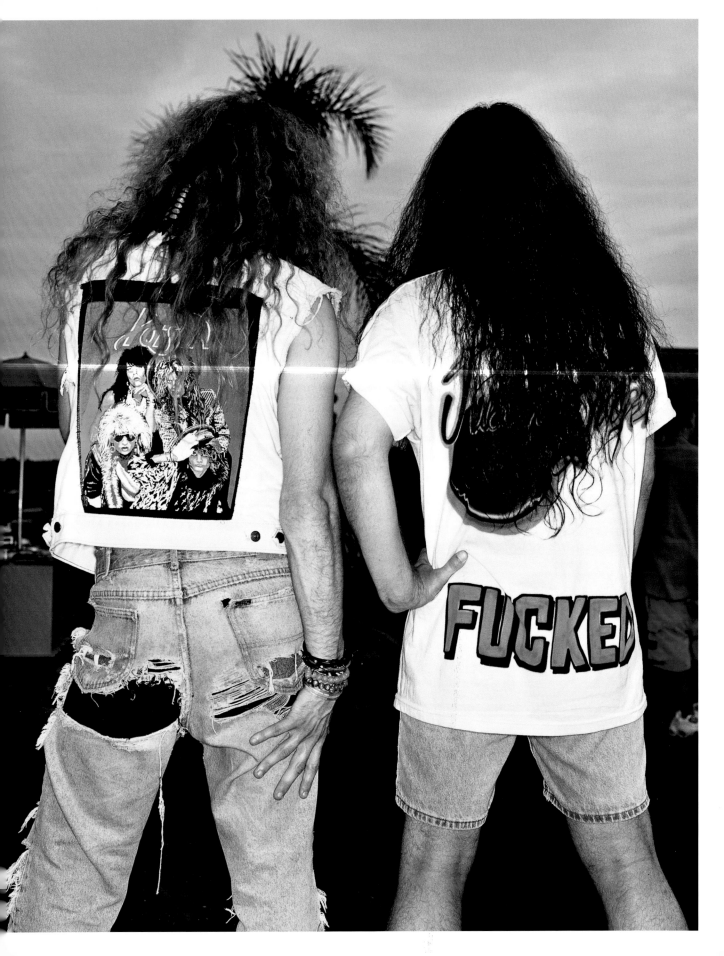

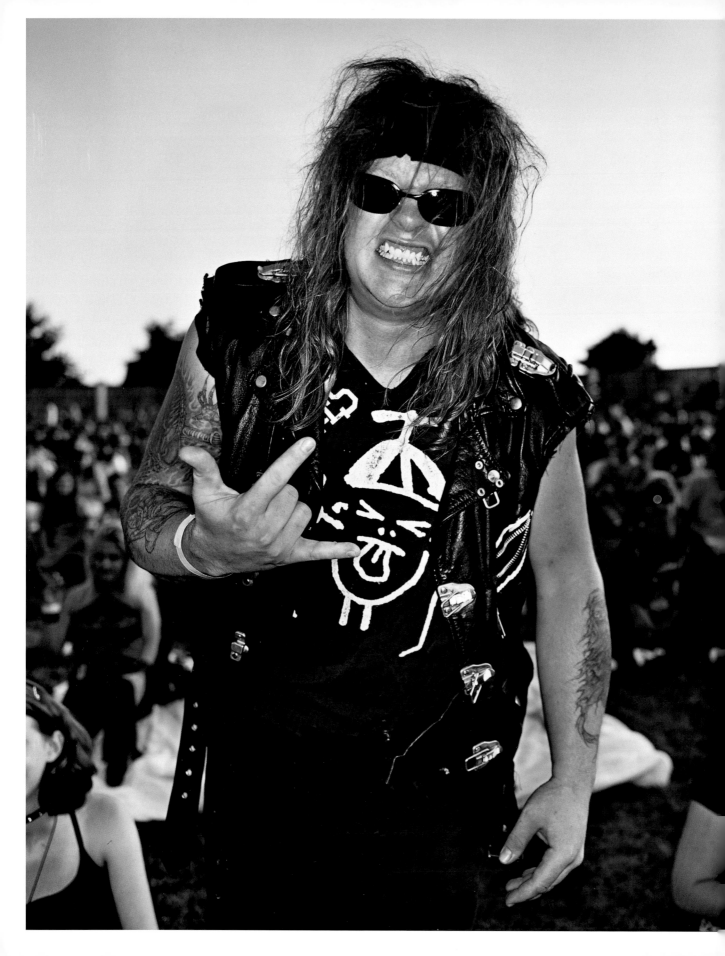

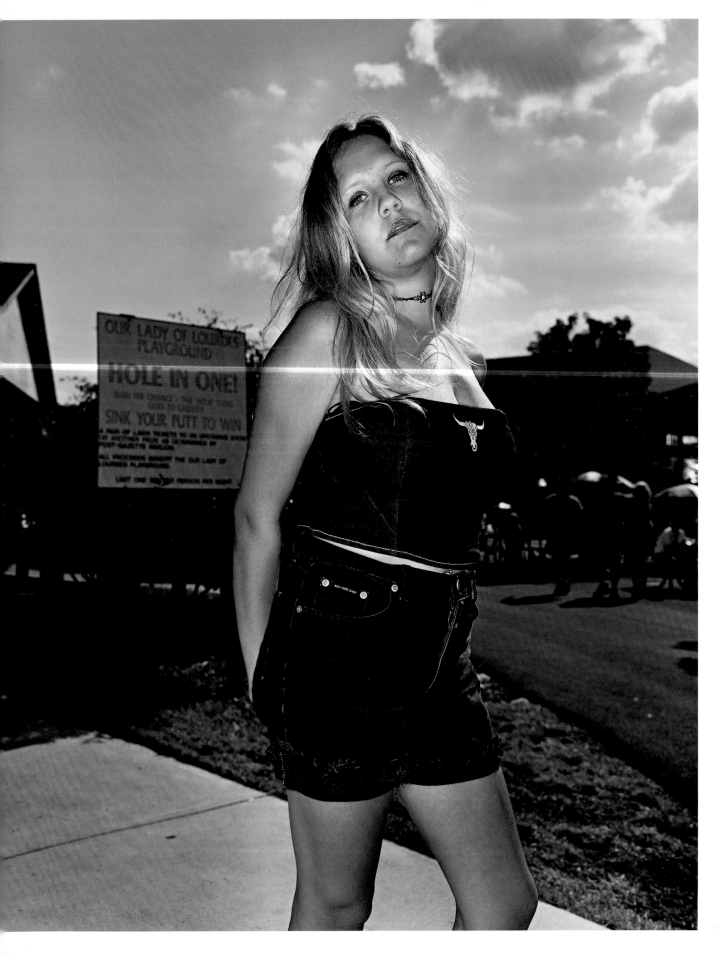

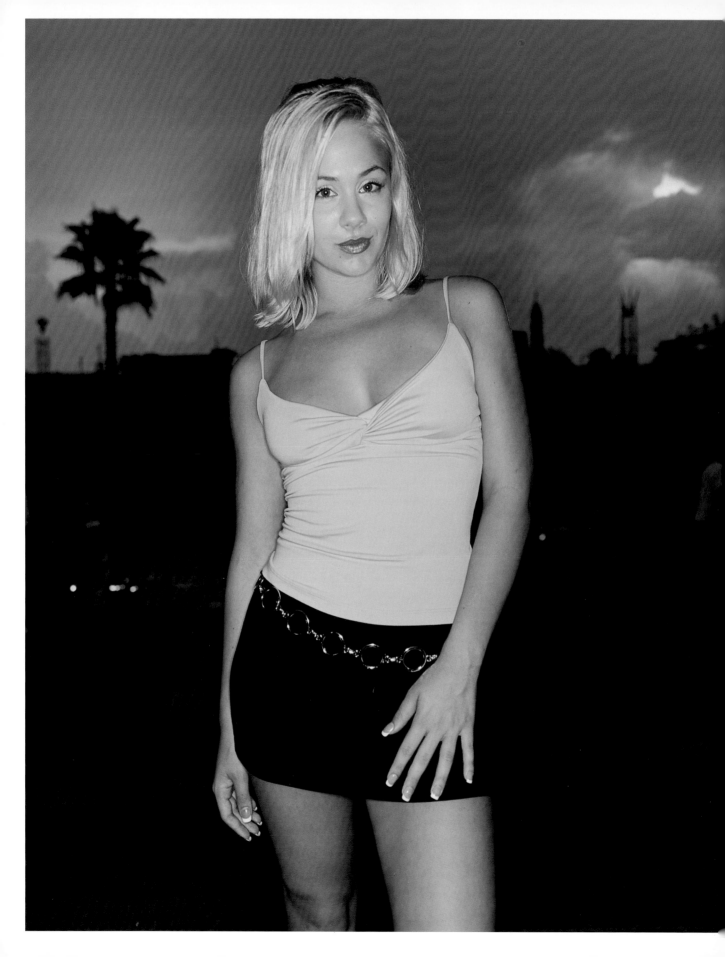

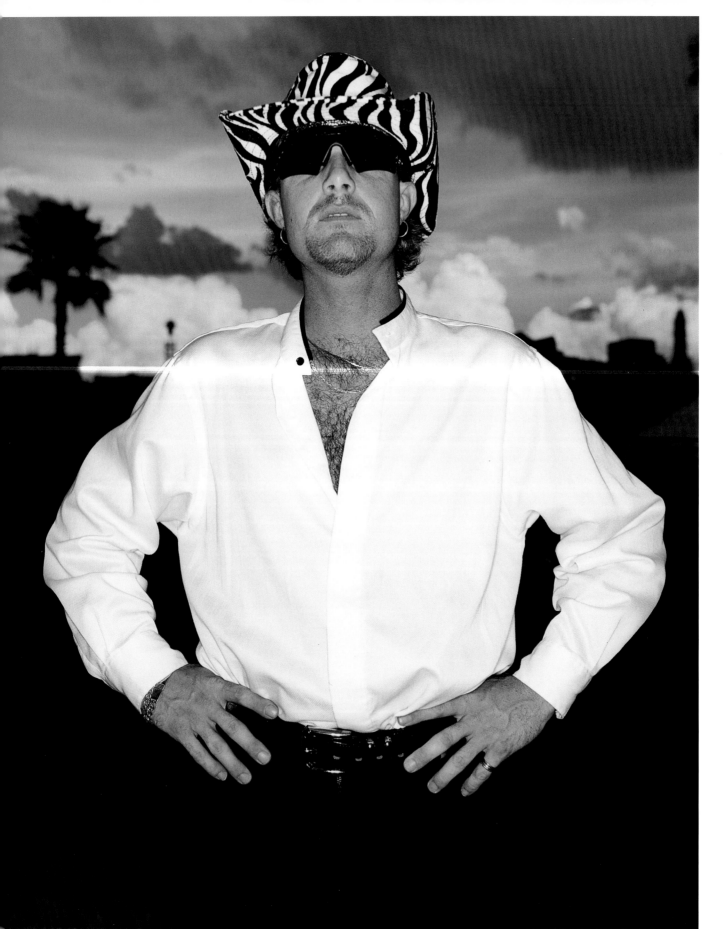

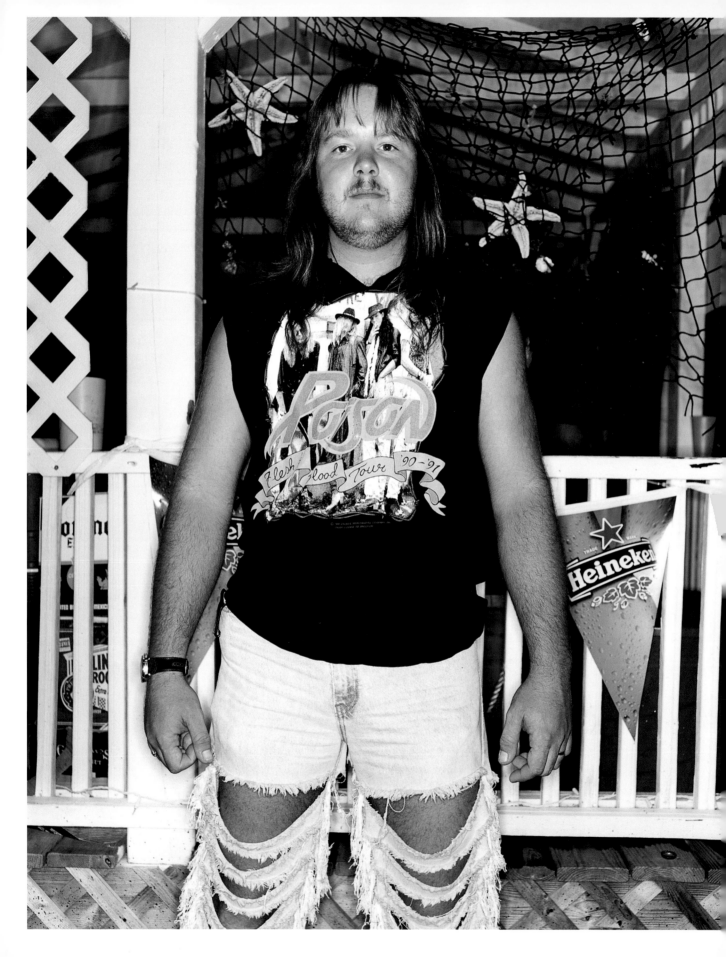

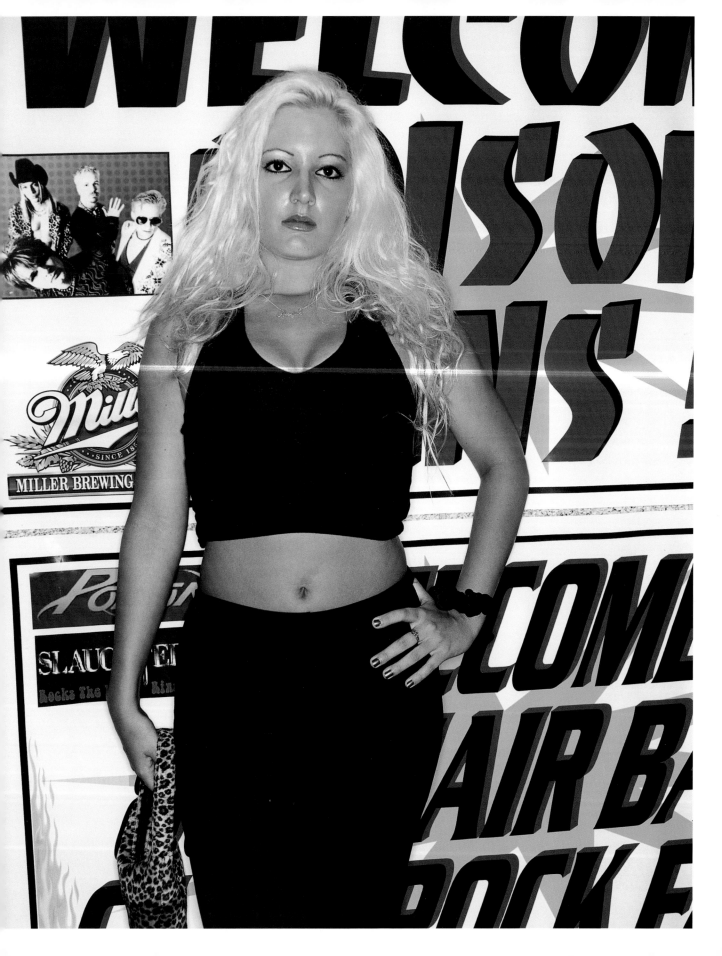

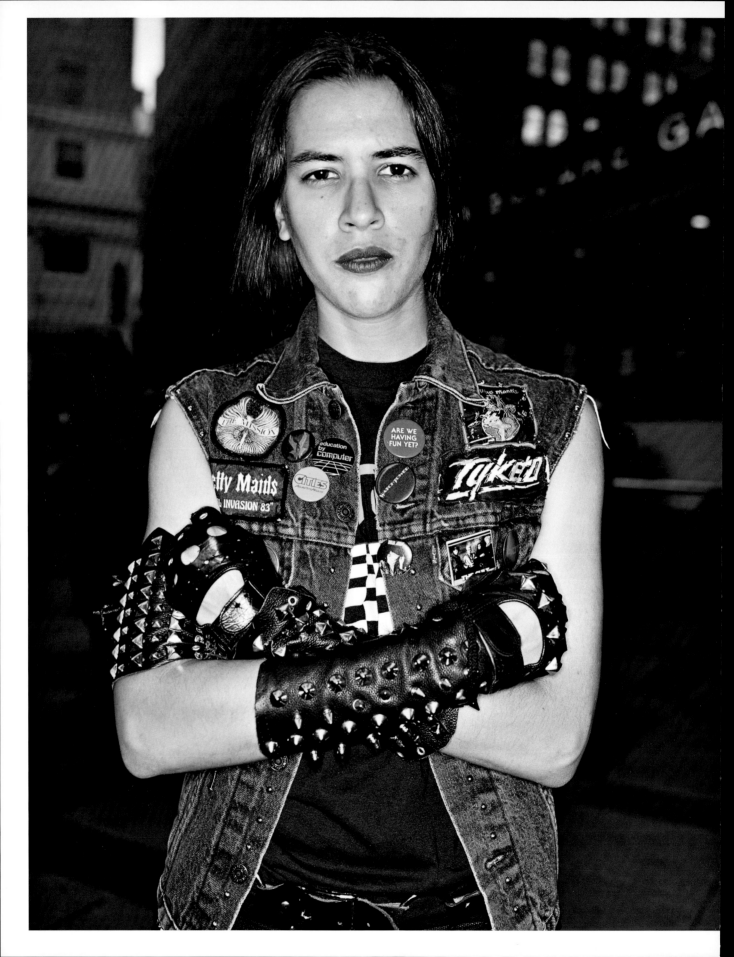

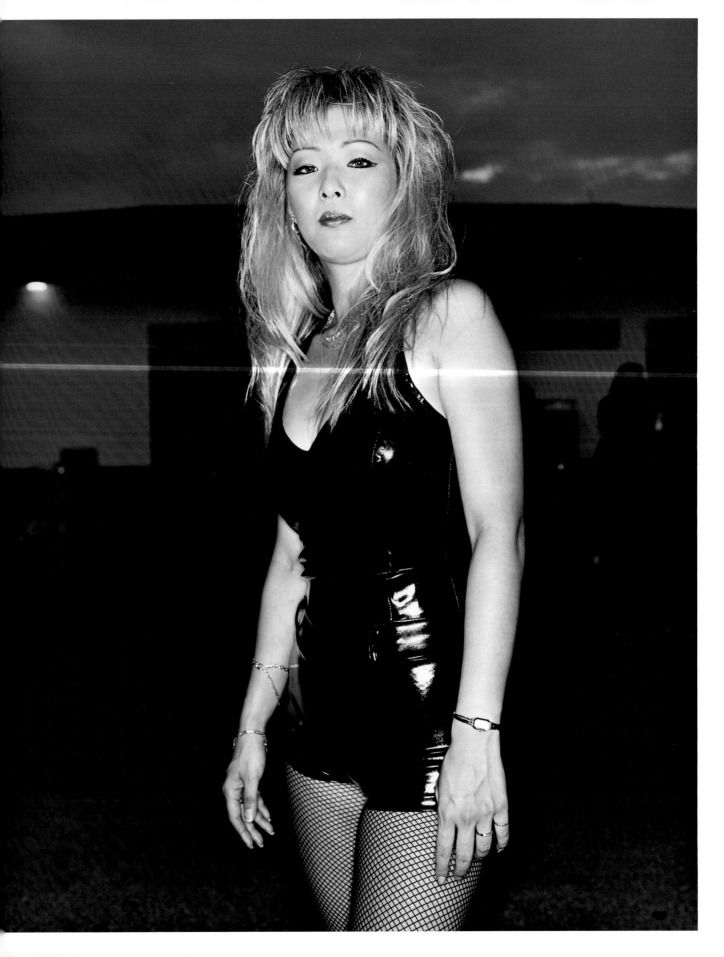

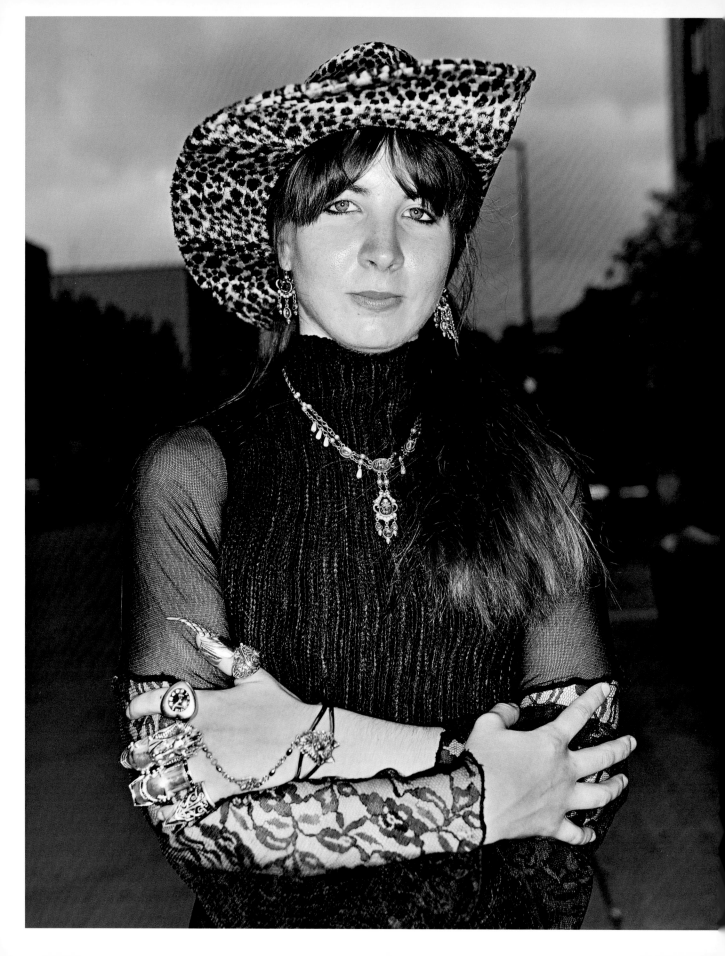

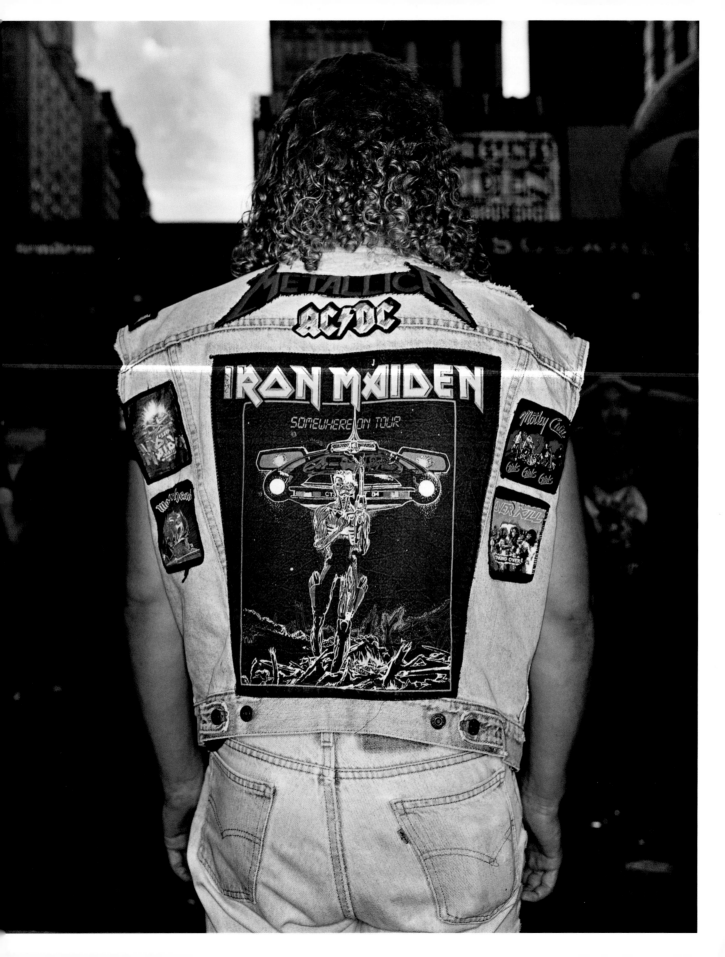

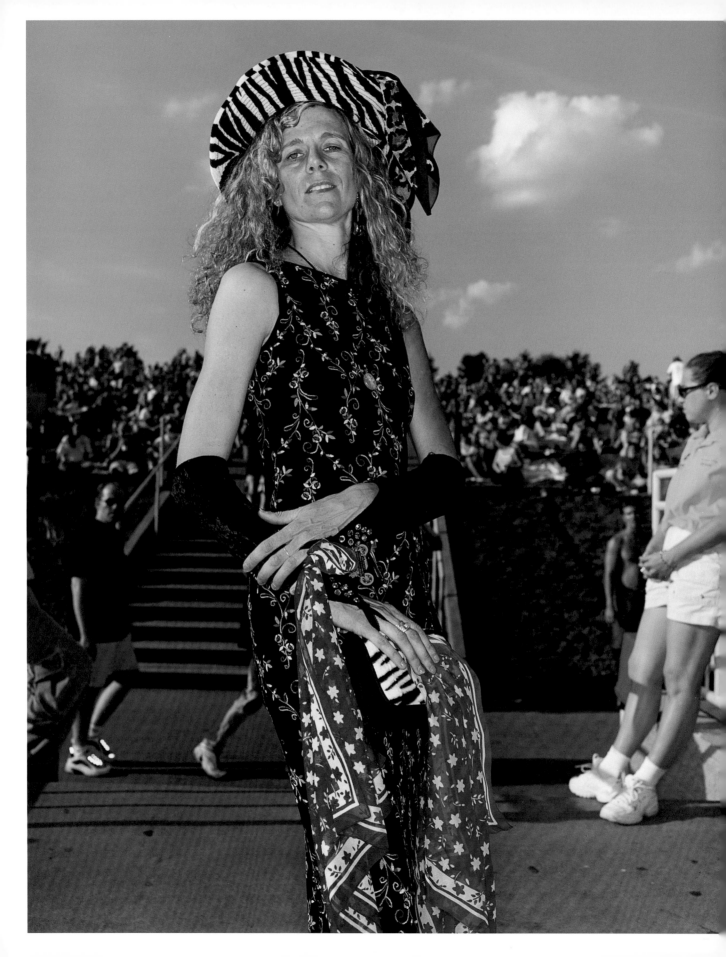

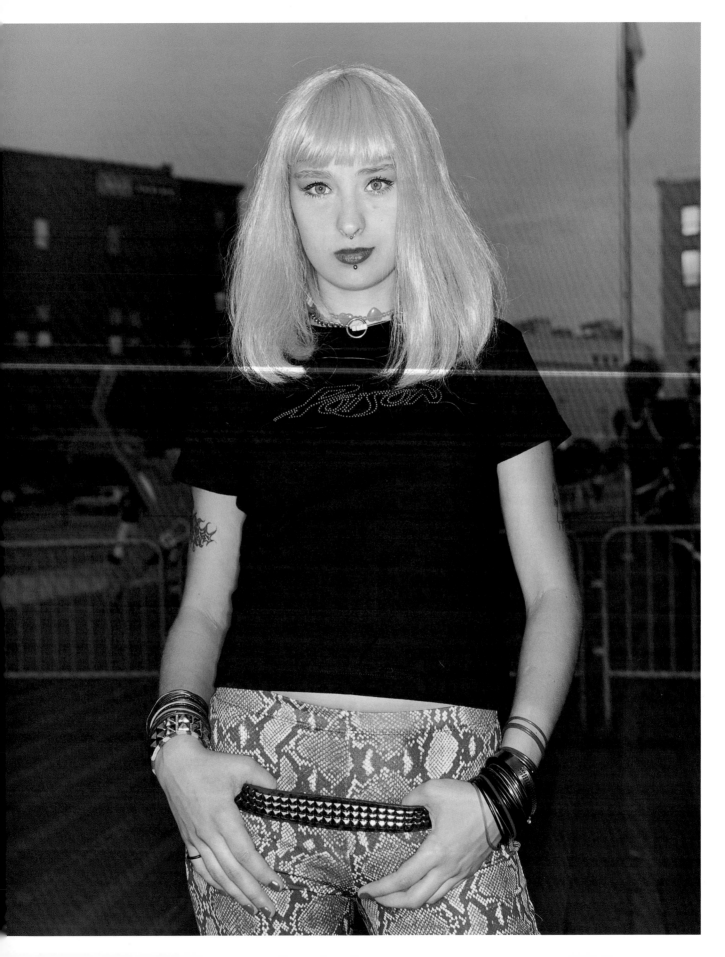

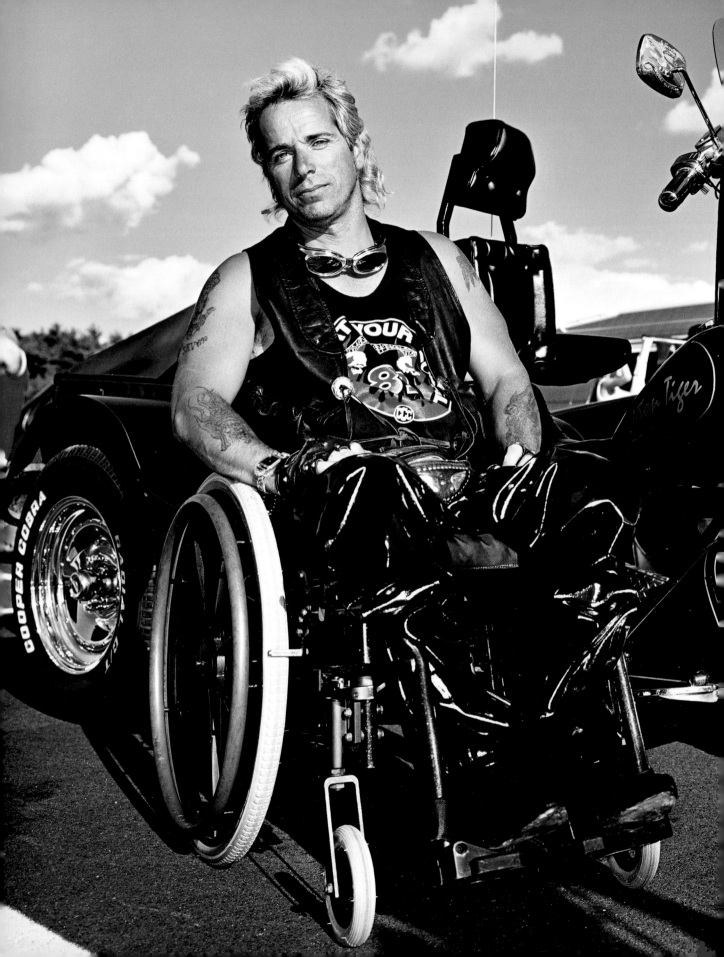

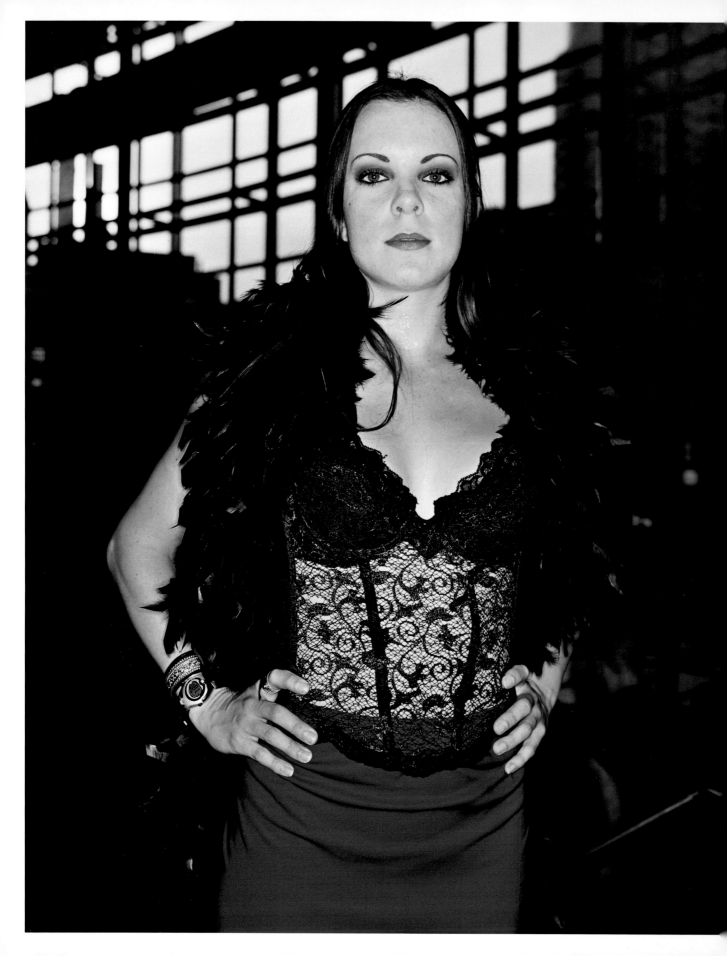

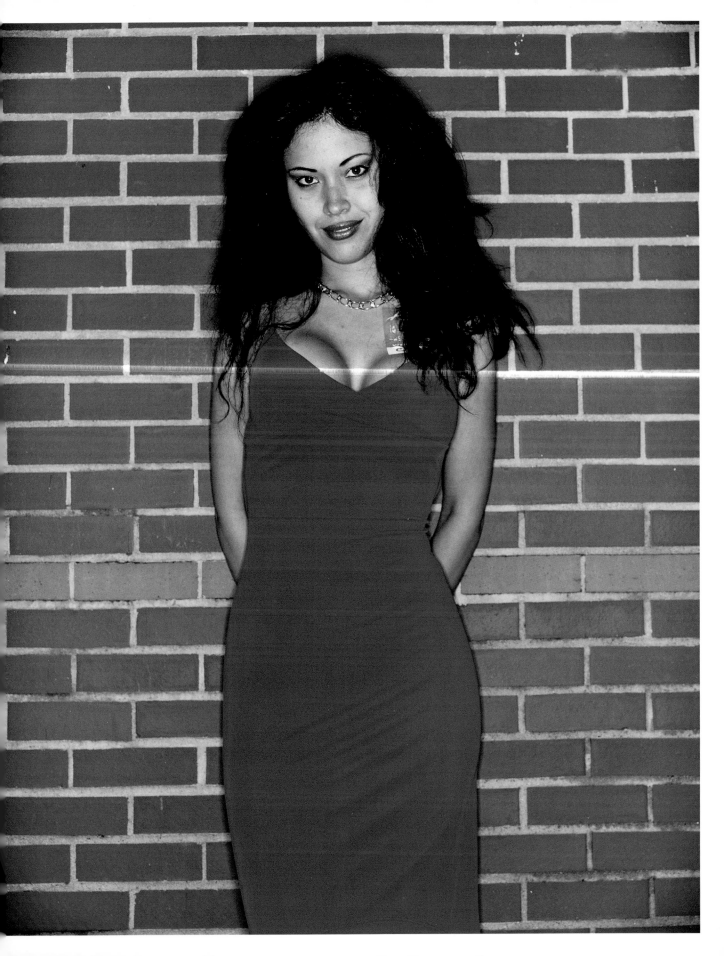

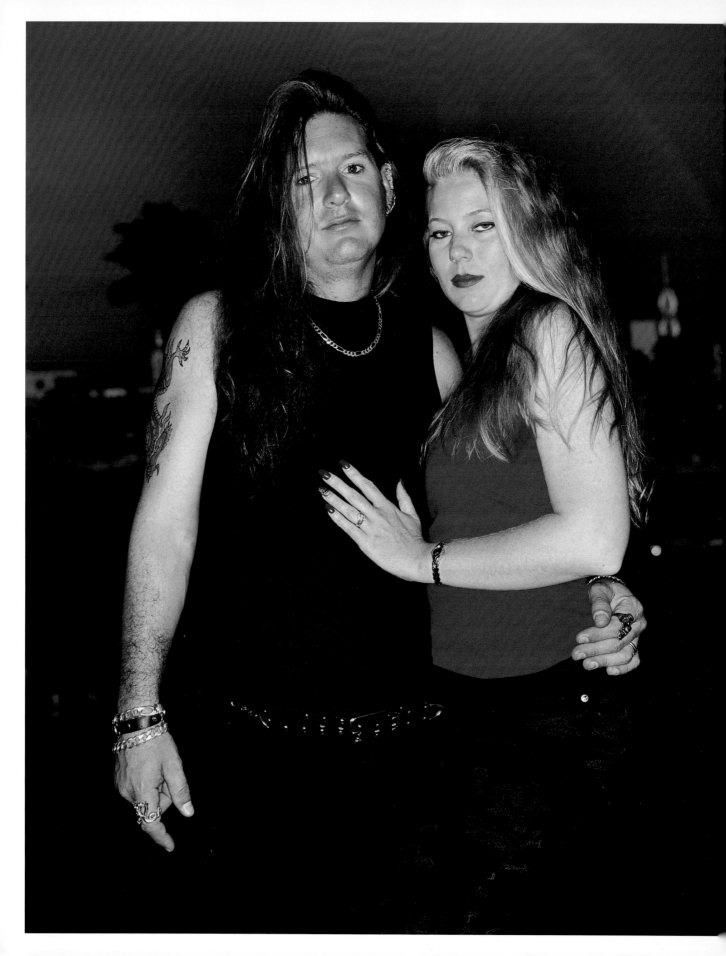

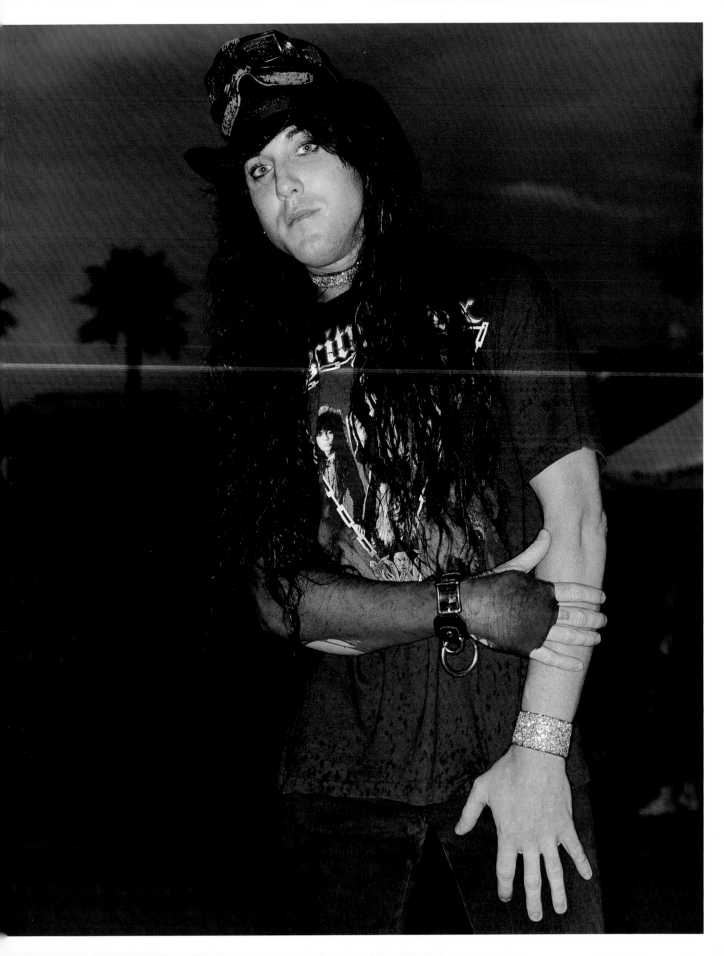

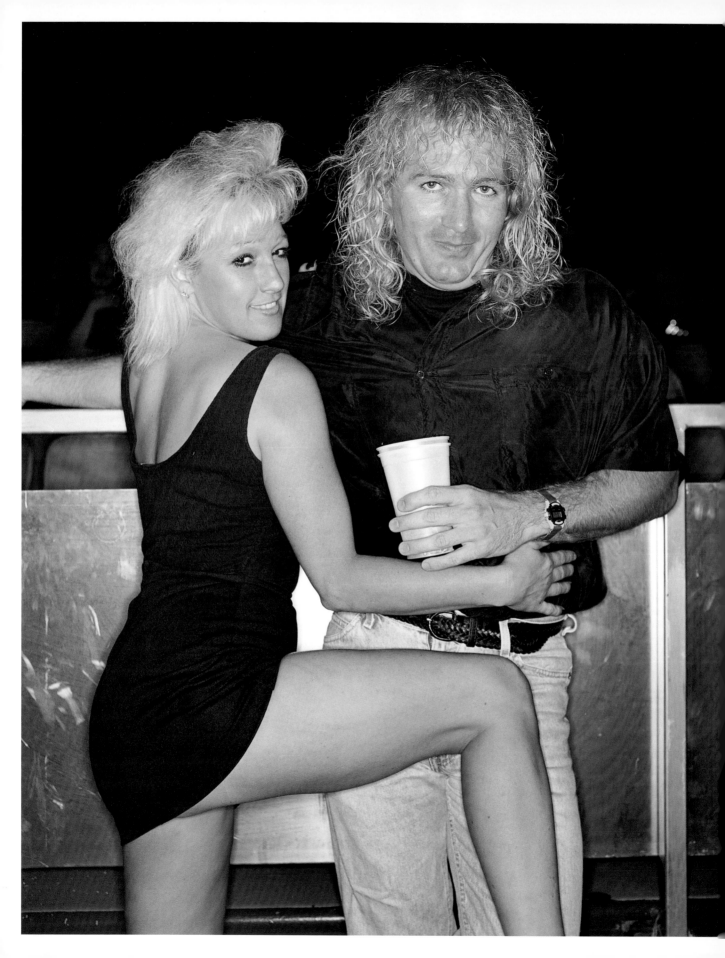

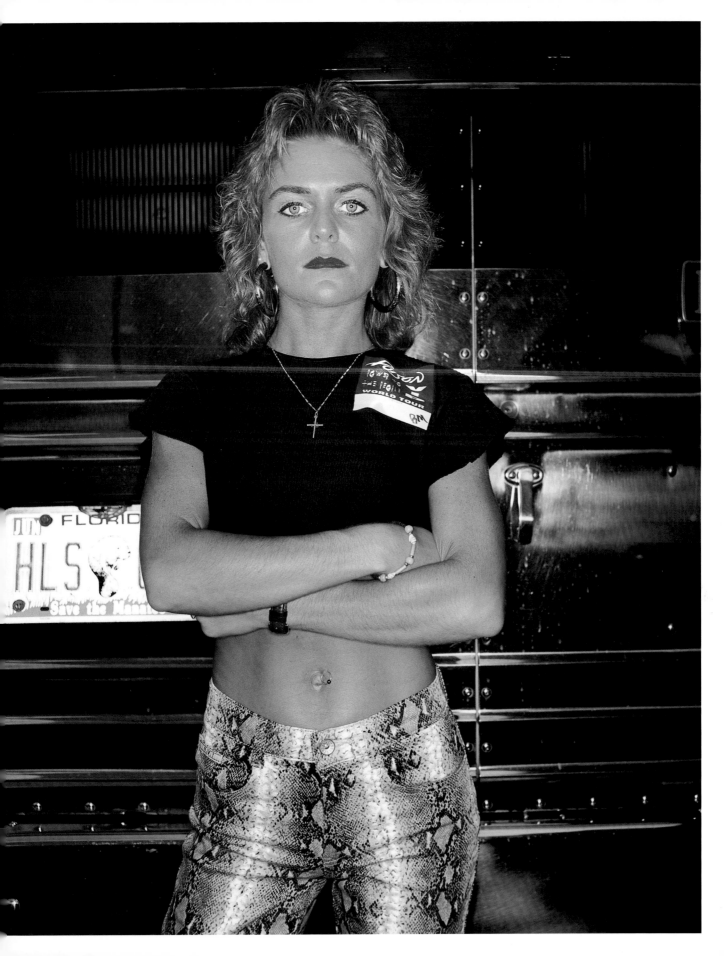

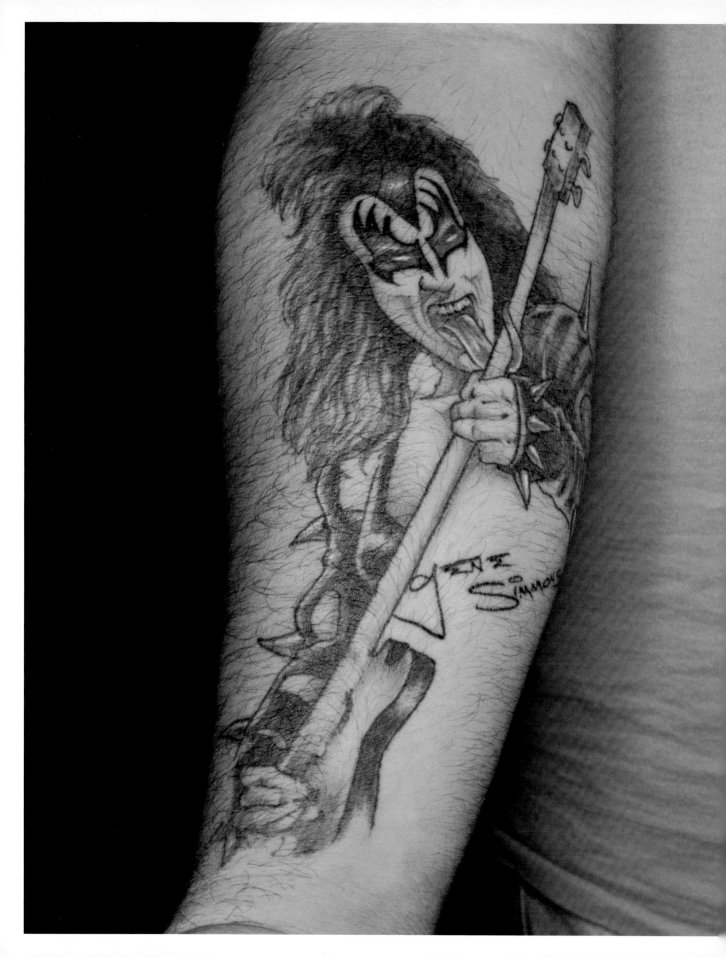

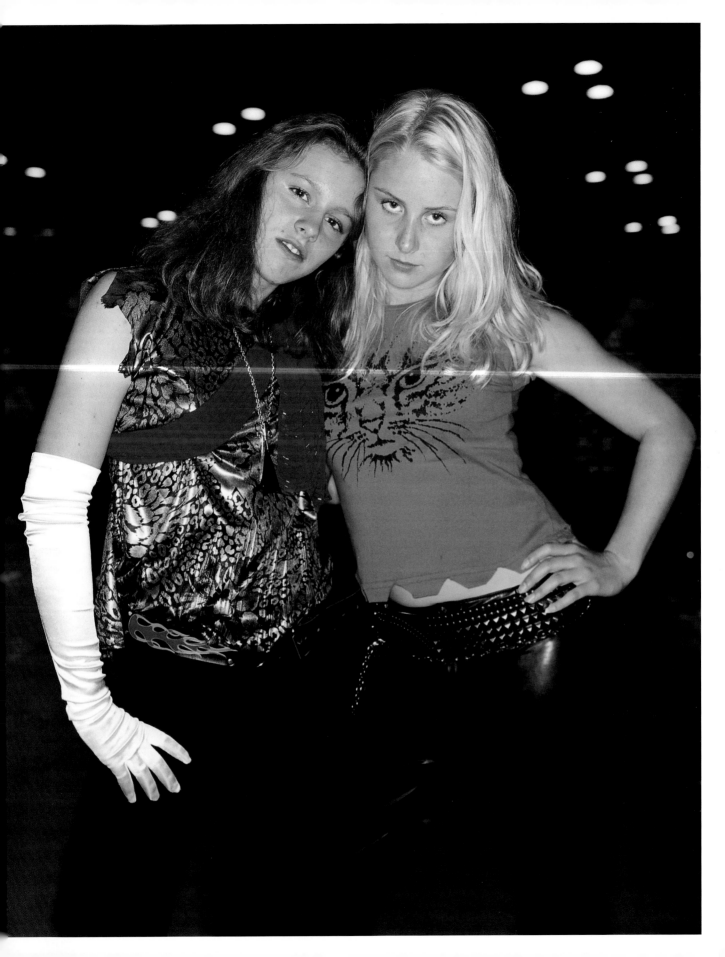

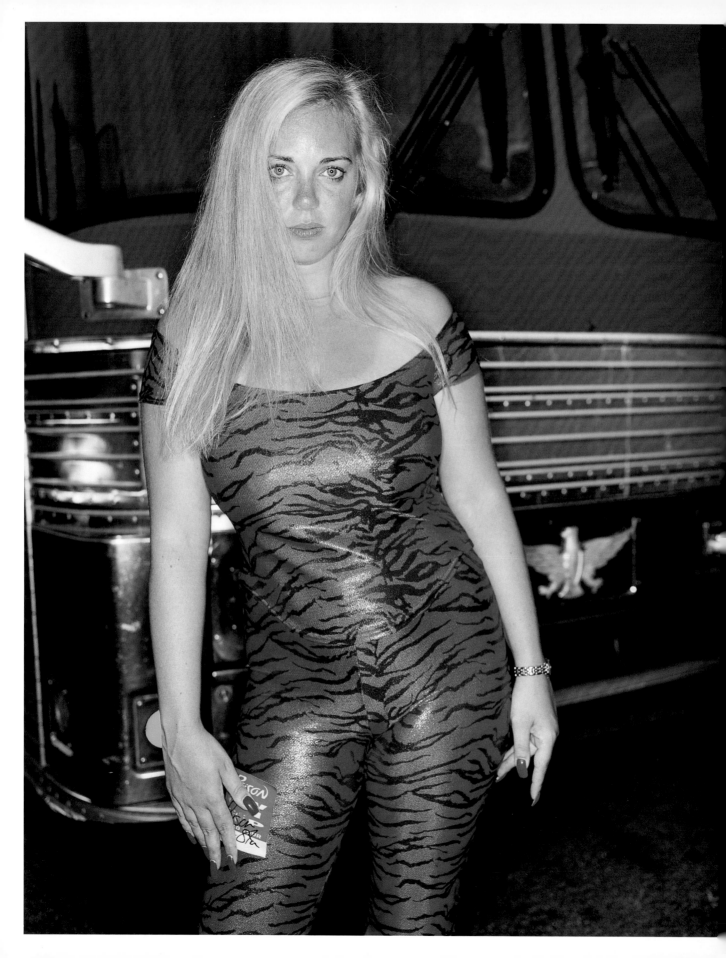

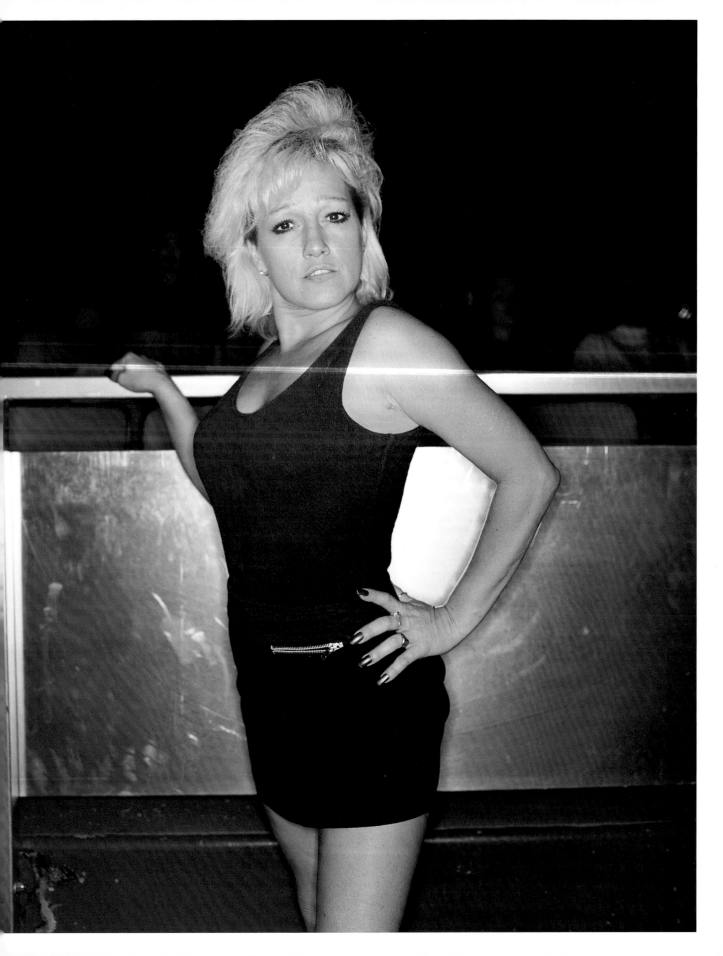

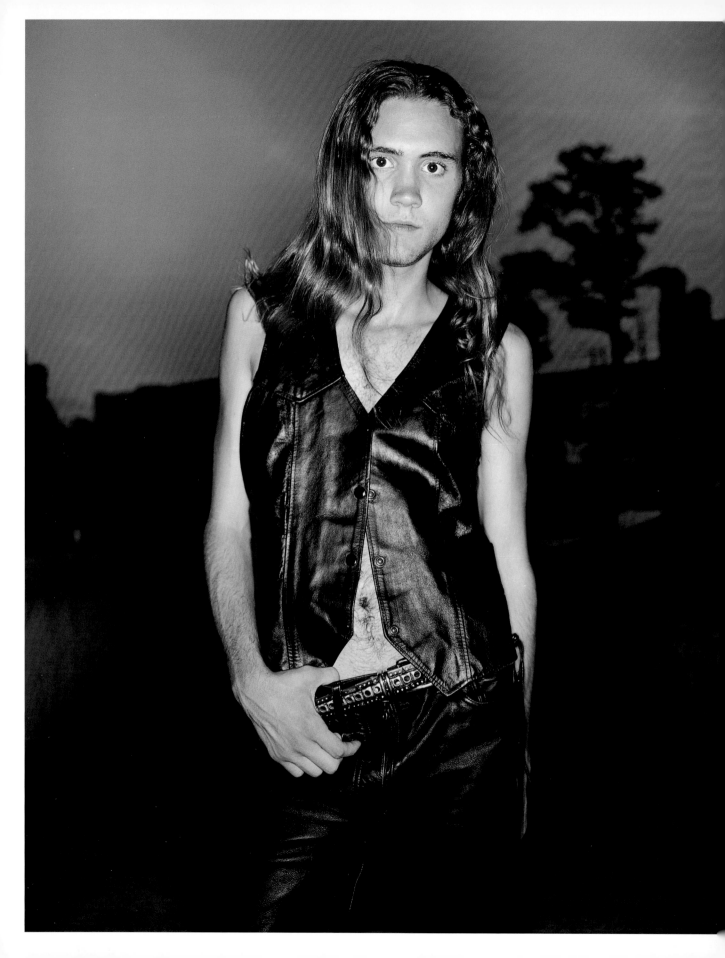

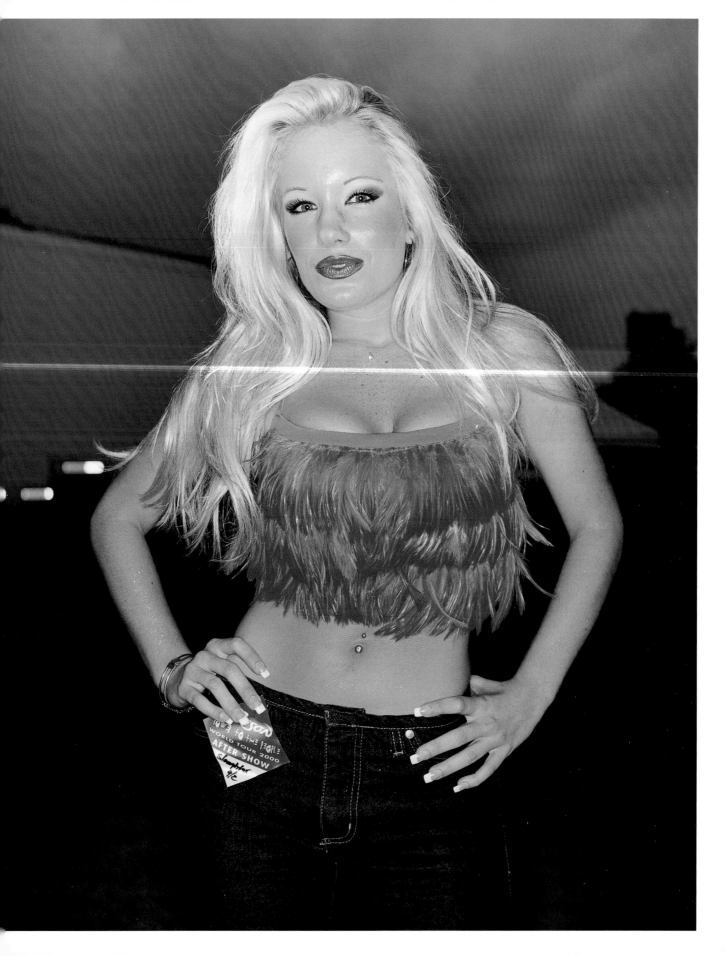

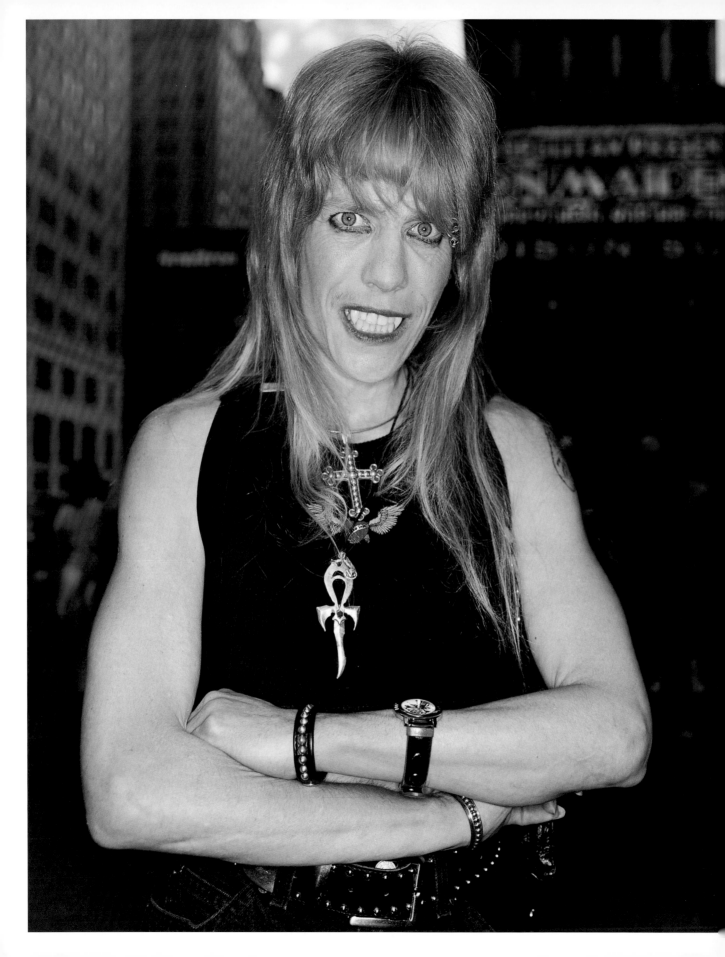

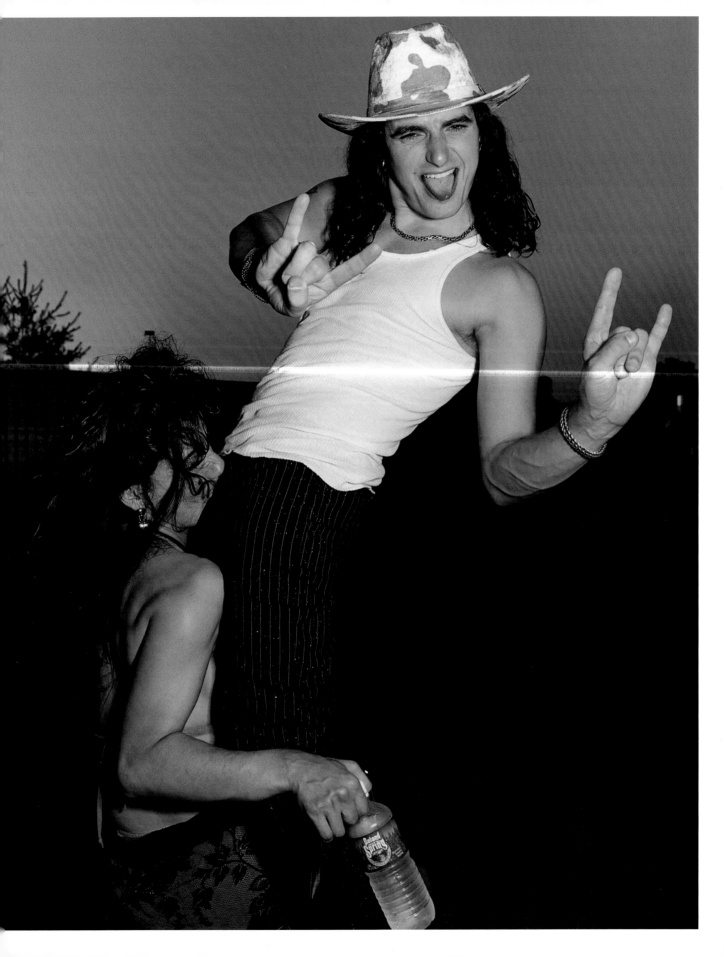

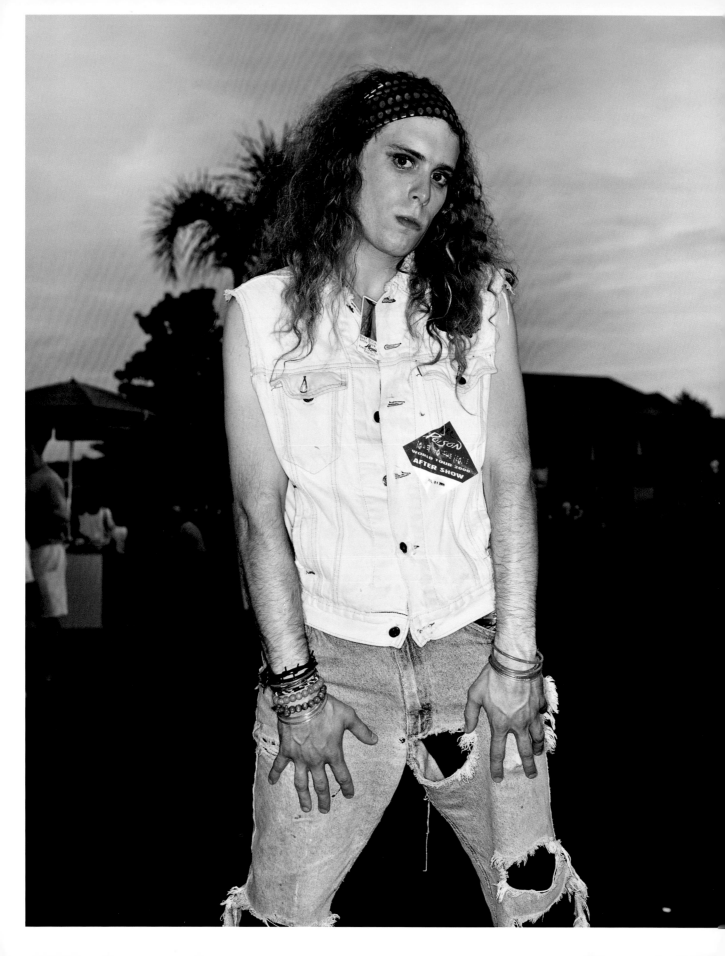

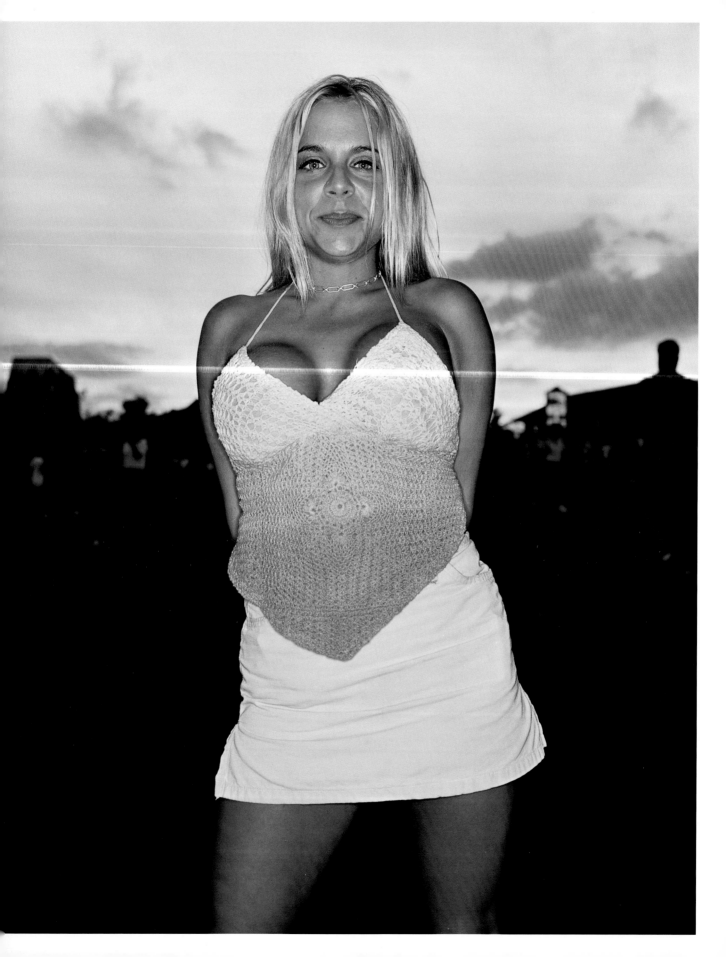

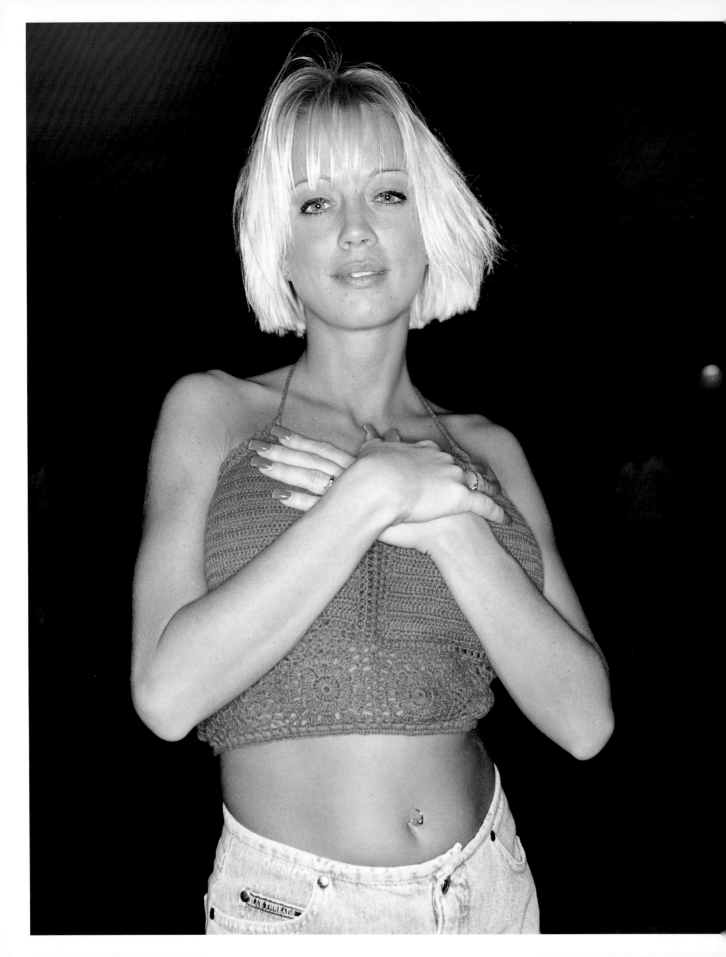

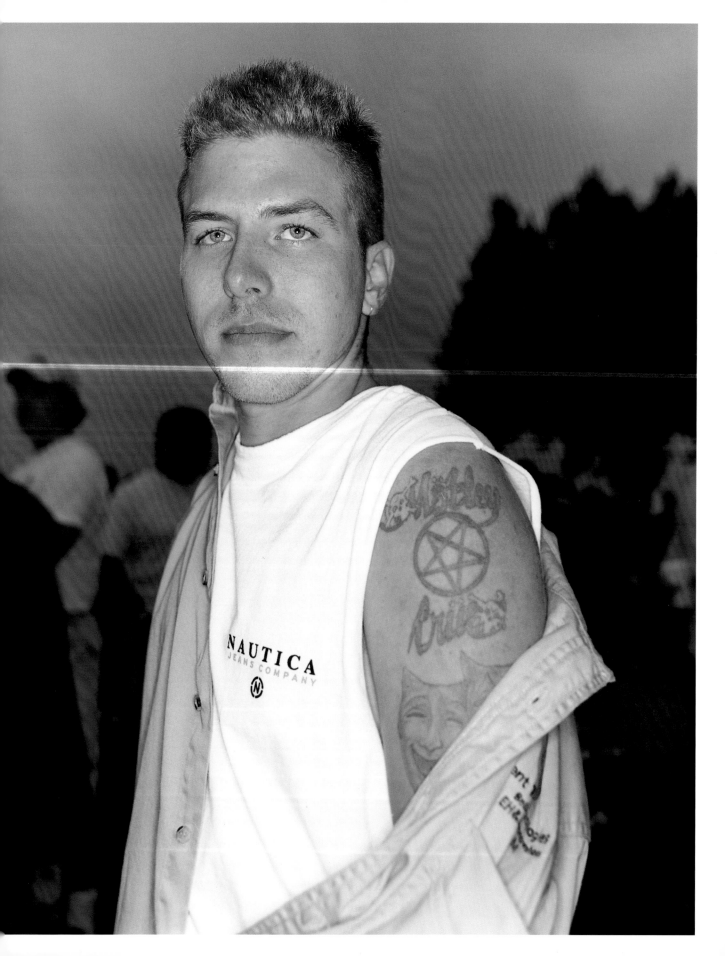

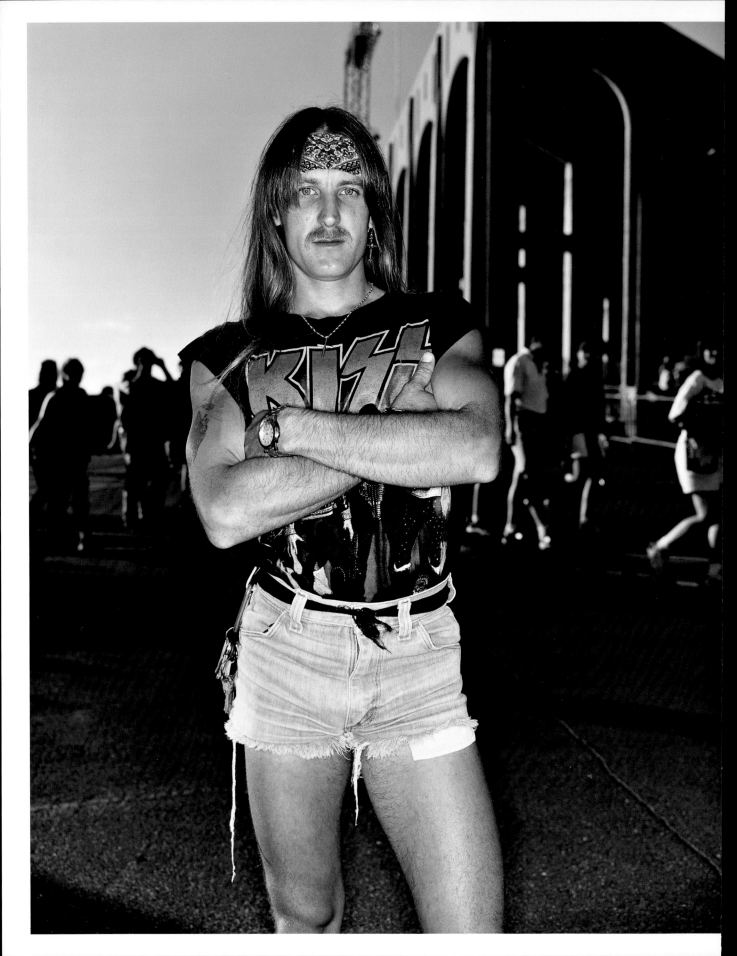

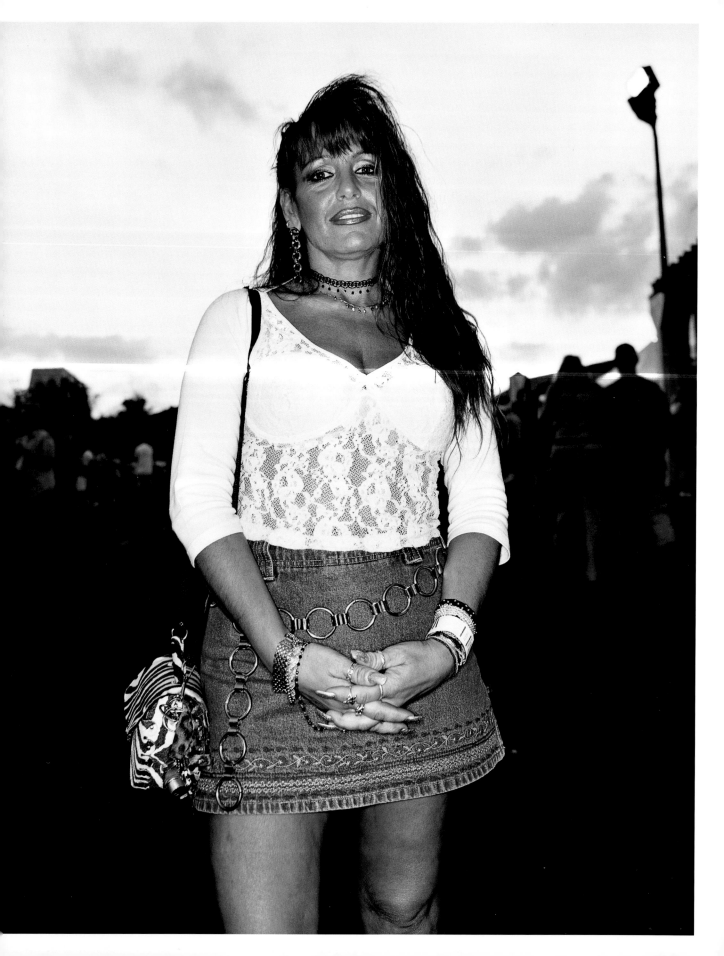

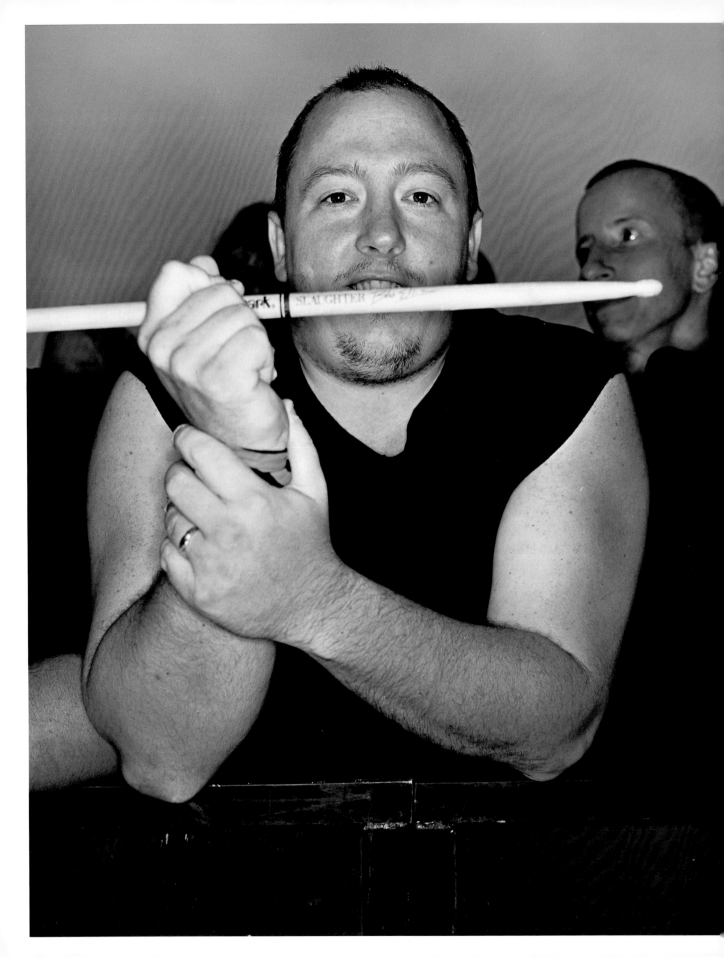

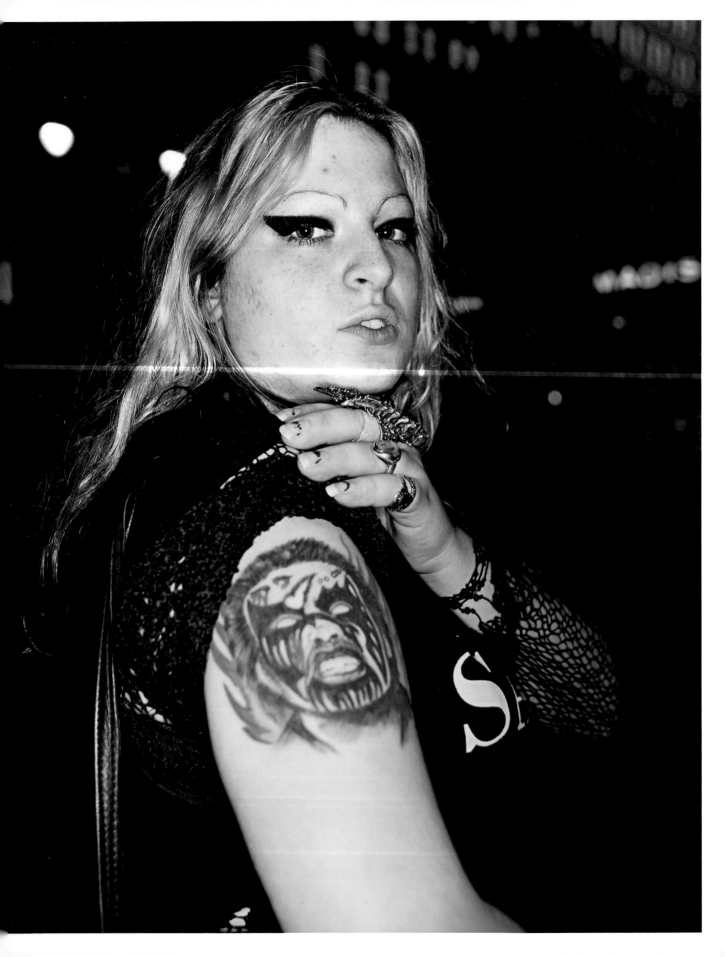

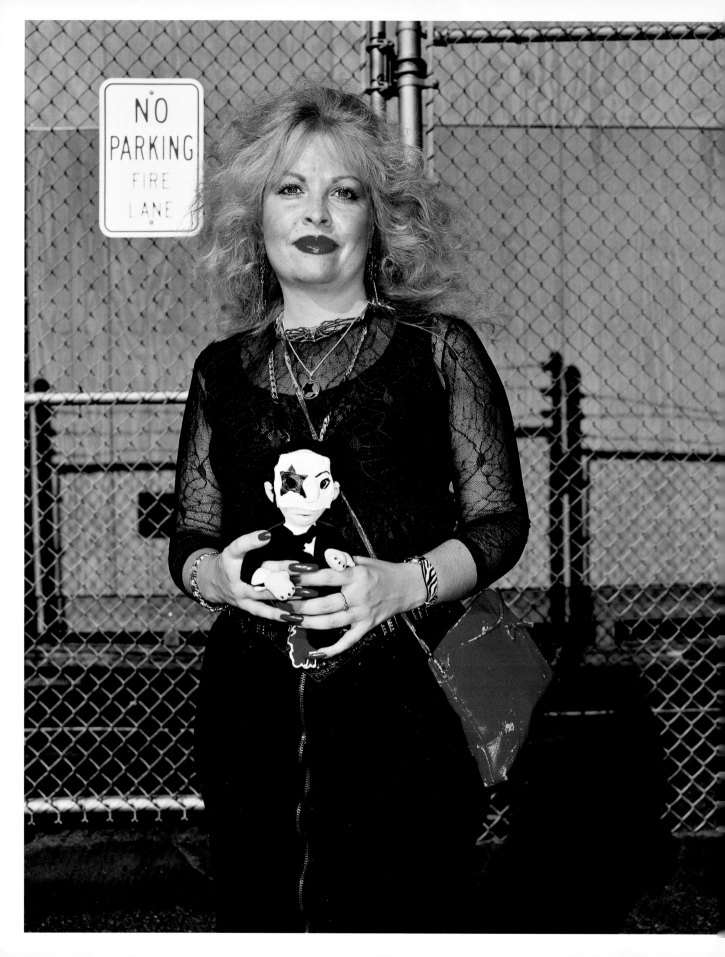

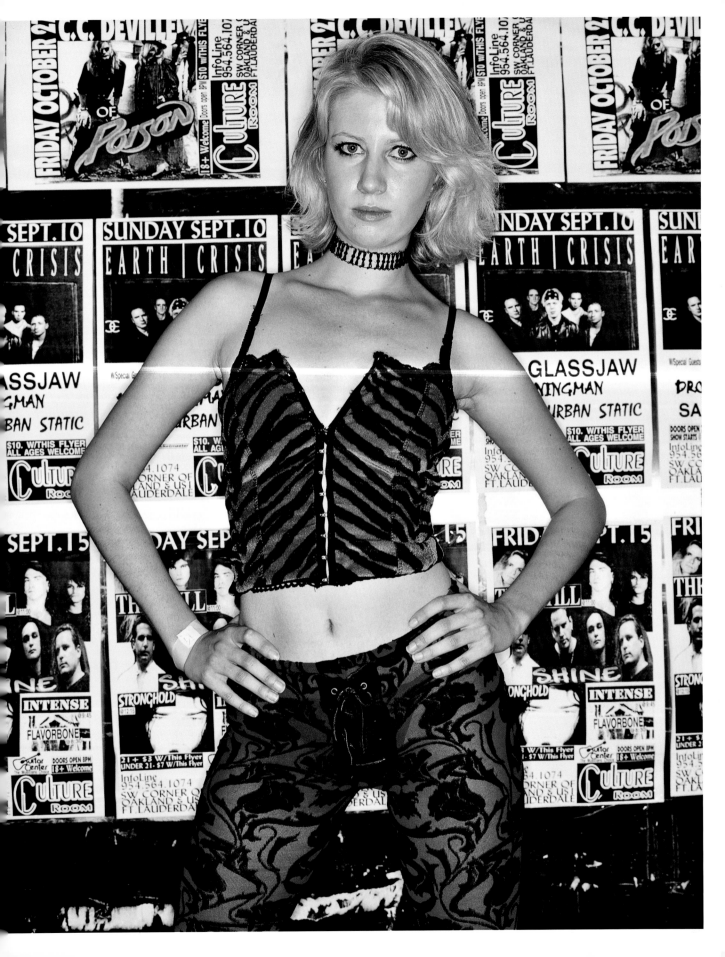

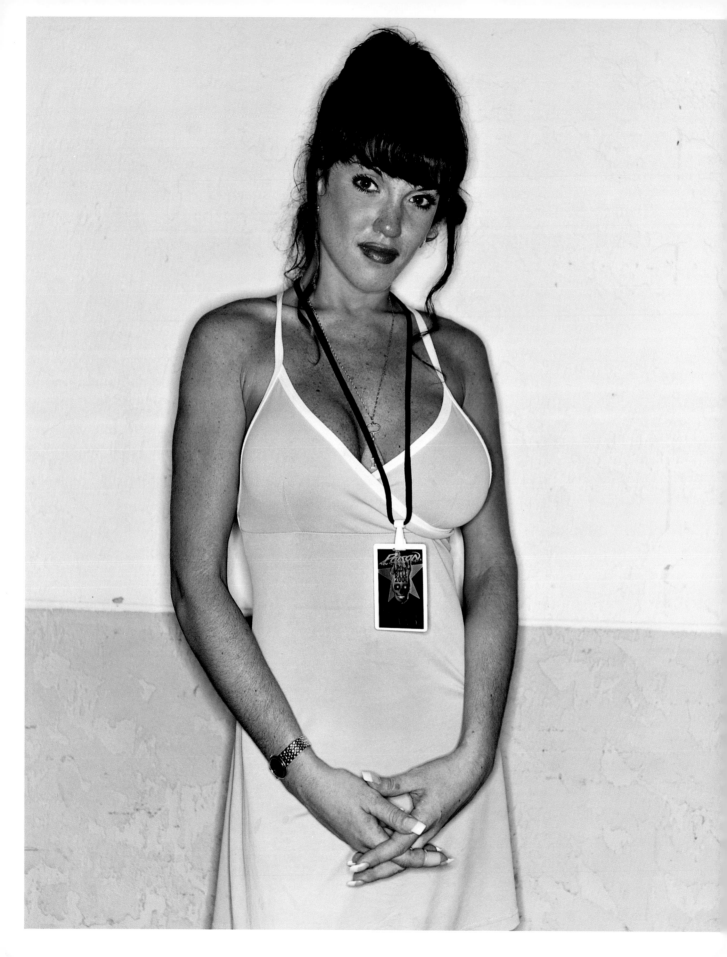

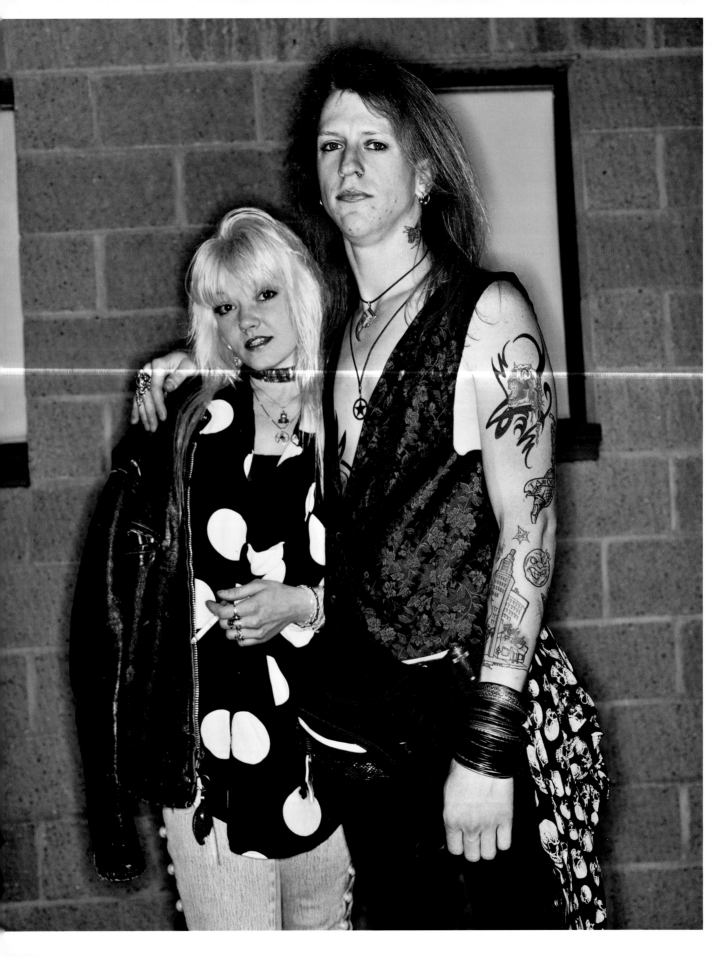

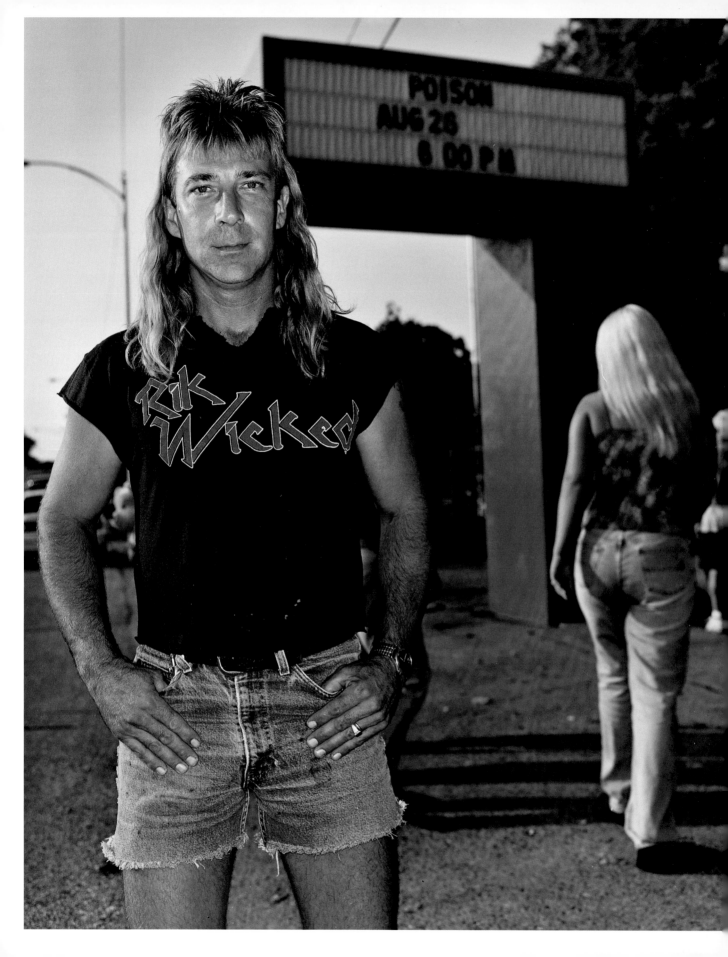

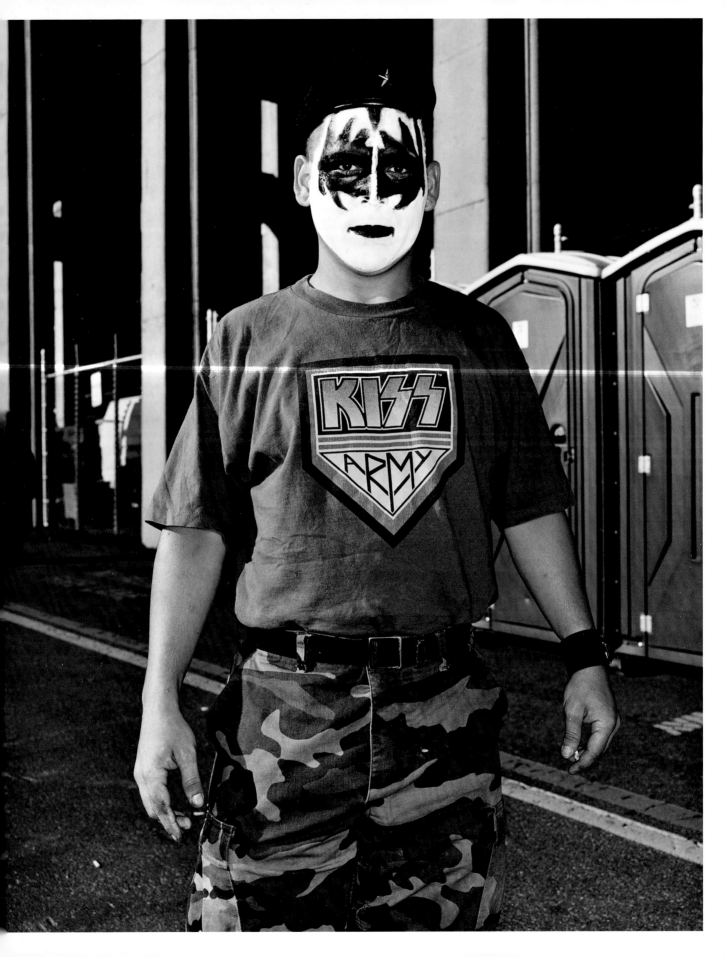

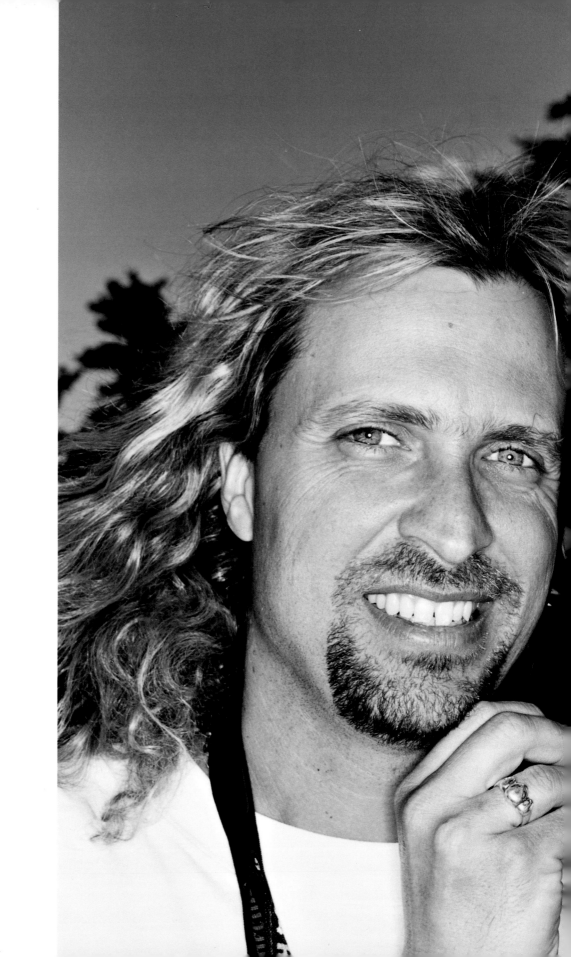

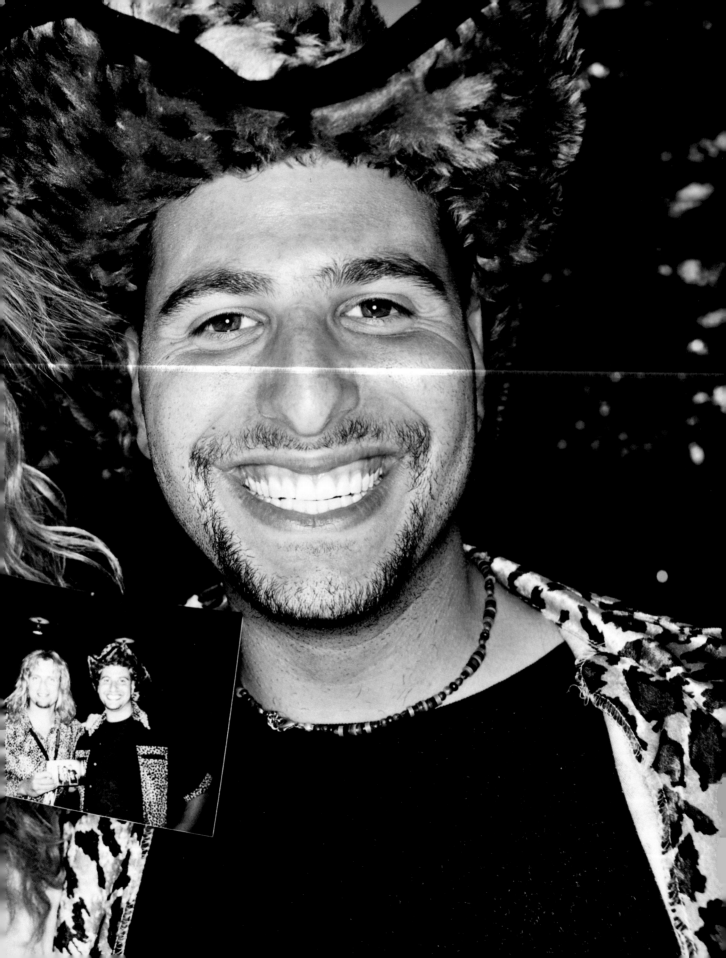

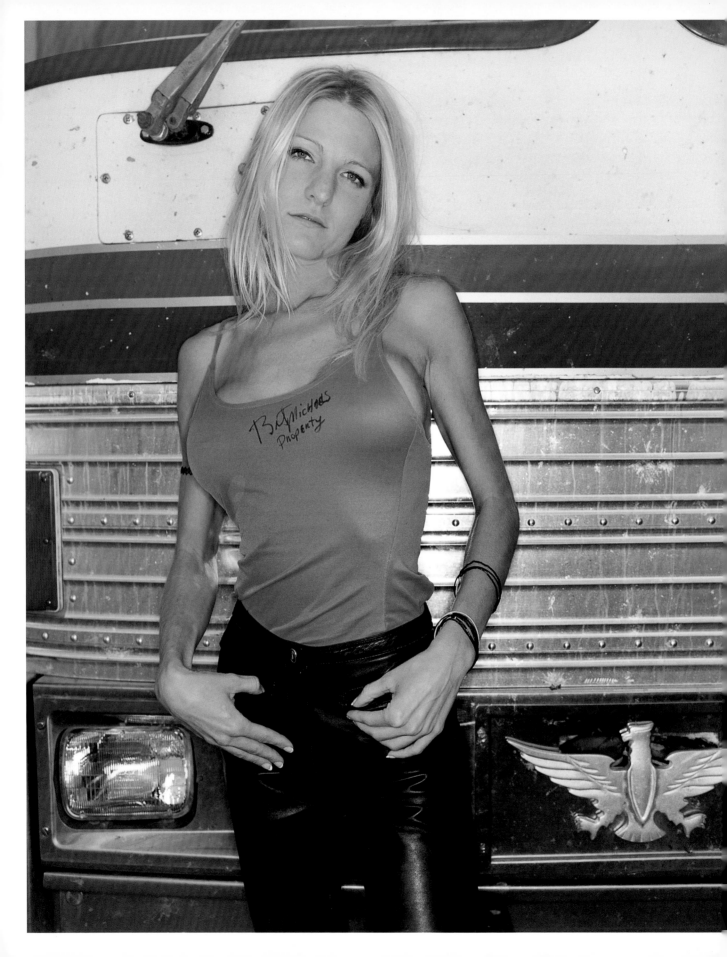

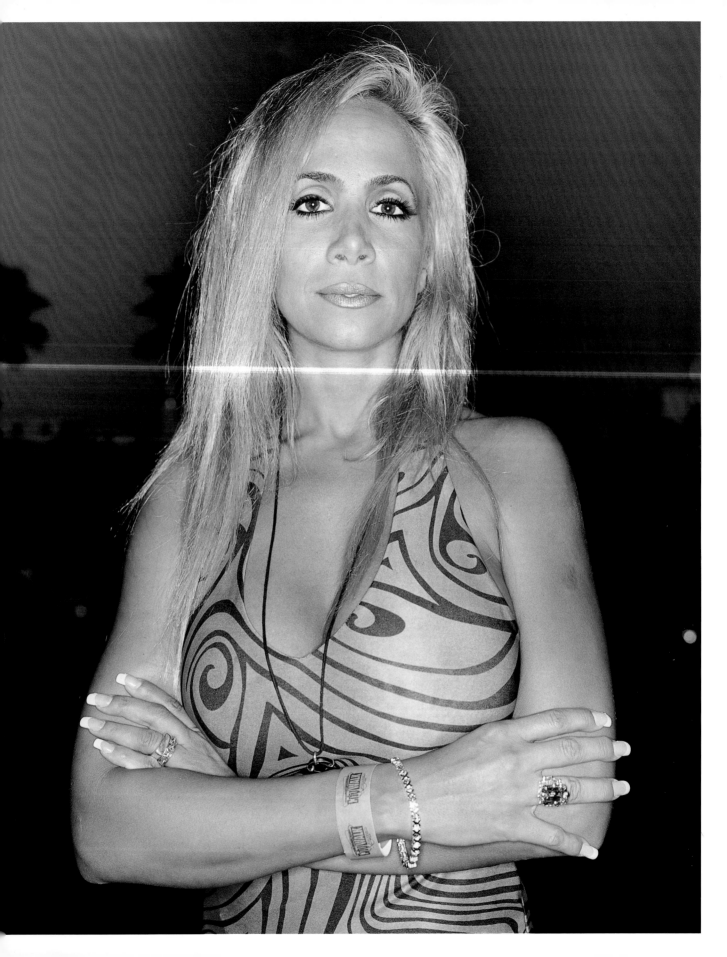

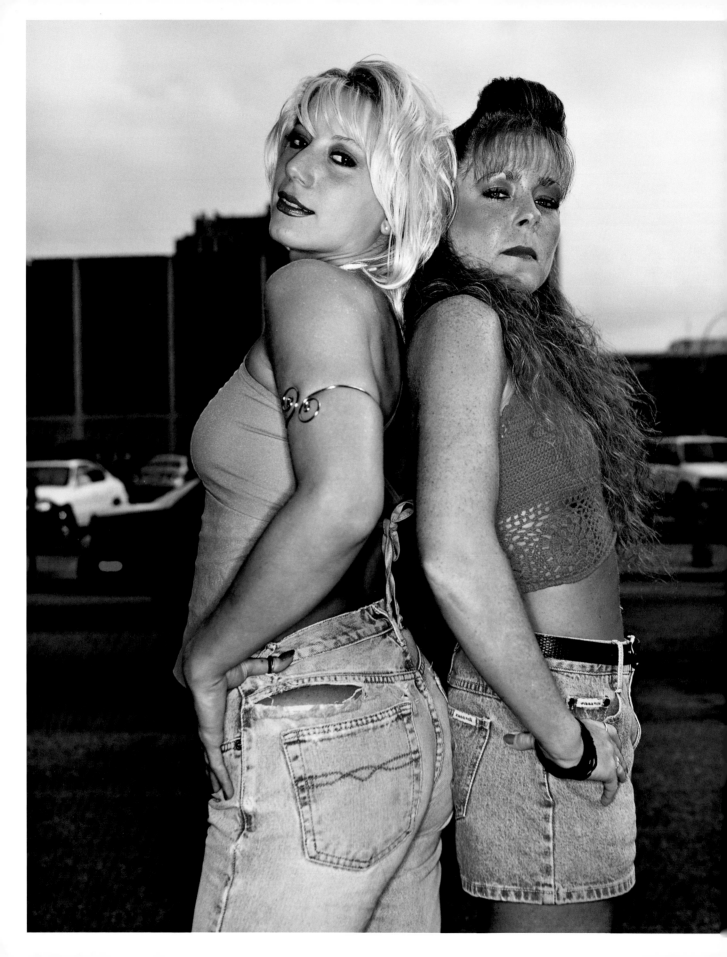

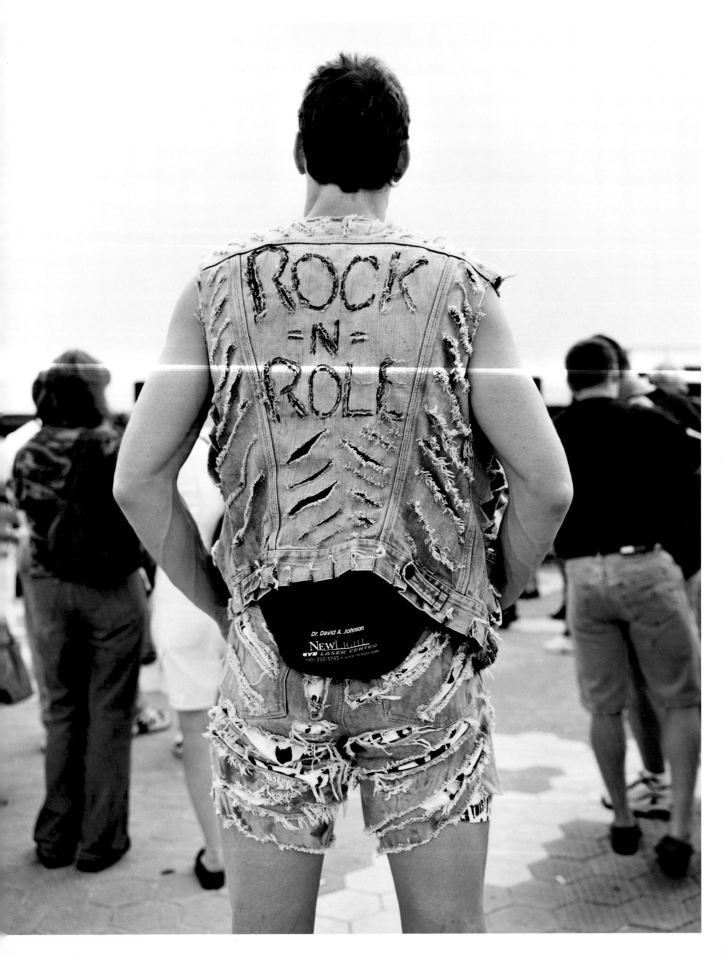

Pittsburgh, PA July 1, 2000

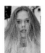

Wilmington, DE July 4, 2000

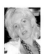

West Palm Beach, FL July 15, 2000

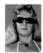

Pittsburgh, PA July 1, 2000

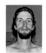

Pittsburgh, PA July 1, 2000

Ann Arbor, MI August 19, 2000

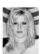

Virginia Beach, VA July 11, 2000

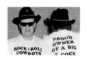

Wallingford, CT June 16, 2000

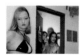

Indianapolis, IN August 17, 2000

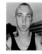

Ann Arbor, MI August 19, 2000

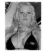

Omaha, NE August 10, 2000

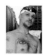

New York City, NY August 20, 2000

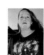

Saratoga, NY June 14, 2000

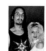

Orlando, FL August 25, 2000

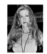

Minneapolis, MN August 8, 2000

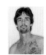

Holmdel, NJ June 17, 2000

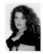

Holmdel, NJ June 17, 2000

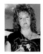

Scranton, PA July 6, 2000

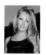

Scranton, PA July 6, 2000

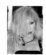

New York City, NY August 20, 2000

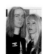

New York City, NY August 20, 2000

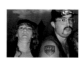

Jacksonville, FL August 23, 2000

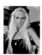

Evansville, IN August 18, 2000

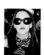

Wilmington, DE July 4, 2000

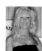

Raleigh, NC July 12, 2000

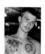

Raleigh, NC July 12, 2000

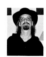

Tampa Bay, FL July 16, 2000

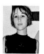

Tampa Bay, FL July 16, 2000

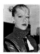

Ann Arbor, MI August 19, 2000

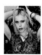

Wilmington, DE July 4, 2000

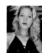

West Palm Beach, FL July 15, 2000

Charlotte, NC July 13, 2000

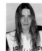

Bristow, VA July 9, 2000

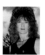

Pittsburgh, PA July 1, 2000

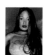

Orlando, FL August 25, 2000

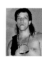

Holmdel, NJ June 17, 2000

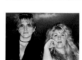

Jacksonville, FL August 23, 2000

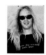

Wilmington, DE July 4, 2000

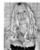

Orlando, FL August 25, 2000

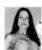

Orlando, FL August 25, 2000

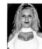

Orlando, FL August 25, 2000

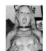

Antioch, TN July 19, 2000

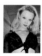

Evansville, IN August 18, 2000

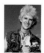

Mansfield, MA July 8, 2000

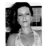

Tampa Bay, FL July 16, 2000

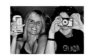

Jacksonville, FL August 23, 2000

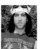

Ann Arbor, MI August 19, 2000

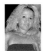

Holmdel, NJ June 17, 2000

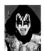

Hershey, PA June 15, 2000

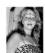

Hershey, PA June 15, 2000

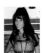

Ann Arbor, MI August 19, 2000

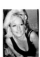

Atlanta, GA July 18, 2000

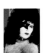

Hershey, PA June 15, 2000

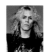

Scranton, PA July 6, 2000

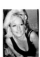

Fishers, IN June 25, 2000

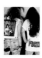

Evansville, IN August 18, 2000

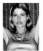

West Palm Beach, FL July 15, 2000

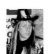

Wantagh, NY June 18, 2000

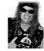

New York City, NY August 20, 2000

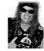

Pittsburgh, PA July 1, 2000

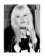

Cuyahoga Falls, OH June 30, 2000

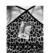

Wilmington, DE July 4, 2000

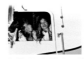

On The Road, OH June 30, 2000

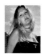

Mansfield, MA July 8, 2000

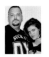

Mansfield, MA July 8, 2000

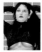

Wantagh, NY June 18, 2000

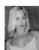

Fishers, IN June 25, 2000

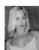

Pittsburgh, PA July 1, 2000

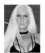

Holmdel, NJ June 17, 2000

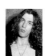

Wallingford, CT June 16, 2000

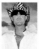

Fishers, IN June 25, 2000

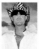

Orlando, FL August 25, 2000

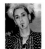

Indianapolis, IN July 23, 2000

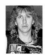

Evansville, IN August 18, 2000

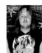

Holmdel, NJ June 17, 2000

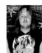

Orlando, FL August 25, 2000

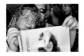

West Palm Beach, FL July 15, 2000

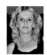

Evansville, IN August 18, 2000

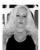

Holmdel, NJ June 17, 2000

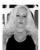

Raleigh, NC July 12, 2000

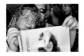

Jacksonville, FL August 23, 2000

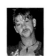

Orlando, FL August 25, 2000

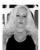

Holmdel, NJ June 17, 2000

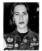

Bristow, VA July 9, 2000

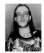

Omaha, NE August 9, 2000

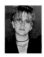

Jacksonville, FL August 23, 2000

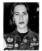

Wallingford, CT June 16, 2000

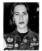

New York City, NY August 20, 2000

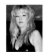

Jacksonville, FL August 23, 2000

Fishers, IN June 25, 2000

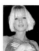

West Palm Beach, FL July 15, 2000

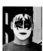

Hershey, PA June 15, 2000

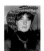

Fishers, IN June 25, 2000

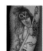

Atlanta, GA July 18, 2000

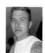

Antioch, TN July 19, 2000

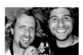

Mansfield, MA July 8, 2000

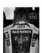

New York City, NY August 20, 2000

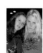

Evansville, IN August 18, 2000

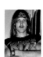

Hershey, PA June 15, 2000

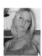

Clear Lake, IA August 15, 2000

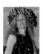

Pittsburgh, PA July 1, 2000

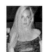

Jacksonville, FL August 23, 2000

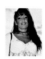

Pittsburgh, PA July 1, 2000

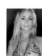

Orlando, FL August 25, 2000

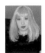

Ann Arbor, MI August 19, 2000

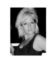

Evansville, IN August 18, 2000

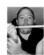

Auburn Hills, MI July 2, 2000

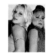

Evansville, IN August 18, 2000

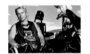

Mansfield, MA July 8, 2000

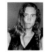

Antioch, TN July 19, 2000

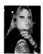

New York City, NY August 20, 2000

Tampa Bay, FL July 16, 2000

Ann Arbor, MI August 19, 2000

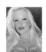

Jacksonville, FL August 23, 2000

Hershey, PA June 15, 2000

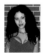

Wantagh, NY June 18, 2000

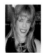

New York City, NY August 20, 2000

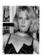

Fort Lauderdale, FL July 15, 2000

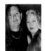

Orlando, FL August 25, 2000

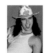

Wallingford, CT June 16, 2000

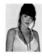

West Palm Beach, FL July 15, 2000

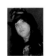

Orlando, FL August 25, 2000

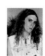

Pittsburgh, PA July 1, 2000

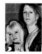

Mansfield, MA July 8, 2000

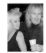

Evansville, IN August 18, 2000

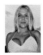

Bristow, VA July 9, 2000

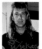

Fishers, IN June 25, 2000

ACKNOWLEDGEMENTS

I would like to thank my family for their faith in me. Jennifer Kilberg for her mastery of editing and artistic inspiration. Beth Schiffer for transforming these images into works of art. Chuck Klosterman for his in-depth knowledge of Heavy Metal. Rommel Alama for making this book look cool. Johanna Lenander for showing me how to live again. Shannon Greer for keeping me sane with late night phone calls while I was on the road. Socrates Gomez for being my boy in the hood. Joan Hernandez for coming through even when frostbite was inevitable. Susan Rideout for turning me on to photography. Rene and Jodi Mata for offering me refuge. Soo-Jeong Kang, Gladees Prieur, and Armin Harris for giving an unknown photographer a chance. Olivia Richardson for always having something positive to say. Brendan Wilcox for keeping me in check. Knox Chandler for guiding me. My assistants Louise Samuelsen, Christian Larsen, and Justin Guarino for keeping me together. Jean-Marc Vlaminck and Gwon Walberg for helping me grow as a photographer. My teachers Jed Devine, John Cohen, Joanne Walters, and Jules Allen. Rocky Lenander for his retrieving skills. I would like to thank Las Brisas, Sammy's Romanian Steak House, and Denny's all around the U.S. for their fine cuisine. A special thanks to all the bands that allowed me to tour with them: Poison, Cinderella, Dokken, Slaughter, Kiss, Ted Nugent, and Iron Maiden. A very special thanks to Craig Cohen and the staff at powerHouse Books for believing in and publishing this project.

David Yellen is represented by Arc Representation.

BIOS

David Yellen was born in 1972 in Bayside, Queens. He graduated from SUNY Purchase, where he studied under John Cohen (THERE IS NO EYE, powerHouse Books, 2001) and Jed Devine. Yellen exhibited work from TOO FAST FOR LOVE in 2001 at the Visionaire Gallery, New York. His photographs have appeared in publications such as *The New York Times Magazine*, *Time*, *Spin*, *Rolling Stone*, *XXL*, *ESPN: The Magazine*, *Dutch*, *Nylon*, and *V*. He lives and works in New York.

Chuck Klosterman is the author of SEX, DRUGS, AND COCOA PUFFS: A LOW CULTURE MANIFESTO (Scribner, 2003) and FARGO ROCK CITY: A HEAVY METAL ODYSSEY IN RURAL NÖRTH DAKÖTA (Scribner, 2001). He is a senior writer for *Spin*, a columnist for *Esquire*, and has also written for *GQ*, *The New York Times Magazine*, and *The Washington Post*. Klosterman lives in New York.

Too Fast for Love
Heavy Metal Portraits

© 2004 powerHouse Cultural Entertainment, Inc.
Photographs © 2004 David Yellen
Introduction © 2004 Chuck Klosterman

Published in the United States by powerHouse Books,
a division of powerHouse Cultural Entertainment, Inc.
68 Charlton Street, New York, NY 10014-4601
telephone 212 604 9074, fax 212 366 5247
e-mail: 2fast4luv@powerHouseBooks.com
website: www.powerHouseBooks.com

First edition, 2004

Library of Congress Cataloging-in-Publication Data:

Yellen, David, 1972-
 Too fast for love : heavy metal portraits / photographs by David Yellen ;
introduction by Chuck Klosterman.-- 1st ed.
 p. cm.
 ISBN 1-57687-215-7
 1. Heavy metal (Music)--United States--Pictorial works. 2. Rock musicians--United States--Pictorial
works. I. Title.

 ML3534.3.Y45 2004
 781.66--dc22

 2004044719

Hardcover ISBN 1-57687-215-7

Separations, printing, and binding by D'Auria Industrie Grafiche S.p.A., Ascoli Piceno

Book design by Rommel Alama

A complete catalog of powerHouse Books and
Limited Editions is available upon request;
please call, write, or bang your head on our website.

10 9 8 7 6 5 4 3 2 1

Printed and bound in Italy